Talking Trash

Talking Trash

Cultural Uses of Waste

Maite Zubiaurre

Vanderbilt University Press
Nashville

© 2019 by Vanderbilt University Press
Nashville, Tennessee 37235
All rights reserved
First printing 2019

This book is printed on acid-free paper.
Manufactured in Canada

Library of Congress Cataloging-in-Publication Data
Names: Zubiaurre, Maite, author.
Title: Talking trash: cultural uses of waste /
Maite Zubiaurre.
Description: Nashville, Tennessee: Vanderbilt
University Press, [2019] | Includes bibliographical
references and index. |
Identifiers: LCCN 2018029659|
ISBN 9780826522283 (cloth: acid-free paper) |
ISBN 9780826522290 (paperback: acid-free paper)
Subjects: LCSH: Refuse and refuse disposal—
Psychological aspects. | Refuse and refuse disposal—
Philosophy.
Classification: LCC TD793 .Z83 2018 |
DDC 628.4/45—dc23
LC record available at *lccn.loc.gov/2018029659*

ISBN 978-0-8265-2228-3 (cloth)

To all creatures discarded

Contents

Acknowledgments

Talking Trash: Cultural Uses of Waste is the result of life-long rummaging among trash (an interest, a passion really, that goes back to my childhood), and of many years spent musing about the nature of the discarded. It is the result also of inspiring readings, particularly, though not only, in the forcefully emerging field of rubbish theory, and of witnessing the true and very recent explosion of art that uses discarded artifacts and trashscapes as its prime materials. I am deeply indebted to the writers, visual artists, and filmmakers who have used their talent to bring garbage back to life (though trash really never dies). Some of these artists I had the privilege to interview and befriend, such as Spanish artists Daniel Canogar and Francisco de Pájaro, British creator and curator Alice Bradshaw, Mexican artists Ilana Boltvinik and Rodrigo Viñas, from the art collective TRES, and the German and Berlin-based art collective Bosso Fataka, whose members wish to remain anonymous. Their works and theoretical reflections have exerted a crucial influence on my own thinking.

Talking Trash is born out of a persistent dialogue between academic writer Maite Zubiaurre and visual artist Filomena Cruz, my alter ego. This is a scholarly volume, but one that incessantly submits its conclusions to the scrutiny of the artistic eye. While Zubiaurre writes, Cruz photographs and collages but also infuses poetry into the pages of this book as well as to the discarded artifacts the text and images retrieve and bring to light. Furthermore, my teaching endeavors at UCLA have also greatly influenced my book, and vice versa. My gratitude goes out to the undergraduate students from the sciences, the humanities, and the arts who attended and brilliantly contributed to my two Honors Collegium seminars on waste and culture; to the graduate students in Spanish and Portuguese who participated in my seminar on theories of the discarded and made me rethink many of my assumptions; and to the graduate students in architecture, humanities, and urban planning I had the pleasure to teach in the context of the Mellon-sponsored interdisciplinary Urban Humanities Initiative (UHI), and whose reflections on so-called border trash (Chapter 2) have not only enriched this book, but opened up a whole new area of inquiry for me. Many of my undergraduate and graduate students took it on themselves to send me references and news about trash in the world and the works of artists, and I thank them for it. I particularly want to highlight the contributions of Kevin McDonald, who introduced me to the Garbage Pail Kids phenomenon and trading cards and even made his collection available to me; of Isaura Contreras, who offered meticulously researched insight into the trash art scene in Mexico City; and even more emphatically

those of Gabriela Barrios, who not only was instrumental and notably resourceful in securing copyright permission for the many images and tackling all the technical aspects pertaining to the latter, but also showed remarkable talent as editor of the manuscript and provided invaluable input.

I also wish to thank the universities, institutions, and initiatives that invited me to talk on my research on the cultures of the discarded, namely the Mellon-sponsored Urban Humanities Initiative—UCLA; the Mellon-sponsored Sawyer Seminar on the Environmental Humanities—UCLA; TRANSIT: Transnationality at Large: The Transnational Dimension of Hispanic Culture in the Twentieth and Twenty-First Centuries; LASER (Leonardo Art Science Evening Rendezvous); UC–Mexicanistas International Conference—University of Santa Barbara, California; Woodbury University—WOHU Gallery; Yale University; the University of Konstanz, Germany; the University of Southern California (USC); the Universidad Nacional Autónoma de México (UNAM); the Universidad Autónoma de la Universidad de México (UACM); and New York University.

Last but not least, I want to extend my deepest gratitude to the director of Vanderbilt University Press, Michael Ames, who believed in the book project from its inception and greatly contributed to its improvement with his wisdom and expertise. Joell Smith-Borne, the managing production editor at Vanderbilt University Press, took expert care of all the many different steps that make the publication of a book possible, and Peg Duthie excelled in the art of indexing. My sincere appreciation goes out to them, and also to the many friends and colleagues who continuously supported my personal, artistic, scholarly, and pedagogical interest in all things discarded. I am specially indebted to Estrella de Diego and to Jo Labanyi, whose invaluable insights have been a constant source of inspiration and guidance, but also, and in alphabetic order, to Samuel Amago; Jonathan Banfill; Hans Barnard; Ali Behdad; Marisa Belausteguigoitia; Rosa Beltrán; Jim Burklo; Allison Carruth; Jon Christensen; Angelina Craig-Florez; Jonathan Crisman; Dana Cuff; Jason de León; Luisa Elena Delgado; Nina Eidsheim; Pura Fernández; Sergio Florez; Andrea Fraser; Alicia Gaspar de Alba; Kristy Guevara-Flanagan; Robert Gurval; Reem Hanna-Harwell; Ursula Heise; Gregory Hess; Gil Hochberg; Roberta Johnson; Tanius Karam; David Kim; Miwon Kwon; Christoph Lindner; Anastasia Loukaitou-Sideris; Rían Lozano; Peter Lunenfeld; Helena Medina; Sara Melzer; Cristina Moreiras; María Moreno Carranco; Laure Murat; Steven Nelson; Kathy O'Byrne; Dolores Orihuel; Christina Palmer; Sara Poot Herrera; Todd Presner; Ricardo Quinones (who suggested that I call the book *Talking Trash*); María José Rodilla; Michael Rothberg; Ananya Roy; Alvaro Ruiz Abreu; David Schaberg; Victoria Vesna; Charlene Villaseñor-Black; Willecke Wendrich; and Yasemin Yildiz.

Needless to say, this book would have never been written without the undying support of my husband, Fernando Zapatero, the first reader and relentless critic of everything I write, and without the loving patience, inspiring wisdom, and refreshing sense of humor of my sons, Nicolas and Sebastian, and my "adoptive daughter," Guadalupe Yáñez León.

Talking Trash

Introduction

In his book succinctly called *Waste* (2015), Brian Thill takes some time to reflect on a plastic bag. "Last winter," he says,

> after the final leaf fell from the tree nearest my kitchen window, I spotted a plastic bag coiled in its thin branches, a common enough site wherever barren trees and a steady supply of litter obtain. These wispy daemons exist in all seasons, but late autumn and early winter seem to be the time of their greatest flourishing. The next day, it was still there; and the next day and the next. Through weeks of howling winds and rains, and eventually, ice and snow, the bag clung to its perch. And then one day several months later, after having trusted in it being there every day, immovable, my trash familiar was gone. (22–23)

The volume you hold in your hands is precisely about the plastic bags of this world, about trash as "an orphan object that can often be found somewhere outside of both the free-floating state (the all-famous dancing plastic bag in *American Beauty*), and entombment, at least for a time" (Thill, 23). *Talking Trash: Cultural Uses of Waste*, thus, is predominantly about "small" and orphaned trash that stays and lingers, even dances and sways, and that takes some time (weeks, months, years even) to detach from branches or to peel off from sidewalks. It is about refuse at its early stages, when it is still tiny and unassuming, still lives in the city, and has yet to grow, leave the metropolis, and accumulate in landfills. Unavoidably, the monumentality of garbage will frequently show in the pages that follow, but, mostly, it is small trash that you will find, an emphasis on litter as a "living creature" that inhabits the streets, creates micro-trashscapes, and acquires anthropomorphic features in art and thought.

Fixed on the small, *Talking Trash* is not a book on the environment and on environmentalism, sensu stricto, nor does it conceive of garbage and nature as two separate entities. Instead of taking the conventional view of trash as the formidable outsider that invades and sullies the natural world, this book casts a musing look at the complex and muddled conflation of the artificial and the natural (Donna Haraway–style) when it comes to all things discarded. In Gay Hawkins's eloquent and poetry-infused words, "the abandoned car rotting quietly in the landscape is alive with the activity of corrosion, it's become a habitat, it looks perfectly at home, it's both organic and machinic" (*Ethics of Waste*, 10). Sure enough, during one of my walks in Los Angeles, California, I found a tiny leaf etched into a blotch of bubble gum on the pavement (Fig 2.15 in Chapter 2). I was struck by the delicate beauty of autumnal

debris, its golden hue further enhanced by the background of Pop pink; but mostly I was in awe of the easiness with which nature had serendipitously nestled into the artificial (and sometimes vice versa).

It is in the rather free and playful spirit of this volume to identify and facilitate experiences like this, and to collect epiphanic moments that highlight the nuanced complexity of refuse as the "messy" site where nature and culture collide; and as the paradigmatic locus where marginality and social inequality express themselves with particular eloquence. Of the various binomials from which *Talking Trash: Cultural Uses of Waste* draws direct and powerful inspiration—namely, trash and art, trash and the transient, trash and the margins, trash and innocence, trash and gender, and trash and compassion—the latter (trash and compassion) is by far the most potent and prevalent one. In fact, not only in this book but also in my undergraduate and graduate seminars on the subject I have made it my pedagogical mission to teach compassion and social awareness through (small) trash.

Drawing loosely and capriciously from the findings of hermeneutics, phenomenology, psychogeography, situationism, art and its "ways of seeing" (Berger), and, last but not least, from forcefully emerging "rubbish theory," *Talking Trash* applies the triple strategy of pausing/looking down/musing to litter analysis. Since the Renaissance, Western culture has favored, and capitalized on, the upright position and the sweeping panoramic view. *Talking Trash*, however, takes the opposite stance. Instead of standing straight and looking ahead, it bends down and lowers its eyes. Tired of the arrogant verticality and piercing eyesight of "doers" and conquerors, it favors the myopic approach to things that first Charles Baudelaire and

then Walter Benjamin learned to appreciate in ragpickers and chiffoniers and draws inspiration from the stooping silhouette of the scavenger so masterfully portrayed in Agnes Varda's award-winning documentary *Les Glaneurs et la Glaneuse* (*The Gleaners and I*, 2000). In fact, if I were to choose a landscape that defines my book, it would probably be the one below:

> There is a pile on the side of the train tracks. Light-blue cloth—a shirt, perhaps—jumbled up with something dirty white. It's probably rubbish, part of a load dumped into the scrubby little wood up the bank. It could have been left behind by the engineers who work this part of the track, they're here often enough. Or it could be something else. My mother used to tell me that I had an overactive imagination. . . . I can't help it, I catch side of these discarded scraps, a dirty T-shirt or a lonesome shoe, and all I can think of is the other shoe and the feet that fitted into them. (P. Hawkins 1)

Like the main character in Paula Hawkins's widely acclaimed novel, *The Girl on the Train* (2015), this book too approaches "discarded scraps" with an overactive imagination and, similarly to Rachel the protagonist, reconstructs reality from the castoff objects ("a dirty T-shirt," "a lonesome shoe") that "soil" the urban landscape. Moreover, it scrutinizes the work of artists who like to stoop, bent over, and take a nearsighted look at litter. Some become meticulous collectors of the castoff, no matter how inconsequential or minuscule, such as German artist Al Hansen, who found inspiration in cigarette butts (Fig. I.1), or French artist Fanny Violet, who from 1984 to 1990 painstakingly gleaned small pieces of debris found on

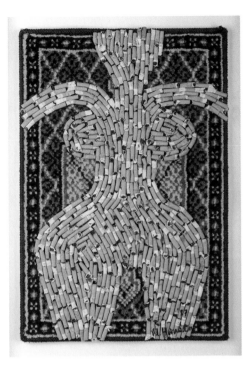

Fig. I.1: Al Hansen, *Orange Cigarette Butts: Venus on Carpet*. 1987. Hamburg, Germany.

sidewalks and stitched them to more than ten thousand annotated cards kept in sixty-nine boxes (box number 4 is now part of the Centre George Pompidou collection). In 2011 Viollet initiated yet another project where she would tie tiny pieces of robe, lace, plastic, and so on into one thousand balls (Fig. I.2).

Other artists do not collect, strictly speaking, though they end up creating vast urban collections of similar artifacts. This is the case of Spanish artist Francisco de Pájaro, who roams the streets of Barcelona, Madrid, London, Berlin, Los Angeles, and New York at night armed with paintbrush and masking tape, and turns garbage bags and discarded items into anthropomorphic creatures (Fig. I.3; see also Figs. 1.24, 1.30, 1.31, 1.32, 1.33, 1.34, 1.35, and 1.37 in Chapter 1). His compassionate plea in defense of the homeless and the urban outcasts is further proof of how trash art is as much about social

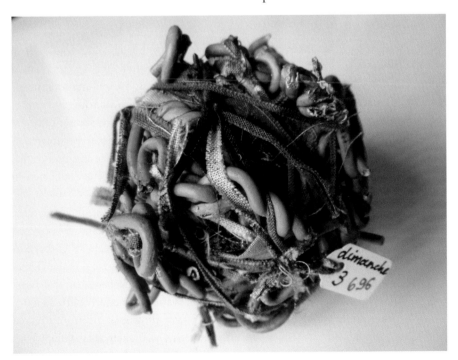

Fig. I.2: Fanny Viollet, Paris, France.

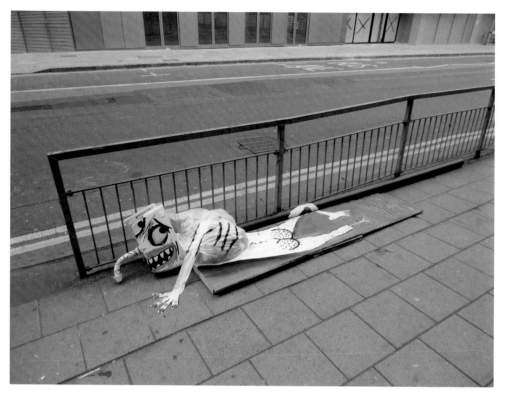

Fig. I.3: Francisco de Pájaro, London, UK, 2013.

inequality and injustice as it is about the environment (if not more so). In fact, it is de Pájaro's work ultimately that made me "see" trash, and understand its ability to eloquently and compassionately speak about the human condition. Trash is alive (and rots, like we do). Trash, particularly small rubbish that lingers and is reluctant to leave the city, is our mirror. At the end, it is all about scale. The monumentality of landfills captures our imagination, as does the enormity of outer space. But, eventually, it is in the small and near where we recognize ourselves.

Daniel Rozin's famous interactive piece *Trash Mirror* (2001; Figs. I.4 and I.5) is based precisely on this same principle. To build it, Rozin used small-scale rubbish or litter, specifically "500 pieces of variously colored trash collected from the streets of New York." With the help of motors, control electronics, a concealed video camera, and a computer, the "trash mirror" makes it possible then for "any person standing in front of one of these pieces [to be] instantly reflected on its surface," for, as the artist himself is quick to point out, the ultimate goal of this piece is "to suggest that we are reflected in what we discard" (Rozin).

Trash thus as city-bound "miniature" that reflects the human—and as opposed to the widespread perception of garbage as alien, monumental, and afar—is the thread ultimately that ties the pages of this book together. Always mesmerized with "small," *Talking Trash* progresses from animated trash "loitering" on sidewalks (Chapter 1); to litterscapes and archives of urban refuse (Chapter 2); to city-bound Dumpsters and

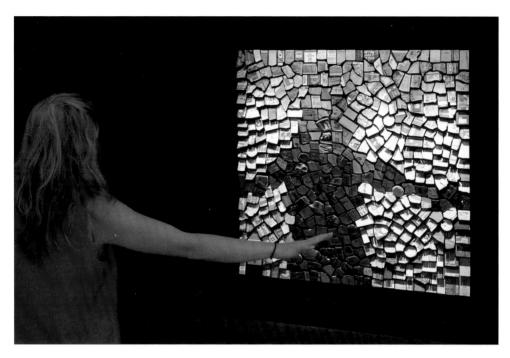

Fig. I.4: Daniel Rozin, *Trash Mirror Number 3*, 2001–2011. Discarded Objects, Motors, Video Camera, Wood, Custom Electronics, Custom Software; 76 x 76 x 6 in / 193 x 193 x 15.2 cm. Courtesy Bitforms Gallery, New York.

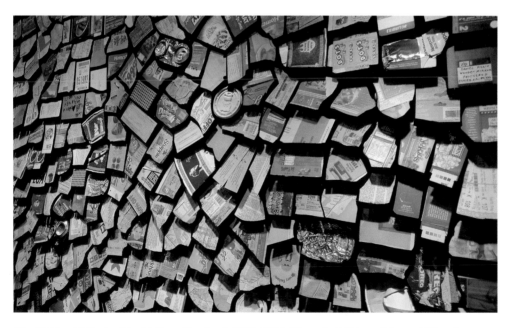

Fig. I.5: Daniel Rozin, *Trash Mirror Number 3*, 2001–2011. Discarded Objects, Motors, Video Camera, Wood, Custom Electronics, Custom Software; 76 x 76 x 6 in / 193 x 193 x 15.2 cm. Courtesy Bitforms Gallery, New York (Detail).

semantically rich "Dumpsterology" (Chapter 3); and, finally, to the fate and meaning of garbage when it falls into the small (and gendered) hands of children (Chapter 4).

Chapter 1 ("Sentient Filth: The Motions and Emotions of Garbage") reflects on the mobile and transient nature of trash, but, even more importantly, it unravels the more complex and less evident meanings of "motion" when it comes to rubbish. First, trash ages—it moves in time, and not only in space. Second, and because it so compellingly speaks of age and, ultimately, of decay, and bygone beauty and "usefulness," as well as of abandonment and social marginalization, it also strongly appeals to our emotions and ignites the creativity of artists and "artivists": garbage "moves," it moves *us*, that is to say. Against the backdrop thus of large-scale dumping grounds and artists interested in the monumentality of garbage (Andreas Gursky, Chris Jordan, Daniel Canogar, Vik Muniz, and HA Schult immediately come to mind), this chapter explores the artistic creations around animated small-scale urban trash and the role emotion and compassion play in the works of Bill Keaggy, Bosso Fataka, Alice Bradshaw, "My Dog Sighs," "Filthy Luker," Mierle Laderman Ukeles, Gregg Segal, and Francisco de Pájaro.

Equally invested in rubbish at its early stages of growth, Chapter 2 ("Litterscapes: Topographies and Archives of Waste") however is not as much interested in the anthropomorphic nature of small-scale refuse as it is in its ability to transform space. Litterscapes leave their imprint on urban and natural surroundings, and in both cases they elicit a series of reactions (and actions) among artists and regulators. Litterscapes are often seen as threatening by the latter, and even the former feel the urge to restore

order via a number of artistic strategies and interventions. Artists, art collectives, trash collectors, and researchers/scavengers such as Ben Wilson, TRES, Ester Partegàs, Jeff Ferrell, and Nelson Molina use and collect trash on the streets to create art and even museums, and to reflect on its imprint on the urban landscape, the effect it has on people, and the nature and "ways of being" of litter: as this chapter further explores, litter "happens" in certain contexts, derives complex meaning from repetition and from combination, and maintains a rich dialogue with nature and its debris.

Not only urban refuse, so-called border trash in particular—namely, the castoff belongings of undocumented immigrants found in the desert along the US-Mexico border—generates a similar compulsive need to (photographically) record, classify, archive, and creatively manipulate the unwanted and the discarded. Guillermo Galindo, Susan Harbage, Thomas Kiefer, Richard Misrach, and anthropologist Jason De León figure prominently among the artists and scholars intent on working with "migrant trash" as a way of raising awareness about the reality of the US-Mexico border. And they are the ones also who alter the habitual itinerary and direction of trash. Whereas the latter usually moves from the metropolitan centers to the rural landfills, artistic practices, archival efforts, and curatorial activities bring "desert trash" back to urban enclaves. Collections and exhibits of border refuse can now be found at the Center for Religious Life at the University of Southern California, Los Angeles; the Museum of World Culture, in Goteburg, Sweden; the Smithsonian National Museum of American History, in Washington, DC; the LACMA, Los Angeles; and the Centro Cultural Universitario Tlatelolco, in Mexico City.[1]

While the previous chapters reflect on ref-use that litters the streets (and borderlands) unbridled, Chapter 3 ("Dumpsterology: A Cultural History of the Trash Container") moves from scattered debris to "stored" rubbish or, rather, from content to urban trash containers. Dumpsters in particular are the site—a hospice of sorts—where trash is allowed to "rest" and linger before its final demise and journey to the landfill. Although Dumpsters were conceived and built as hermetic containers when the Dempster brothers invented and successfully merchandised them during the early 1940s in America, with time, Dumpsters became open containers (though there is a marked trend now toward restricting access to them), and it is this now long-standing accessibility that has enriched their meaning. Open Dumpsters are the origin of Dumpster diving as a predominantly white male "sport," and also the reason for its gendered nature. Chapter 3 looks at the different meanings and progressive "feminization" of the Dumpster (and of trash) with the help of three documentaries—a promotional film from the 1950s commissioned by the Dempster company; Agnes Varda's *The Gleaners and I*; and Jeremy Seifert's *Dive! Living off America's Waste*—and of Aliza Eliazarov and C. Finley's artistic pieces on Dumpsters and their contents. Finally, Chapter 3 reflects about certain recurrent types of trash containers (such as the overflowing Dumpster, the locked Dumpster, or the Dumpster as crime scene) and their cultural implications.

In truth, Chapter 4 ("Dirty Innocence: Childhood, Gender, and Muck") should have probably been the first chapter of the book, since to a great extent it is our experiences as children and our upbringing that determine the nature of our relationship with trash and dirt. In any case, this chapter is necessarily packed with texts and themes. It moves from the tragic reality of garbage dump children and the photographic and cinematic theme of children playing amid debris common in German "rubble films" to the paradigmatic conflation of domestic dirt and misogyny in the hugely successful Garbage Pail Kids trading cards series. It also considers the home as the site where commodities "miraculously" turn into trash, and where trash menaces to never leave, to the grave detriment of the children of hoarders. The chapter devotes a whole section to the memoirs of these now grown-up children. Written almost exclusively by women, these memoirs—of which to this date Britney Fuller's *Trash: An Innocent Girl; A Shocking Story of Squalor and Neglect* (2014) is probably the most compelling and heart-wrenching example—have expanded into a new and rapidly growing subgenre where the painful exploration of the mother-daughter relationship literally drowns in filth. Chapter 4 draws a sharp distinction between two very different and even opposing subcategories within the increasingly popular genre of trash narratives, namely, the aforementioned "daughter of a hoarder" memoir that routinely showcases a victimized and traumatized female protagonist; and the "trash hero" adventure novel or film (Wolfgang Herrndorf's *Tschick*; Luis Alberto Urrea's "Dompe Days" as part of *By the Lake of Sleeping Children: The Secret Life of the Mexican Border*; Andy Mulligan's *Trash*; Harris and Morazzo's *Great Pacific Trashed!*), where trash becomes an excuse for climbing mountains and overseeing a landscape as a metaphor for (male) conquest and appropriation. Finally, the last section of the chapter describes what I like to call "sanitation narratives," yet another "trash subgenre," this time geared toward

young readers, that chants the beauty of municipal waste management and the thrill of garbage truck activity. A careful analysis of a representative number of these narratives (in both illustrated book and video format) confirms that they are all but "innocent" or ideologically neutral. To this day, American popular culture and pedagogical narratives are quick to instill in young audiences, from toddler age on, that the very important (and puritanism-drenched) virtue of "cleanliness" is white, thus casting a persistently pejorative shadow once more on skin and neighborhoods that are not. Trash mirrors human nature and behavior. And so do "cleansing" practices and cultural constructs around hygiene.

1

Sentient Filth
The Motions and Emotions of Garbage

Look at the image in Fig. 1.1. What do you see? Two trash cans, one green, one blue; a red-patterned and tattered armchair lying on its side; a shredded piece of carpet pad emerging from the blue trash can; and carpet and carpet pad rolls precariously piled onto each other. The trash pile is transitory (or so we hope). Eventually, somebody will pick it up and transport it somewhere, in the same way in which it was retrieved from a home and later dumped on the sidewalk. Trash moves, all the time, in the most basic sense of the word, and it is our experience—and our expectation—that it will, until we lose sight of it.

This chapter certainly caters to the mobile and transient nature of trash and looks at discarded carpet rolls and derelict

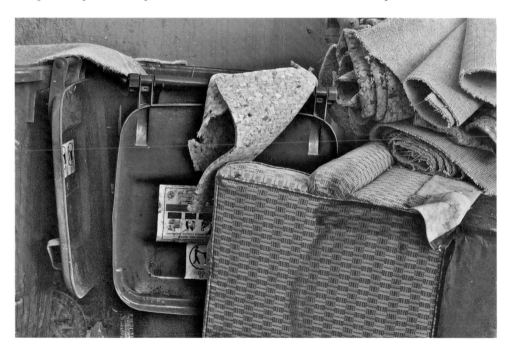

Fig. 1.1: Filomena Cruz, photographic series *The Blue Garbage Can*. Venice, CA.

Portions of this chapter appear in a slightly different form in Maite Zubiaurre, "Trashtopia: Global garbage/art in Francisco de Pájaro and Daniel Canogar," in *Global Garbage: Urban Imaginaries of Waste, Excess, and Abandonment*, ed. Christoph Lindner and Miriam Meissner (Abingdon: Routledge, 2016), 17–34.

armchairs as objects destined to travel. But it also unravels the more complex and less evident meanings of "motion" when it comes to rubbish, for rubbish "moves" in at least two additional and related ways. First, it ages—it moves in time, and not only in space (Thill). Second, and because it so compellingly speaks of age and, ultimately, of decay and bygone beauty and "usefulness," as well as of abandonment and social marginalization, it also strongly appeals to our emotions (G. Hawkins, *Ethics of Waste*," "Sad Chairs"; Kendall, "Cinematic Affects," "Utopia Gleaners") and ignites the creativity of artists and "artivists" (Vergine; Whiteley): trash "moves," it moves *us*, that is to say (Zubiaurre, "Trash Moves"). A red armchair, old, tattered, and invalid (from the picture, one infers it is missing its legs), is not only one more piece of trash; it is a memory-laden object from our expansive object worlds, something (somebody) that had a home, and whose air of domesticity does not fade when forced to live on the streets. In fact, it becomes even more poignant, since in discarded artifacts—much more than in objects that we still keep and desire, and therefore are ever-present to us—the past and also the future are more tangible and ever more forceful than the now. We look at the armchair, and what we see is what it was (when it—when I—was "young," "healthy," and sheltered), while at the same time dreading what will become of it (and of me). The present pales under the deep nostalgia for the past and the fear of impending abandonment, dissolution, and death. As Brian Thill succinctly puts it, "waste is every object, plus time" (8), and it is because of time that motion and emotion become so strongly manifest in all things discarded.

Trash the Traveler

If one were to search for a true paradigm change in the "behavior" and particularly in the movement and traveling pattern of garbage in the Western world one would have to go back only to the first half of the twentieth century, not further than that. As historians have amply documented, trash remained in situ or traveled only very short distances and never beyond the immediate outskirts of urban enclaves during much of its existence. In the ancient world, as Monica L. Smith states, waste "often times was piled up in residential areas and became part of the living landscape. Research at ancient Mayan cities shows consistent patterns of trash disposal around households, with some areas devoted to ordinary trash and other zones with chemical signatures of heavy metals from the production of pigment. Monte Testaccio, in Rome, is a hill almost entirely made of discarded pottery vessels from the early centuries C.E." (348).

Historians (Jorgensen; Humes; Roy; Liborion, "History of Consumption; Petrova Nikolova, "History of Consumption"; Folino White; Farina—) have systematically documented that keeping refuse close to dwellings is not only particular to the ancient world but remained an entrenched custom until the late nineteenth century. Still, Martin V. Melosi is quick to note, it is precisely during that time when "urban America discovered the garbage problem. . . . The refuse problem attained such massive proportions in the industrial United States that even the most insensitive city dweller could no longer ignore it. Heaps of garbage, rubbish, and manure cluttered alleys and streets, putrefied in open dumps, and tainted the watercourses into which refuse was thrown. Nineteenth-century Americans began to realize that mounds of garbage,

rubbish, and other discards were not simply eyesores but unnecessary encumbrances and potential health hazards" (17). As Folino White indicates, "at the turn of the 20th century, [American] rural households and city dwellers were still largely responsible for waste removal. This often entailed garbage being thrown out of windows onto streets [or onto rivers and waterways that traversed cities and villages], burned, composted, or sold" (364). The vivid image below of New York swimming in filth is a perfectly accurate example of the consequences of unregulated trash disposal and of trash that stays uncomfortably close:

> Imagine a city so full of garbage, muck, horse manure and standing sewage that sailors can smell it six miles out at sea. Where a proper gentleman has to toss a coin or two to a broom-wielding street urchin to sweep a path through the knee-high debris just so he can get in his front door. And where pigs trundle down sidewalks and dodge traffic, rooting through the garbage that the locals simply throw out their doors and windows, in vain hope that the ravenous animals will clean up some of the mess. Welcome to New York City at the dawn of the twentieth century. Welcome to American urban life before the rise of the landfill. (Humes, 36)

The landfill, a British invention adopted by the United States during the 1930s—the first modern landfill on American ground, the Fresno Municipal Sanitary Landfill, is said to have opened in Fresno, California in 1937—signals a new era in garbage disposal. Sanitary landfills "multiplied after the [Second World] War as supposedly the most effective solution to the twin problem

of the putrid open dump and the one-time highly touted but belching incinerator" (Farina, 368). Landfills, as Susan Strasser puts it, "differed from the common dump in two important ways: First, refuse was not simply dumped but covered over with dirt every day. Second, 'controlled tipping'—dumping things in a sanitary landfill—cost money" (271–72). Landfills thus soon became profitable businesses, but to this day, they face a number of hurdles. In the 1980s, the Environmental Protection Agency

> began to protect social and environmental health by requiring landfill operators to either close their landfills or restructure them by instituting leachate- and methane-collection systems. Facing more stringent enforcement, operators of many of the nation's sanitary landfills failed to embrace the mandatory structural improvements. Hence, many landfills ceased operation, so that . . . the nearly 8,000 sanitary landfills that functioned nationwide in 1988 plummeted to 2,314 in 1999 and to 1,777 in 2002. (Farina, 368)

When landfills start to close down, trash needs to go somewhere else: the demise of landfills further intensifies garbage's traveling frenzy. As Vivian E. Thomson explains, in the United States, "garbage has long been trucked, barged, and moved by rail across state lines, but such interstate movement has increased noticeably in the past fifteen years. In 2005, 25 percent of disposed or incinerated municipal solid waste or MSW (the technical term for trash), traveled to another state, which represents an increase of 147 percent in ten years. This increase is due in part to stricter environmental regulations

that have caused many old, local landfills to shut down" (3).

When trash travels, the city landscape changes dramatically. The New York of the turn of the twentieth century described by Humes in the quotation above has nothing to do with the New York of the turn of the twenty-first century, when its gigantic land-fill, Fresh Kills—the biggest in US landfill history—closed down in 2001 (Nagle, "The History"). Manhattan is not covered in filth and ashes anymore, but it is has to suffer the health, environmental, and financial consequences of massive trash transportation. As Elizabeth Royte points out, "since Fresh Kills closed, almost all of the city's waste is trucked from transfer stations to out-of-state landfills and incinerators. . . . It takes about 450 tractor-trailer trucks to complete this task each day, burning roughly 33,700 gallons of diesel fuel. The combined round trips add up to 135,000 miles. An additional 150 packer trucks, carrying about fifteen hundred tons of waste a day, make shorter trips to three incinerators in New Jersey and Long Island" (44).

But trash not only noisily crosses cities and state lines; it travels overseas and more often than not ends up on dumps and land-fills of the developing world.[1] This is the case particularly of e-waste (Gabrys; Grossman). Our electronic appliances contain a number of sought-after metals, such as gold, silver, and copper, and it is often the nimble fingers of children and women in Africa and Asia that extricate the small pieces of prized materials from the discarded computers and cell phones of the Western world. After reminding us in her article "Where Do Old Cellphones Go to Die?" (*New York Times Sunday Review*, May 4, 2013) that "the United States . . . remains the only industrialized country that has not ratified the Basel

Convention, an international treaty that makes it illegal to export or traffic in toxic e-waste," Leyla Acaroglu paints the following harrowing picture of e-waste inferno:

In far-flung, mostly impoverished places like Agbogbloshie, Ghana; Delhi, India; and Guiyu, China, children pile e-waste into giant mountains and burn it so they can extract the metals—copper wires, gold and silver threads—inside, which they sell to recycling merchants for only a few dollars. In India, young boys smash computer batteries with mallets to recover cadmium, toxic flecks of which cover their hands and feet as they work. Women spend their days bent over baths of hot lead, "cooking" circuit boards so they can remove slivers of gold inside. Greenpeace, the Basel Action Network and others have posted YouTube videos of young children inhaling the smoke that rises from burned phone casings as they identify and separate different kinds of plastics for recyclers.

The broad-stroke picture I have drawn above on the history of trash is the standardized and all-prevalent version dear to Western (and particularly American) modern sensibility. According to such picture—one more imperialist "success story," this time about the taming of waste whose unavoidable consequence or "lateral damage" is relentless exploitation—cities in the Western world were filthy once (with trash covering streets knee high), but not anymore, for progress has managed to get rid of refuse. Trash happens elsewhere, in spaces conveniently hidden from view, such as transfer stations, recycling centers, and sanitary landfills, and in remote areas of the world one will never visit, such as Africa's

and Asia's hinterland. However, trash does not "exist" solely in the margins. Waste, as Strasser points out, is "central to our lives," despite being "generally silenced or ignored" (18), and despite its penchant toward marginality (8). And trash leaves traces everywhere and continuously generates more waste, even when it hurriedly moves out of cities. Royte is quick to acknowledge that the massive daily flow of trucks transporting New York's debris out of Manhattan generates further toxic refuse: "The trucks wear down city streets and outlying highways, and their emissions of carbon dioxide, sulfur dioxide, chlorofluorocarbons, and other pollutants contribute to elevated asthma and cancer rates, acid rain, ozone depletion, and global warming" (44). And Thomson cautions that even landfills, considered the safest waste disposal system available to date, will eventually leak and contaminate our groundwater.[2]

This chapter, therefore, is not only about trash that travels big and then "vanishes," but about "sedentary" trash that moves short distances, and ultimately remains and lingers. It is not about the persistent fallacy of humankind conquering and "killing" waste, but about the truth of trash's ultimate immortality, ubiquity, and incontrollable bounty. Bataille's reflections on excess, and more specifically on excretion, hold particularly true when it comes to refuse. Trash is "das ganz Anderes" (that what is completely different and other; 94), the (often terrifying) excretion that unavoidably follows appropriation: we eat—according to Bataille, "oral consumption is the elementary form of appropriation," although other forms also include the acquisition of "clothes, furniture, dwellings, and instruments of production" (95)—and before eating, we engage in food preparation. Food preparation (even

more than the act of eating, which already includes some elements of excess and "excretion," such as the "sudden liberation of great quantities of saliva"; 95) adopts the "appearance of striking homogeneity, based on strict conventions" (95). But then we excrete, which is an action directly opposite to eating or to appropriating: "The process of appropriation is thus characterized by a homogeneity (static equilibrium) of the author of the appropriation, and of objects as final result, whereas excretion presents itself as the result of a heterogeneity, and can move in the direction of an even greater heterogeneity, liberating impulses whose ambivalence is more and more pronounced" (95).

We appropriate and consume, we excrete trash, and then trash gets out of hand, orgy-like. Garbage always ends up littering the streets, and our homes (even "superclean" cities house a modern breed of "sick" and particularly untidy tenants, known as hoarders). We are told that our waste disposal system is highly efficient, and that garbage will always find its way to faraway landfills. Nothing could be more distant from the truth, however, and that is why this chapter has chosen not to jump on a truck, or a barge, or a train, following the national and international mega-itinerary of solid waste. Instead, it remains within city bounds and looks at the "small" trash that lingers on sidewalks and curbsides, or accumulates in recycling centers that are part of the urban fabric. "All garbage is local," states Thomson (11), and it is "small" trash in its locality and at its urban point of origin—trash as in "litter"—that intrigues me. "Daily experience suggests that trash is a dynamic category," says Strasser (3), and it is the various metamorphoses, slight motions, and nuanced meanings of trash "stuck" in the city that caught my attention, not the megamovements of

large-scale waste transport. Garbology—the science or archeology of garbage—studies the history of human behavior and patterns of consumption through the careful exploration and interpretation of waste sediments in a landfill (Rathje and Murphy). What I propose here is a "new" city-based garbology on the lingering waste—the slow-moving, left-behind kind—that populates the urban landscape. As Eric Paulos and Tom Jenkins point out, "just as an archeologist excavates layers of debris from past civilizations to inform histories of ancient civilizations, so too can the discarded artifacts of today's urban inhabitants be used to create the rich milieu of everyday stories of urban life. In fact, we can observe these patterns by extracting the secondary traces that are left behind by the flows of urban inhabitants—the archaeology of public urban trash." "The archeology [or garbology] of public urban trash" thus focuses on "lingering" rubbish, as I prefer to call it, or, in Max Liborion's words, on "everyday, escaped trash" ("Litterati," 2). Liborion's emphasis on garbage that "escapes" is fitting. As she notes, "a lot of litter blows out of infrastructure rather than being tossed by heartless people. The vast majority of ocean plastics, for example, often called plastic litter, are in fact from inshore sources where the light, durable material escapes bins, trucks, and transfer stations. Of the plastic that originates on beaches and in the ocean, most of it comes from aquaculture and commercial ships. In short, the waste is systemic" ("Litterati," 7). But even "non-systemic" small-scale litter thrown away by "heartless people" is still trash that escapes (or delays) the trip to the landfill. And, by doing so, it becomes an integral part of the urban fabric that adds a dynamic dimension to urban topography (it effectively alters the landscape), and imposes a certain versatility and rhythm to city life. Still, street litter lives

a life at the fringes of the law. "Escaped" garbage is a loiterer and looked on with suspicion and disgust. For many, trash, like the homeless, is where it is not supposed to be (garbage belongs in a trash can; homeless too should be banned from sidewalks and thrown into shelters). City refuse (no less than the urban poor) becomes the repository and the trigger of powerful and often contradictory emotions: trash "moves" in more than one sense and in many complex ways, and, as this chapter will show, street artists readily and compassionately react to and enhance the "moving" aspects of garbage in their artworks.

The Rhythm of Rubbish

Trash introduces versatility—and with versatility, a particular rhythm—to the urban landscape. Urban topography, and specifically sidewalks (Kim; Loukaitou-Sideris), tend to be relatively static. Not only buildings, but also more "movable" artifacts, such as urban furniture (benches, trash cans, bus stop canopies, etc.) and even murals and graffiti, are fairly permanent. Windows, on the other hand, are hybrids that evoke both immobility and change. The imposing windows of high-rise buildings in particular reflect the changing sky with dramatic intensity, and store windows are intersecting spaces where the displayed goods, often inanimate, melt with the moving silhouettes of passersby. But, besides windows, the most important "lifeless" object that adds movement to the sidewalk and introduces rapid changes to its landscape is trash, and trash containers.

Trash cans and Dumpsters on sidewalks and back alleys are portable urban furniture, often standing on wheels. Their ability to move makes them efficient "urban landscape modifiers," and so does the fact that their

use and purpose can also suffer significant alterations. Occasionally, it is municipal authorities who agree on expanding the meaning and use of trash cans, as it happened recently in Manhattan, where, according to Kelly Faircloth, a company named "Bigbelly," "which makes solar-powered public garbage cans festooned with sensors . . . now wants to turn more of its several hundred garbage and recycling bins in New York City into Wi-Fi hotspots." But more often than not, "divergent" uses of trash cans and Dumpsters come directly, and spontaneously, from urban dwellers. Trash cans are supposed to be there so that people throw in their garbage and don't litter the streets, but a trash can intervention done in San Francisco by urban researchers Eric Paulos and Tom Jenkins shows surprising results: "Less than 75% of the trashcan interactions involved actually discarding trash." "Regular interactions with the trashcan included . . . scavengers searching within it, scavenged items being removed, bikes being parked and collected from the trashcan (an impromptu bike stand), and the trashcan being cleaned or emptied."

The primary goals set by "urban garbologists" Paulos and Jenkins were to "a) reveal the patterns of usage and flows surrounding trash and trashcans in the city; b) challenge assumptions about the use of the trashcan; and c) gain qualitative insights into urban trash and its connection to everyday stories of people and place." If these same goals had been applied to a different trash container, a Dumpster, the results probably would have offered more dramatic insights about use and the "every day stories of people and place." The semantics of the Dumpster—what I like to call "Dumpsterology" (Chapter 3)—is particularly rich and covers a wide range of meanings and usages. Dumpsters have embraced crime for a long time—"body found

in a Dumpster" (more often than not bodies of women and newborns) yields countless images in Google, and it is a recurrent motif also in fiction and film—but lately they have also catered to the domestic realm and expanded from "mere" trash (or corpse and body part) containers to swimming pools, gardens, exhibition spaces, and even tiny houses. Dumpsters, finally, are sought after loci for freegans, graffiti artists, and street artists in general and frequently provide food and shelter to the homeless population.

The photographic series in Fig. 1.2 shows precisely how trash around a Dumpster—and its different uses by artists and homeless—continuously alters the appearance of a particular corner in Venice, California. Each photograph corresponds to one weekday during one particular week. The "Monday photograph" shows two Dumpsters in front of a wall exhibiting a mural. The "Tuesday photograph" offers a less "pristine" image, with a mattress and a bed frame, clearly too big to go into the Dumpsters, simply left on the street. The "Wednesday photograph" introduces yet another modification of the landscape: overnight, the mattress has transformed into a canvas to a street artist. The "Thursday photograph" highlights a new rearrangement. Now, the bed frame leans against the mattress/canvas and adds to the painted flag the texture of intertwined iron. Whereas Thursday's "artistic intervention" was probably unintended and serendipitous, the "Friday photograph" showcases another deliberate attempt at beautifying trash via art, this time in the form of a lion face painted on a discarded bed sheet thrown over the bed frame. But by Saturday, art has given way to dire necessity: the mattress now has gone back to its "true" calling. A vertical canvas no more, it has reclaimed horizontality and probably served as resting spot to a homeless person during the night. In the morning, the bed sheet with the

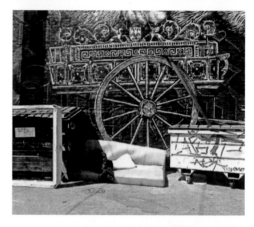

Fig. 1.2: Filomena Cruz, *Trashscape:*
Seven Photographs. Venice, CA.

Fig. 1.3: Dan Yaccarino, *Trashy Town*. Harper Collins, 1999.

lion face on it lies crumpled on the mattress. The "Sunday photograph" finally shows a more sophisticated sleeping arrangement: the bed frame and a piece of cardboard, propped against the mural, create a roof over the mattress. The small Dumpster and a blanket serve as a protective walls to the homeless person, with his bicycle standing beside his improvised "trash" dwelling.

In neighborhoods that are more lenient with street debris (such as Venice, California), trash becomes malleable, and a part of city life. It offers a place of rest to the disenfranchised, facilitates the work of can and cardboard pickers, and inspires artists.

Trash not only continuously changes the look of sidewalks, but also imposes a certain rhythm—and a certain sound—to city life, with garbage trucks punctually arriving at certain days, and at certain times (in some cities and countries, trash is collected on a daily basis). "Rhythm" is an important property of

trash and of waste management, often overlooked, with a number of longstanding cultural implications. It is the "rhythm" of trash collecting, for example, that, among other things, makes the world of trash appealing to children (Chapter 4). Children's literature capitalizes on the staunch conservatism of its audience and its love for reassuring routines. In the numerous illustrated books for the young readers devoted to the subject of trash collecting—*Trashy Town* (Zimmerman, Clemesha & Yaccarino, 1999); *I Am a Garbage Truck* (Landers & Miglian, 2008); *I Stink!* (Kate and Jim McMullan, 2002); and *Smash! Mash! Crash! There Goes the Trash!* (Odanaka & Hillenbrand, 2006) are only a few representative examples—the trash man is always an amiable figure, and the "friendly" noises of the garbage truck are as familiar and "domestic" a sound as the chirping of birds outside or Mom's shouted "Dinner is ready!" (Fig. 1.3)[3]

Domestic cadence however turns into heightened noise and frenetic pulse when it comes to portray activity on a sanitary landfill. In National Geographic's acclaimed documentary on Puente Hills landfill in Whittier, California, *Megastructures: Garbage Mountain* (2006), the rhythm of reassuring domesticity gives way to boisterous epics. If the garbageman of children's literature was the generous and soft-spoken friend/hero who cleans up our neighborhoods and cities, the powerful monster-truck driver/demiurge that creates veritable mountains and a new man-made topography out of garbage blends seamlessly with the invincible hero of action movies and war films, with state-of-the-art technology here too as his powerful ally. Sure enough, an anonymous summary of the documentary for IMDb (the Internet Movie Database) readily buys into over-the-top monumentality and technophilia:

> Mammoth machines. Trash piled twenty stories high. Man and technology in a battle against a tidal wave of waste. Uncover the gargantuan world of garbage at America's largest active Mega Dump: Puente Hills, California. Most landfills take in 2,000 tons of trash a day—this one processes 2,000 tons an hour. How does it do it? With mega machines and mega ingenuity. Take a spin in the 120,000-pound Bomag Compactor, with its 55-inch garbage-crushing steel wheels. Power up with methane gas. . . . Puente Hills powers over 100,000 homes and a fleet of vehicles with their landfill gas. And find out what happens to your trash when you're not looking. You're going behind the scenes at LA's dirtiest suburb. Call it big, call it nasty, but don't you dare call it just a hole in the ground! (IMDb)

Cultural representations of garbage tend to move back and forth abruptly from edulcorated quaintness to overbearing gigantism, from happy trash collectors smiling sweetly (and somewhat sinisterly) at children to landfills turning into rather childish monster truck shows. The rhythm of garbage and its movements, however, is more complex and nuanced than these two simplifying and deceitful versions seem to imply. The real experience of a recycling center (in this case the Santa Monica Recycling Center in Santa Monica, California) signals a midway, closer to truth, between the uncritical embellishment of trash management in children's literature and the epic glorification of landfills in (pseudoscientific) documentaries unapologetically catering to masculinist values and macho aesthetics. Located at the southern section of Santa Monica, adjacent to Venice, the Santa Monica Recycling Center is walking distance from a posh gallery complex known as Bergamot Station, and very close also to the construction site for the new train that will soon connect downtown Los Angeles to the beach. Undeterred thus far by the crescent gentrification of Santa Monica's semi-industrial remnants, the recycling center continues to do business as usual. Several "coded" Dumpsters (plastic, glass, metal) line the outer wall of the recycling center, for people to dispose of their recyclables. The inside of the facility is reserved for clients who want—who need—to sell their disposable and recyclable goods. Already the rhythm and nature of trash disposal has become more complex and laden with social meaning: a wall separates the affluent (those who remain outside and give recyclables away for free) from the less privileged (the ones who enter the facility and expect financial compensation for collected cans and plastics). The needy are expected to get near trash: it

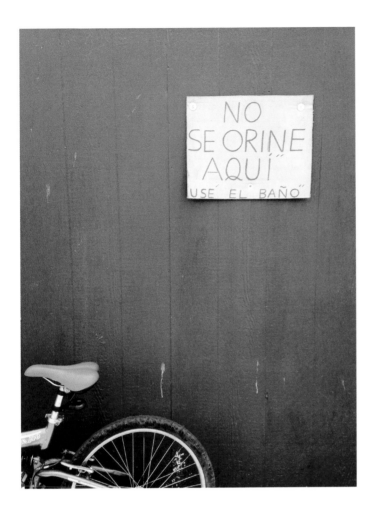

Fig. 1.4: Filomena Cruz, photograph. Allan Company Recycling Center. Santa Monica, CA.

is the needy who witness the noise and the smell of garbage trucks unloading firsthand, and who see garbage piling up at frenetic speed and advancing quickly on conveyer belts. And it is the less privileged also who sort out the recyclable materials standing alongside the band conveyors, and who feed the big, rusty machine that generates an end-lessly flowing cascade of paper (Fig. 1.9). The bountiful cascade is mostly white, with colored specs here and there. People in the recycling center are mostly Hispanic or black (with a few white people here and there): the wall of the recycling center not only separates rich from poor but segregates by skin color.

It also draws a thick line between languages. Spanish-Spanglish is the lingua franca in the recycling center, for both clients and workers alike. The sign meant to caution the workers not to urinate against the wall but to use the restroom instead sees no need for an English translation (Fig. 1.4).

The sky over the recycling center is wide and California blue most of the time, the sun glistening brightly on metal and color-ful soda cans. Only now and then, clouds obscure the horizon and serve as a back-drop to the stocky cement tower that grimly looms over piles of trash and Dumpsters al-ternatively empty or full (Figs. 1.5 and 1.6).

Fig. 1.5: Filomena Cruz, photograph. Allan Company Recycling Center. Santa Monica, CA.

Fig. 1.6: Filomena Cruz, photograph. Allan Company Recycling Center. Santa Monica, CA.

Fig. 1.7: Filomena Cruz, photograph. Allan Company Recycling Center. Santa Monica, CA.

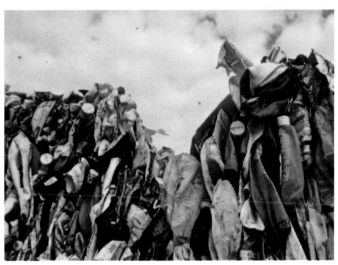

Fig. 1.8: Filomena Cruz, photograph. Allan Company Recycling Center. Santa Monica, CA.

The Los Angeles County Fire Department uses the tower for training purposes, but mostly it remains lonely and aloof, its motionless gray walls bare and desolate in stark contrast to the incessantly growing and shrinking towers of color-streaked white compacted paper and polychromatic crashed cans and plastics (Figs. 1.7 and 1.8).

The topography of the recycling center is constantly changing and is always alive with noise, color, and smell. The rhythm of its movements is particularly compelling and rich in contrast. The paper cascade flows down fast and heavy, propelled by relentless machinery (Fig. 1.9), but the big cubes of pressed paper shreds, piled onto each other, convey a soothing sense of solidity and calm (Fig. 1.10). The ends and bits of paper that manage to disentangle themselves from the tightly compacted cubes gently sway in the ocean breeze (Fig. 1.11).

But the contrasts and differences are also discernible beyond the topographic (and the poetic) and become particularly apparent

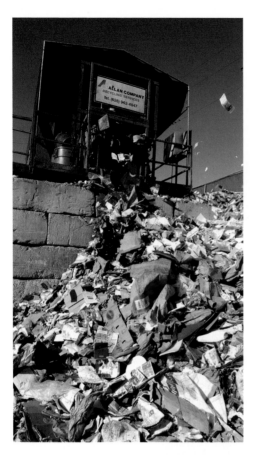

Fig. 1.9: Filomena Cruz, photograph. Allan Company Recycling Center. Santa Monica, CA.

in the realm of labor. The industrial work of the roughly half a dozen employees who stand on the band conveyor with their backs to the public, quickly and mechanically separating refuse into different categories (glass, metal, plastic, paper) and discarding what is not recyclable, diverges radically from the quasiartisanal occupation of yet another employer sitting at a rugged, wooden working bench. Although his job is also to separate different metals (this time copper and zinc from iron and less valuable materials), the metal worker faces the clients and chats with them, while carefully manipulating different pipes and rusted parts with the help of tongs

and other tools. Not only is he not turning his back to us, but he is also in command of his working pace, and not at the mercy of a machine and its frenetic speed. Thus in Santa Monica's recycling center, artisanal premodernity (the working bench) and industrial modernity (the band conveyor) share the same space/trash, and two very different rhythms somehow manage to combine their sounds.

Van Gogh's *Shoes*: On Animated Garbage, Emotion, and Art

Trash loci and units that handle refuse are rife with cultural contradictions, social complexity, and in-your-face hardship and inequality. Trashscapes, such as recycling centers, transfer stations, and landfills, and activities around trash, such as garbage collecting, cannot be reduced to the amiable and decaffeinated "altruism" of the garbageman in children's literature, or to the hard-core, tough-guy "heroism" portrayed in documentaries on the highly technologized sanitary landfills of the Western world. More often than not, trashscapes are zones of social and racial segregation, with a wall (like the one in the Santa Monica Recycling Center) that separates the ones who shop and throw away (or can afford to give away their recyclables), and the ones who earn a living by handling somebody else's garbage, or trying to make ends meet by selling their trash and that of others.

During one of my research visits to the Santa Monica Recycling Center, on my way out, two worn boots precariously holding their balance on the narrow rim of an empty Dumpster caught my attention (Fig. 1.12).[4] I was immediately struck by their uncanny resemblance to Van Gogh's famous 1885 oil

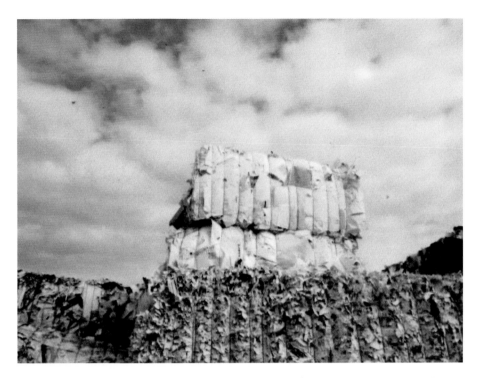

Fig. 1.10: Filomena Cruz, photograph. Allan Company Recycling Center. Santa Monica, CA.

Fig. 1.11: Filomena Cruz, photograph. Allan Company Recycling Center. Santa Monica, CA.

Fig. 1.12: Filomena Cruz, photograph. Allan Company Recycling Center. Santa Monica, CA.

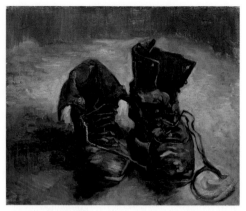

Fig. 1.13: Vincent Van Gogh, *Shoes*; September-November 1886. Van Gogh Museum. Amsterdam, Netherlands.

painting *A Pair of Shoes*, which Heidegger also used as an example in his renowned reflection "On the Origin of the Work of Art" (1935–1937) (Fig. 1.13). My thoughts, however, did not go back to the German philosopher and his musings on art, but to the Dutch painter and his profound reflection on poverty and hardship via a pair of worn boots. It also made me reflect on how purposeful "isolation" remains the most prevalent strategy among artists "moved" by trash and eager to convey the emotive, "moving" nature of garbage to their audience. Bill Keaggy's photo collection *50 Sad Chairs* (*www.keaggy.com/chairs/sad*) is a case in point (Fig. 1.14).

At first sight, Keaggy doesn't do much to the chairs he finds, abandoned and discarded, on the streets, besides "simply" photographing them in the same way Van Gogh "simply" copied the worn contours of a pair of

old boots. But of course he, not unlike the Dutch master, is doing much more than that. First of all, he is "isolating" the chairs he photographs, and separating them from nondescript garbage. Isolation (we can also call it selection or individuation) automatically instills life into inanimate objects, and art (and kitsch) do this ad nauseam. But in the case of trash, the effect of isolation and individuation is even more forceful and immediate (and, ultimately, more "moving" and even melodramatic), because garbage—like death—automatically suggests the opposite, namely, lifeless accumulation and irreparable identity loss. Isolated trash (a grimy toaster, reigning over a trash pile; a discarded mattress, propped up against a tree; a disabled armchair, hugging a trash can—Fig. 1.1) is still alive, though barely, its moribund identity and fading aura of domesticity soon to vanish for good once it arrives at the dump. Landfills and mass graves are related, and the works of artists like Keaggy thrive on such eerily kinship.

Berlin street art collective Bosso Fataka also caters to metaphors of life and death. Clear foil-wrapped Dumpsters that emulate

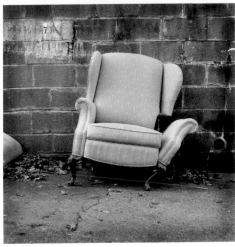 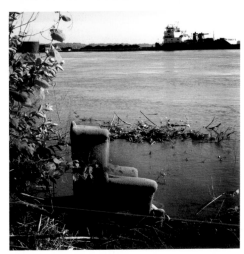

Fig. 1.14: Bill Keaggy; *Sad Chairs* series; ©Bill Keaggy/*keaggy.com*.

the shape of army tanks are a common motif in Bosso Fataka's art (Figs. 1.15 and 1.16). But blunt reflections on military and state violence share the urban cartography with other pieces less keen on death and destruction and more interested in hinting at the first stages of the life cycle. Larva-esque creatures made out of discarded objects once again wrapped in clear foil hang grotesquely from lampposts and "Litfasssaeulen" (freestanding cylindrical advertisement columns). Bulk trash—that is, sizable pieces

and unwanted furniture known in German as "Sperrmuell"—has been lifted from the ground, and given the opportunity of rebirth and a second life (Figs. 1.17 and 1.18).

The ideological implications of Bosso Fataka's clear foil frenzy are many, go well beyond a clear antiviolence and antimilitaristic stance, and aren't freed from contradiction. When I interviewed three of the artists from the collective in 2013 (all its members wished to remain anonymous, to escape police control), they made it clear

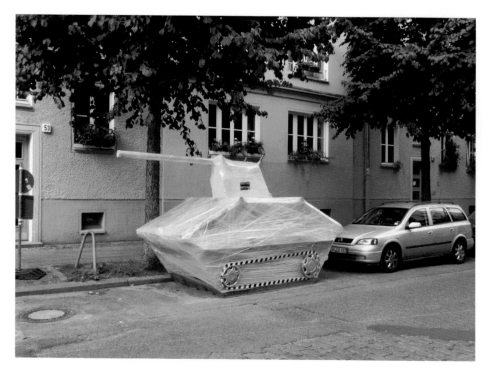

Fig. 1.15: Bosso Fataka, *Make Love, Not War*.

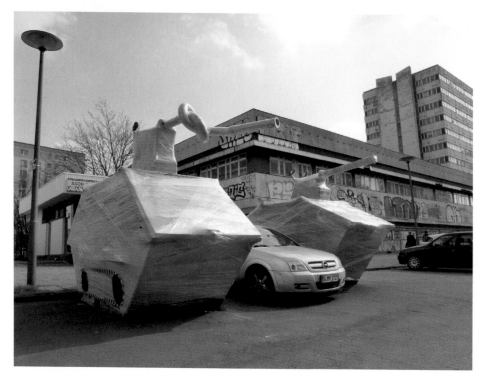

Fig. 1.16: Bosso Fataka, *Military Parade*.

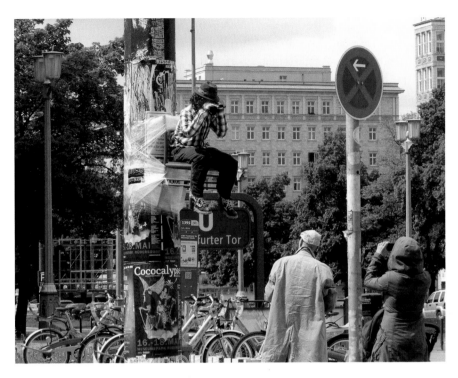

Fig. 1.17: Bosso Fataka, *Jagd auf Nihil Hipster.*

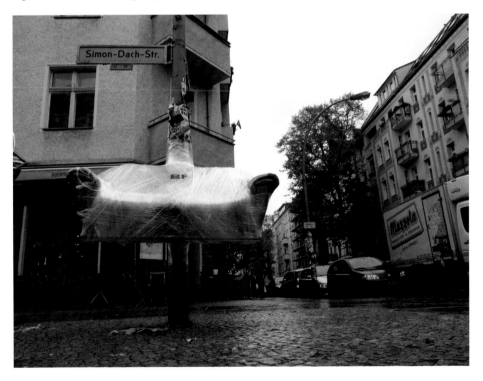

Fig. 1.18: Bosso Fataka, *Flying Cozy Sofa.*

that their main goal was to raise aware-
ness about capitalism's senseless consump-
tion and squandering of goods. At the same
time, they were quick to acknowledge that
their street interventions generated even
more trash, and of the worst and more in-
vasive kind: plastic. So as to attest to the le-
thal nature of plastic refuse, many of Bosso
Fataka's pieces look like monstrous tumors,
growing out of urban paraphernalia, though
rarely out of trees. The Berlin-based collec-
tive deliberately tries to avoid these, not only
because it wants to protect our planet (in the
short run: within the larger scope of things,
the clear foil Bosso Fataka consumes in
such bountiful quantity will certainly have
harmful effects), but also because criticism
is directed against the exploitative practices
of humans, and not against the excesses of
nature: in Bosso Fataka's work, malignant
lumps thrive on metal, not on flesh or or-
ganic matter.

The art of the (former East) Berlin–based
collective thus allows for two contradictory
or even complementary readings: discarded
objects densely packed in clear foil hanging
from lampposts look like larvae bursting in
their cocoons and eager to begin a new life,
or else they remind us of monstrous out-
growths that speak of pathology and death.
In both cases, however, and precisely be-
cause it has been isolated and individuated
through art, trash turns into a weirdly tran-
sitional creature, an object on the verge of
either being reborn or dying, and therefore
intensively alive. Heidegger used to call the
typewriter a "Zwischending," a "thing in be-
tween," "ein Zwischending zwischen einem
Werkzeug und der Maschine" (a thing be-
tween a tool and the machine—*Parmenides*,
126). Isolated trash is certainly a "Zwischen-
ding," a thing between the "functional" ar-
tifact and the alienated object that loses its

identity in the soulless agglomeration of the
landfill. Individuated trash is like us, an im-
perfect being, still alive, only halfway func-
tional, and marching toward its grave.

Not surprisingly, artists are drawn to the
profoundly human nature and fate of gar-
bage, and attempts at further individuating
and anthropomorphizing trash are not limi-
ted to Keaggy's photographs of "sad" chairs,
or to Bosso Fataka's plastic-wrapped trash
"parasites." British artist Alice Bradshaw, for
example, in 2010 created and still curates
an online Museum of Contemporary Rub-
bish (MoCR), "dedicated to collecting, cata-
loguing and exhibiting contemporary rub-
bish" (*museumofcontemporaryrubbish.blogspot
.com*). The MoCR showcases minimalist pho-
tographic reproductions of everyday trash: a
blue coffee cup holder (Fig. 1.19), a crumpled
sheet of white paper (Fig. 1.20), a green plas-
tic bag (Fig. 1.21), and a red-and-white the-
ater ticket (Fig. 1.22). The trash pieces appear
once more in isolation, against a grayish-
silvery backdrop and bathed in soft light.
They look delicate, almost frail, and expen-
sive, like exquisite adornments. The temp-
tation certainly is to keep them, instead of
throwing them away, to "untrash" them ex-
peditiously. But "untrashing," alas, is not an
option, and as impossible as "undying." The
tragedy of Alice Bradshaw's exquisite collec-
tion is that it is a "mausoleum," rather than
a "museum," a gallery of pictures of "people"
long gone or irretrievably lost.

It makes particular sense to speak about
"people" here, since, to the eyes of so many
trash artists and thinkers, discarded artifacts
are in fact "strangely vital things" (Bennett,
3). W. J. T. Mitchell, for example, refers to
the particular instance when things suddenly
"become the Other, when the sardine can [or
the coffee cup holder, the crumpled paper
sheet, the plastic bag, the theater ticket]

Fig. 1.19: Alice Bradshaw, Museum of
Contemporary Rubbish. Item #0656.

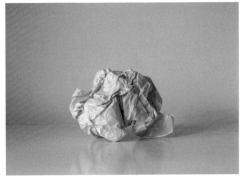

Fig. 1.20: Alice Bradshaw, Museum of
Contemporary Rubbish. Item #0667.

Fig. 1.21: Alice Bradshaw, Museum of
Contemporary Rubbish. Item #0669.

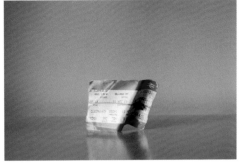

Fig. 1.22: Alice Bradshaw, Museum of
Contemporary Rubbish. Item #0490.

looks back, when the mute idol speaks, when the subject experiences the object as uncanny and feels the need for what Foucault calls 'a metaphysics of the object, or, more exactly, a metaphysics of that never objectifiable depth from which objects rise up towards our superficial knowledge'" (*What Do Pictures Want?*, 156–57).

Furthermore, in her chapter "The Force of Things," Jane Bennett quotes not only Mitchell, but also

Thoreau . . . , who had encouraged me to practice "the discipline of looking always at what is to be seen"; . . . Spinoza [who] claims that all things are "animate, albeit

in different degrees"; and Merleau-Ponty, whose *Phenomenology of Perception* had disclosed for me "an immanent or incipient significance in the living body [which] extends . . . to the whole sensible world" and which had shown me how "our gaze prompted by the experience of our own body, will discover in other 'objects' the miracle of expression." (5)

According to Bennett, it was writers and philosophers such as Thoreau, Spinoza, and Merleau-Ponty who made her open to the sentient nature of objects and in particular of discarded artifacts. For, as she confesses, "for me on that June morning [when she

stumbled upon "one large men's black plastic work glove; one dense mat of oak pollen; one unblemished dead rat; one white plastic bottle cap; and one smooth stick of wood" (4)] thing power rose from a pile of trash. Not Flower Power, or Black Power, or Girl Power, but *Thing Power*: the curious ability of inanimate things to animate, to act, to produce effects dramatic and subtle" (6). Certainly, Bradshaw's stylized museum/mausoleum and the artifacts it houses have "effects dramatic and subtle" and trigger distinctive and powerful feelings in us (of abandonment; of sadness about beauty unappreciated and fleeting), though the British artist favors a more nuanced approach to the anthropomorphization of trash, in comparison to Keaggy, and particularly to Bosso Fataka. This is due in great part to the fact that Bradshaw keeps her trash treasures in the sheltered and somewhat impersonal space of an online gallery, whereas Keaggy's and Bosso Fataka's trash critters live and survive in the city. No matter however where these objects are to be found, and regardless of the "real" or virtual nature of their habitat, they come to life precisely because the three artists and artist collectives mentioned above simply decided to pause, to look down, and to concentrate on what is usually ignored. As John Berger observes in his article "A Professional Secret," the "aliveness" of objects depends to a large measure on how intensively we look at them: "When the intensity of looking reaches a certain degree, one becomes aware of an equally intense energy coming towards one, through the appearance of whatever it is one is scrutinizing" (539).

In the case of Bosso Fataka's artistic street interventions, particularly the more recent ones, the "intense energy" coming from the ardently scrutinized objects has sped up the anthropomorphization process.

Many of its more recent pieces showcase expressive facial features, thus uniting forces with other street creators equally intent on openly endowing trash with eyes and a set of intense emotions (Fig. 1.23). One such case is Spanish artist Francisco de Pájaro, whose agenda is quite similar to Van Gogh's: he too attempts to restore visibility and give voice to the disenfranchised, only this time with the help of trash bags carelessly thrown on the sidewalk, in lieu of a pair of old work boots (Fig. 1.24).

"El arte es basura" (art is trash) is Francisco de Pájaro's signature, which he scribbles, graffiti-like, on the pieces he creates with the help of trash bags and old cardboard boxes. His art pieces were first seen in the crowded streets in Barcelona, but later also on the busy sidewalks of London and New York. De Pájaro, an artist from Extremadura, Spain, soon became deeply disenchanted with the exclusionary elitism of the art world. As he pointed out in a recent interview with TheDustyRebel, "I started painting on the street because the art galleries of Barcelona closed [their] doors [on me]; it was very difficult to evolve with limited financial means. Expressing myself on the trash gives me endless elements to paint, without having the obligation to maintain or market the finished work. You paint it, leave it in the street and keep going until you get tired. There's nothing like painting on the streets for freedom of expression" (Albanese).

The fact thus that the established art world is exclusionary, that art materials are expensive, and that his meager financial means could not keep up with his effervescent and quick-paced imagination, compelled de Pájaro to look for cheaper canvases. And . . . what could be cheaper than trash bags? In fact, the shiny (mostly black

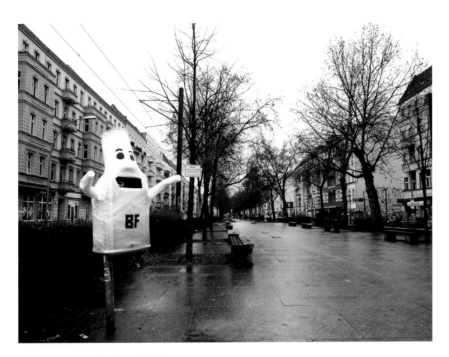

Fig. 1.23: Bosso Fataka, *Ghostbuster*.

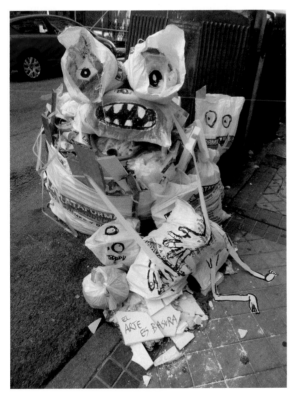

Fig. 1.24: Francisco de Pájaro, Madrid, Spain, 2012.

or white) surface of plastic, and the bloated contours of bags bursting with rubbish, not only was free for grabs (and, in de Pájaro's eyes, thirsty for color) but also offered an invaluable opportunity for the public display of his talent. Thus armed with a skimpy rucksack that contained a few essentials—a couple of cheap brushes, four or five color tubes and sprays, a pair of scissors, and duct tape—de Pájaro took by storm the streets of nocturnal Barcelona. His working method was simple, and also pedantically fixed on routine. He would splash color with broad strokes on trash—plastic bags, discarded furniture, cardboard boxes left at curbsides, and so on—four nights a week (the other three he worked as a waiter in one of Barcelona's most venerable restaurants), and he would do so between seven p.m. (which is when trash cans were rolled into the sidewalks, and bags and boxes would start littering the sidewalks), and ten p.m., the time of the arrival of municipal trash collectors. De Pájaro worked feverishly during these three hours, quickly pacing the streets on the lookout for trash—or clusters of trash—that appealed to his imagination, concentrating solely on the task at hand, oblivious to what was happening around him, and never answering questions from curious pedestrians.

I met de Pájaro back in the summer of 2012 and spent a whole night with him roaming the streets of Barcelona. I did not have a chance to see de Pájaro's artwork that particular night, because, as stated above, de Pájaro refuses to talk and paint at the same time. Also, his pieces only last a few hours, the short span between birth and death, between the making of the piece and the arrival of the garbage truck. The provisional nature and ultimate fragility of his trash pieces are very important to de Pájaro. In fact, it infuriates him when passersby try to

"rescue" his pieces and take them home. If we have pictures of some if his early artwork, it is because a friend started following him with his camera, keen on preserving a lasting copy of short-lived creation.

Since then, de Pájaro's art, which was essentially unknown beyond the Barcelona street art scene, has grown exponentially and has materialized in other cities and continents (London, New York, and lately the cities of San Diego, San Francisco, and Los Angeles, California). Francisco de Pájaro is now an artist whose fame is escalating (a London gallery recently housed an exhibition of his work), and who nonetheless remains proudly faithful to his early artistic agenda, his modus operandi (thus far, de Pájaro has not traded his cherished trash bags for "real" canvases), and his ideological principles. For de Pájaro, "art is trash" (el arte es basura), but the reverse—"trash is art" (la basura es arte) is equally true, and probably more essential to his work and to the cultural and pictorial tradition that his art (consciously, or unconsciously) embraces. De Pájaro's opus is art engagé, in its purest—and perhaps quite old-fashioned—form. For one, his artistic creations connect with the deep-seated romantic tradition of "animating the inanimate," of which the literary piece by German romantic poet Heinrich von Kleist, Ueber das Marionettentheater (On the Marionette Theater, 1810) is an illustrious early example, and the film Toy Story (1995), a very recent and no less famous one. In fact, the animation principle (that according to Bennett also informs trash) is a common feature in street/trash art, and essential to de Pájaro's oeuvre and of the work of other artists as well. Two British street artists/activists, for example, known by their pseudonyms, "My Dog Sighs" (mydogsighs .co.uk) and "Filthy Luker" (www.filthyluker

Fig. 1.25: Filthy Luker.

.org) (Fig. 1.25), have set out recently to paint eyes on discarded objects on sidewalks and at street corners and intersections, which intently look at the passersby.

An even more compelling and sophisticated example is the *Trashcam Project*, a project created and developed in Hamburg, Germany, that instills life into trash Dumpsters, and endows them with eyes that see and photograph (Figs. 1.26, 1.27, and 1.28): "Four German sanitation workers and one photographer put their skills together for an unconventional art endeavor called the *Trashcam Project*, turning 1,000 liter dumpsters into giant, makeshift cameras. Fitting the bins with pinhole cameras, the group toured their favorite spots in Hamburg, capturing stunning black-and-white photographs of the city" (Genuske).

"Maintenance artist" Mierle Laderman Ukeles's artistic intervention *The Social Mirror* constitutes a similar experiment, where inanimate objects of the most "abject" kind (trash, or trash related) become alive, and "dare" to look at their surroundings (Fig. 1.29). Since 1983, the mirror-covered garbage truck drives along during parades and community festivals, a burlesque reincarnation of Stendhal's famous dictum, "a novel is a mirror walking down a road." It certainly embraces much of Stendhal's romantic spirit (Stendhal never fully endorsed or represented hard-core realism), and much of the romantic fervor of his fellowman Victor Hugo. Sanitation workers are the Misérables, and the harsh reality of the city (be it Paris, or New York) is reflected in their eyes, and in the big, square "mirrors/spectacles" of Ukeles's garbage truck.

Francisco de Pájaro thus is yet another of the trash provocateurs who have dared to endow garbage with the sense of sight. And

Fig. 1.26: Mirko Derpmann, Hans-Dieter Braatz taking a picture of Speicherstadt. Hamburg, Germany.

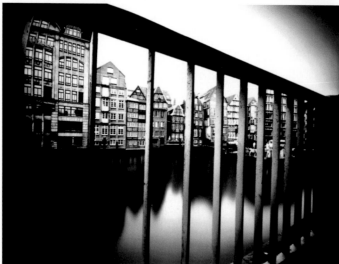

Fig. 1.27: Werner Bunning, Christof Blaschke, Mirko Derpmann, Katharinenfleet. Hamburg, Germany.

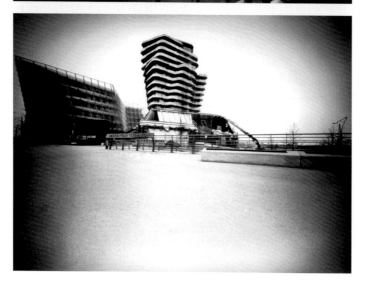

Fig. 1.28: Michael Pfohlmann, Christof Blaschke, Mirko Derpmann, Marco Polo Tower. Hamburg, Germany.

it is through the close scrutiny of some of his street art pieces (Figs. 1.24; 1.30; 1.31; 1.32; 1.33; 1.34; 1.35; 1.36; and 1.37; also Fig. I.3 in the Introduction) that we will be able to answer the question of what happens when, instead of being us who stare at trash, it is trash that stares at us. First, it is important to note that, in my conversations with Francisco de Pájaro, he insisted on how boring trash is, how fixed it is on routine, with an arrival and departure schedule that makes the German railway system look sloppy. Mostly, though, trash is always the same, tediously so, according to de Pájaro: "La basura es siempre lo mismo," "la gente siempre tira las mismas cosas, las bolsas llenas de resto de comida, las sillas cojas, los colchones viejos y manchados. Muchas sillas, y muchos colchones" (Trash is always the same. People always throw away the same stuff, plastic bags full of food remains, limping chairs, and stained mattresses. A lot of chairs, and a lot of mattresses). And it is precisely this monotone "sameness" of discarded objects that appeals to de Pájaro's critical eye and his strong political consciousness, for in the dull uniformity of refuse he identifies the numbing unvariedness of the urban masses, or rather, the way in which the latter is perceived by the powerful and affluent few. De Pájaro's effort at imprinting the discarded objects with human-like traits that make them different from each other is thus an attempt at humanizing the urban crowd, and at endowing it with individualized faces and souls.

De Pájaro's trash art aims its incisive darts at Baudelaire's dandyesque voyeur in *The Painter of Modern Life* (1863), and only partly identifies with him. For de Pájaro is not as much interested in looking, or at being looked at (that, again, would turn him into yet another predictable flaneur and fin

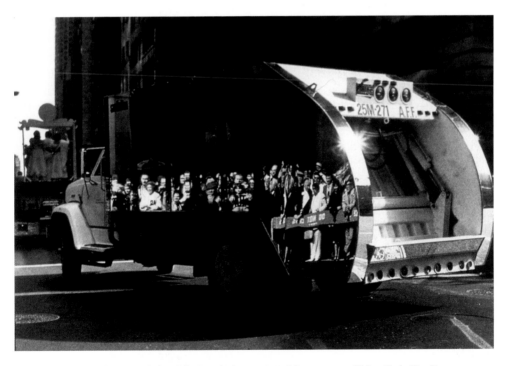

Fig 1.29: Mierle Laderman Ukeles, *The Social Mirror*, 1983. Mirror-covered New York City Department of Sanitation truck. Courtesy of the artist and Ronald Feldman Fine Arts, New York.

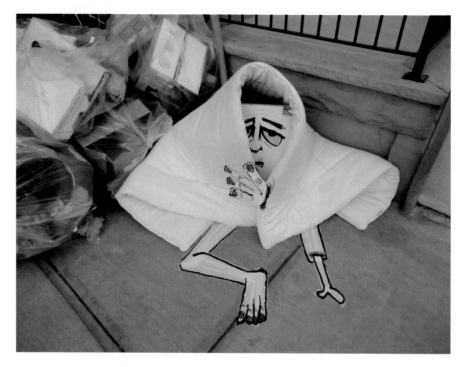

Fig. 1.30: Francisco de Pájaro, New York, 2014.

de siècle dandy), as he is in bestowing the power of sight on the disenfranchised. De Pájaro's distorted trash creatures have expressionistically eloquent faces, with wide-open eyes that defiantly reclaim the attention of pedestrians. They flatly refuse to be overlooked, the way trash (and the poor and homeless) usually are. Moreover, they demand from us that we listen to their stories, because de Pájaro's trash creations have a marked theatrical quality to them and more often than not turn into tableaux vivants imbued with harsh political content. De Pájaro's performative trash art dialogues with Augusto Boal's "theater of the oppressed" and bears even a stronger resemblance with Francisco de Goya's *Caprichos* and *Desastres de la Guerra*. Like his illustrious namesake, Francisco de Pájaro is heavily invested in painting the lives of the poor and

the wretched. And like Goya, he is fearless when it comes to denouncing the horrors of poverty and oppression, and to giving voice to the voiceless. Take the trash piece, for example, of a crippled homeless man covering himself with a blanket as discarded as he is (Fig. 1.30), or, even more cunningly tragic, of a mother begging for food and holding on to her small children (Fig. 1.24).

De Pájaro's trash art is stark and never fails to confront human misery head on. He is a friend of the abject and more often than not caters to urban violence, scatology, and dark humor. Particularly among his early pieces, nakedness prevails, crass sex scenes are not uncommon under the Barcelonan sky, and discarded toilets often serve as prime material for smashed heads (Figs. 1.31 and 1.32), or bare buttocks (Fig. 1.33).

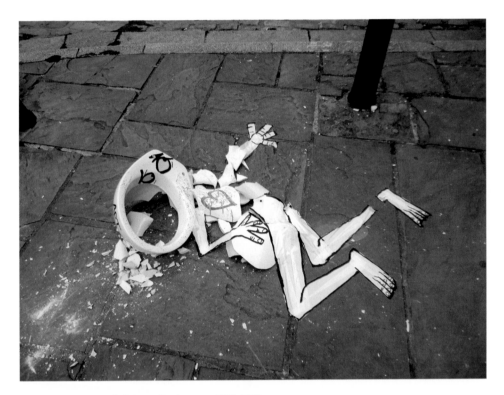

Fig. 1.31: Francisco de Pájaro, Darlington, UK, 2013.

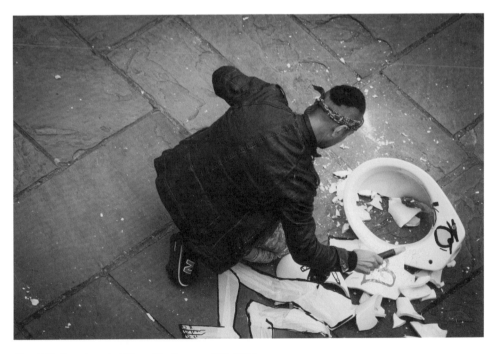

Fig. 1.32: Francisco de Pájaro, Darlington, UK, 2013.

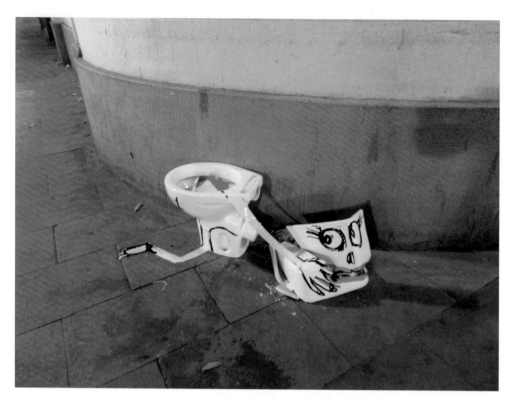

Fig. 1.33: Francisco de Pájaro, Barcelona, 2012.

One of de Pájaro's trash creatures, for example, is depicted as defecating at a corner, while at the same time defiantly brandishing a stick. He presses his index finger against his lips, asking us—in jest, of course—to keep his smelly secret (Fig. 1.34).

But, who is the irreverent jester? It is our trash. It is us, it is Diogenes of Sinope, the cynic, reminding us, through his own laughing obscenity and triumphant debasement, of our true human nature. In Francisco de Pájaro, Diogenes of Sinope and Saint Francis of Assisi unite, for de Pájaro's art is not only unabashedly cynical and irreverent, but also fiercely compassionate (Fig. 1.35).

As I pointed out earlier, in all his trash art pieces, de Pájaro characteristically and insolently signs with "El arte es basura" (art is trash). In Fig. 1.35, however, his signature

makes an unexpected sharp turn. The word "basura" is missing, although if we look closer, we see it has just retreated to one of the sides of the box. In any case, the sentence seemingly ends with "es" (is): there is gap, or a pause, and then the sentence resumes below, with "no te abandona" (does not leave you). "El arte no te abandona" (Art does not leave you). Francisco de Pájaro, by way of his trash creature, is writing a consoling message to the homeless man lying on the floor, for when he wakes up.

De Pájaro, no less than trash, is an indefatigable traveler, and his art engagé has emerged from the debris of a number of cities, first Barcelona, and more recently London, New York, San Diego, San Francisco, and Los Angeles. De Pájaro identifies trash as a globalized "commodity" and universal

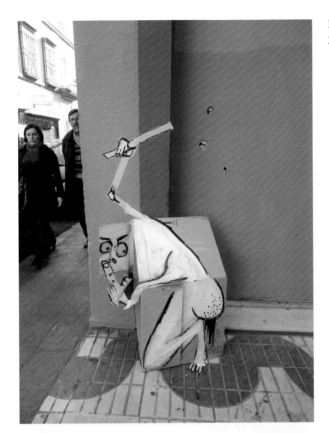

Fig. 1.34: Francisco de Pájaro, Sevilla, 2011.

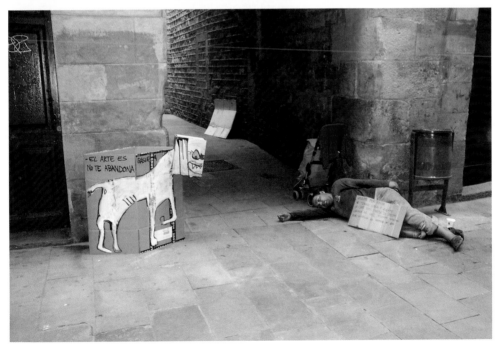

Fig. 1.35: Francisco de Pájaro, Barcelona, 2011.

Fig. 1.36: Francisco de Pájaro, Barcelona, 2011.

Fig. 1.37: Francisco de Pájaro, Barcelona, 2012.

language "consumed" and spoken by natives and foreigners alike. But he also endows it with certain regionalist or idiosyncratic features that directly hint at social and environmental issues specific to local culture. Figs. 1.36 and 1.37 are cogent examples of de Pájaro's double-tongued aesthetics.

The "Dumpster-canned trash-eating-trash fish" (Fig. 1.36) is a straightforward critique of our polluted oceans, and a compassionate homage to the many species that become victims of trash-infested water. But it also makes particular sense in Barcelona, a coastal city with an active fishing industry. In the same wake, the rowing galley of grim-faced men/slaves toiling on a "Dumpster-ship" (Fig. 1.37) speaks eloquently of the enslaving labor conditions of exploitative global capitalism and brings back somber memories of the long-standing Western tradition of slavery and oppression. But it also hints bluntly and unapologetically at the grueling working conditions often imposed on African immigrants in contemporary Catalonia and other affluent enclaves of the Iberian Peninsula.

It is important to note that Francisco de Pájaro is himself an immigrant (he migrated from a small town in Extremadura to Barcelona), and that his work is that of an artist who creates from the margins, and in defense of the marginalized. Thus wherever de Pájaro takes his art, he readily positions himself among the disenfranchised. And he once again resorts to his usual double strategy of tackling global flaws and tragedies (such as poverty and social injustice and oppression), while at the same time pointing to specific and local versions of it. In Manhattan and on the American continent, for example, de Pájaro seamlessly transforms from "charnego" (a pejorative term for immigrants who flock into Catalonia from Andalusia and Extremadura) into a defiant

Native American, and not only metaphorically so. A number of pictures taken during his Manhattan stay depict the artist wearing a feather headband, and Native Americans fighting oppression become a frequent theme in the pieces he has produced in New York and later in California.

De Pájaro's passionate and compassionate adoption of the plea of Native Americans, however, is not without its troubles. Heavily influenced by the popular culture of his childhood, the artist falls prey, to this day, to simplifying essentialism and to the heavily clichéd image of the Native American as represented in the westerns that populated Spanish TV during the Franco dictatorship in the 1960s. Asked during the same interview with TheDustyRebel about the underlying reasons of his frequent depiction of Native Americans on the canvas of Manhattan trash, de Pájaro responds:

[Esas imágenes de indios] nacen de las mentiras de Hollywood. De niño, nunca me creí que los malos fuesen los indios en sus películas. También en la escuela, me enseñaron la falsedad de la Conquista de España como algo maravilloso y grandioso de nuestra historia. Yo he nacido en Extremadura, una región muy bonita que vio nacer a los sanguinarios más grandes de la Conquista del Continente Americano. También me siento identificado con la forma de vida, con el respeto y la filosofía que los nativos tenían. Tan solo tenemos que mirar a nuestro alrededor para darnos cuenta del daño tan grande que estamos causando a la naturaleza con nuestra forma de vivir. Mi espíritu es la de un guerrero que pinta para que no se nos olvide que todos somos hijos de la naturaleza, cada uno tenemos que hacer nuestra lucha interior para preservarla.

Estoy alineado con todos los pueblos indígenas.

([The images of Native Americans] are born out of Hollywood's lies. As a child, I never believed that the bad guys in the movies were the Native Americans. At school, teachers also propagated a number of falsehoods about the Spanish Conquest as a wonderful and glorious event of our History. I was born in Extremadura, a beautiful region that was the cradle also of the most sanguinary conquistadors of the American continent. Also, I closely identify with the way of life, the respect, and the philosophy of Native Americans. We only need to look around to see how much harm we are inflicting on Nature with our way of life. My spirit is that of a warrior who paints so that we don't forget that we are children of nature, and that we all have to keep up our internal fight to preserve our natural world. I am aligned with all the native people.)

Francisco de Pájaro's well-intended (though sometimes problematic) art engagé takes place on the streets of "sanitary" cities in the Western hemisphere, where trash cans patiently wait on sidewalks, empty boxes pile neatly against trees, and Dumpsters never really overflow. This artist's garbage is still somewhat measurable, somewhat "domestic" and "individualized." It is thus relatively easy to humanize it, to create a soul for it and a face capable of expressing feelings, and of triggering emotional responses in others. But . . . what happens when garbage loses all its "human" proportions, when countless computers, printers, televisions, VCRs, cell phones, fax machines, stereos, electronic games, and wrecked cars—on top of the usual trash bags, cardboard boxes, stained mattresses, and mangled pieces of furniture—turn into an unstoppable avalanche? What happens when the gates of transfer stations, recycling centers, and landfills open and garbage floods in, with the force and violence of a tsunami? This is the experience—of trash that defies experience—artists such as Chris Jordan and Daniel Canogar portray. In his photographic series dubbed *Intolerable Beauty: Portraits of American Mass Consumption* (2003–2005), Jordan looks precisely at rubbish gone immense, its inhumane proportions, ironically, brought on nature by humans themselves. Here is what Jordan has to say about his series:

Exploring around our country's shipping ports and industrial yards, where the accumulated detritus of our consumption is exposed to view like eroded layers in the Grand Canyon, I find evidence of a slow-motion apocalypse in progress. I am appalled by these scenes, and yet also drawn into them with awe and fascination. The immense scale of our consumption can appear desolate, macabre, oddly comical and ironic, and even darkly beautiful; for me its consistent feature is a staggering complexity.

Jordan's photographic depictions of monumental waste as a tragic consequence of massive consumption are intriguingly mono-thematic. Rather than portraying trash in the style of conventional landfill iconography—a towering conglomeration of rubbish where all things discarded mix and blend into each other—he chooses to carefully select and sort discarded items (Figs. 1.38, 1.39, and 1.40). Jordan's (and also Canogar's and even Schult's) modus operandi are very different from that of de Pájaro. The latter tackles

Fig. 1.38: Photo by Chris Jordan, *Cell Phone #2*. Atlanta, 2005.

trash at its most "primitive," and before civilization and its heavily regulatory system have a chance to intervene further: "[I paint] as did our primitive ancestors, directly on the walls of caves. . . . For me, painting is the mother of the arts, and [to paint] directly on any surface makes me a child of Nature" (Albanese).

Jordan is much less of an *improvisateur*, and his ties to nature are less evident. His interest, rather, lies in the imprint of civilization on trash. Civilization creates trash in all its "staggering complexity" and also tries to impose an order on it, and it is this concept of waste carefully organized into categories that exerts a peculiar fascination, invariably mixed with horror, for artists like Jordan and Canogar. Jordan's approach in particular is that of a recycler/collector, who seems to derive a strong sense of accomplishment and power from throwing yet another item into the recycling bin, or adding it to his collection (Baudrillard; Stewart). Sure enough, Jordan's *Intolerable Beauty* series showcases monothematic photographs of carefully separated items, such as discarded cell phones (Fig. 1.38); circuit boards (Fig.

1.39); cell phone chargers; spent bullet casings; cigarette butts; diodes; broken glass; crushed cars (Fig. 1.40); and even sawdust mountains.

Spanish media artist Daniel Canogar's series of photocollages *Otras geologías* (*Other Geologies*), also first shown in 2005, builds on Jordan's view of trash as an alien landscape of vast geological proportions. In Canogar's words, "Nuestra basuras están creando un nuevo paisaje excremental que preferimos no ver, razón por la que se retira a la periferia de la ciudad" (Our trash is creating a new excremental landscape that we choose not to see, and that is why we are moving it to the outskirts of our cities; Ibarz). He also relates to the interest of his American counterpart in the classifying fervor of garbage operations around the globe:

El . . . mundo de las basuras es muy especializado, en él se esta constantemente separando y reagrupando los materiales, hay todo un proceso de selección para intentar reciclar algunos materiales, otros no pueden ser reciclados, por ello hay que

Fig. 1.39: Photo by Chris Jordan, *Circuit Boards #2*. New Orleans, 2005.

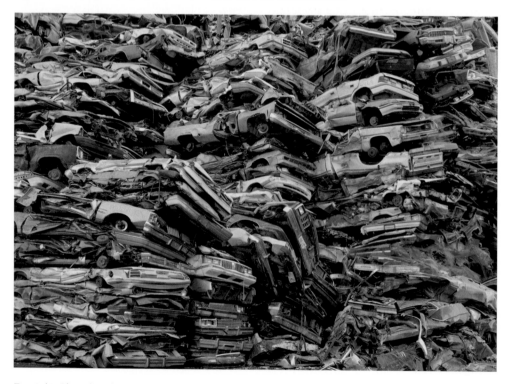

Fig. 1.40: Photo by Chris Jordan, *Crashed Cars #2*. Tacoma, 2004.

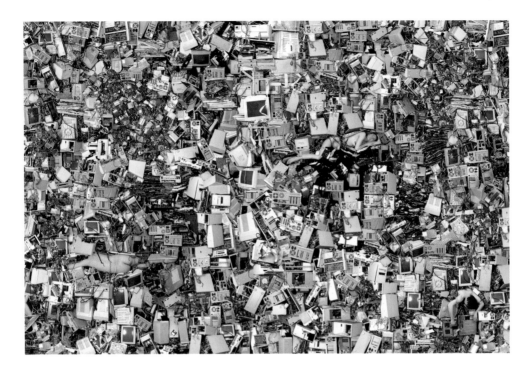

Fig. 1.41: Daniel Canogar, *Other Geologies 2*. 2005. 150 x 225 cm.

enterrarlos directamente. En mis visitas a las cacharrerías industriales, a los puntos limpios, o a los centros de tratamiento orgánico he visto como se separa la basura por bloques o separadores. De alguna forma yo quería representar esos separadores de basura, en forma de cajones o bloques temáticos, para almacenar la basura conceptual.

(The world of trash is a very specialized one, where materials are constantly separated and later reorganized into different groups. There is a whole selection process in place, in an effort to recover certain materials; the ones that cannot be recycled are discarded and buried. In my visits to recycling centers, industrial transfer stations, and organic reclamation plants I was able to witness how waste would be separated into blocks or bins. To a certain extent, I wanted to represent those blocks also by creating drawers or thematic blocks of conceptual trash.) (Ibarz)

Canogar's junkscapes, however—so uncannily similar to Jordan's, so Grand Canyon–like, with their "eroded layers of accumulated detritus"—add one unexpected ingredient to carefully sorted-out trash: the human body (Figs. 1.41, 1.42, 1.43, and 1.44). Canogar is just filling in the gap, adding the missing piece to the ultimately incomplete, and even "unrealistic" depiction of junkscapes à la Jordan: For landfills are not lunar landscapes, eerie geologies devoid of any human presence, but "real" and earthbound loci heavily infused with human presence and responsibility.

Wherever there is trash, Canogar's art implies, there are humans (in the form of both victims and perpetrators), an implication

also present, and compellingly so, in the trash pieces of Francisco de Pájaro, not only because he consistently and stubbornly "humanizes" and anthropomorphizes rubbish, but also because he faithfully records the brutal reality of trash and humans sharing urban filth. Trash and flesh equally blend into each other in Canogar's *Otras geologías*. Naked bodies of humans mix freely with the bodies of discarded computers (Fig. 1.41); a human eye peeks at us—one more eye among innumerable jettisoned camera eyes (Fig. 1.42); a blond mane of a woman cascades down, together with the dark mane of unwanted cassette reels (Fig. 1.43); and a nude pregnant woman lies asleep among the colorful plastic of discarded toys (Fig. 1.44).

One cannot but note that Canogar's "trash art" is fond of juxtaposing rubbish with alluring femininity, thus sexualizing female anatomy and assimilating it to filth. This is probably the most immediate—and déjà vu—reading Canogar's "inhabited" garbage geologies suggest, but there are at least three more, none of which precludes the other. Probably the most obvious interpretation, dear to catastrophizing environmentalist thought, is that trash will devour us, destroy our planet, and crash our ecological balance, in other words, that we will become the victims of our own consumerist greed. Jordan's reflections on his own project *Intolerable Beauty* seem to endorse such an interpretation: "The pervasiveness of our consumerism," he says, "holds a seductive kind of mob mentality. Collectively we are committing a vast and unsustainable act of taking, but we each are anonymous and no one is in charge or accountable for the consequences. I fear that in this process we are doing irreparable harm to our planet and to our individual spirits" (Jordan).

A second reading, deeply embedded, incidentally, in Catholicism-infused Spanish cultural tradition and history, is that humans themselves are "trash" among trash, flesh destined to perish and to decompose. The baroque passion for death symbols, and the obsessive prevalence of the memento mori theme resonates with Canogar, who has often acknowledged the influence that the Spanish and Italian baroque, particularly Rivera and Caravaggio, have exerted on his own art. Not only graveyards and skulls, but landfills also and stained mattresses, as well as electronic waste—Canogar often uses the term "barroco electrónico" (electronic baroque)—somberly utter the words, "Remember that you must die!" The "plastic toy dump" of one of Canogar's "trash collages" is a particularly compelling memento mori, where life and youth—as represented in the playful cheerfulness of toys, and the nude body of a pregnant woman (Fig. 1.44)—clash sinisterly with death and decay: we know that the colorful plastic landscape is not a playpen, but a landfill/graveyard full of discarded toys, doomed to rot, like dead people.

In 2014, Californian photographer Gregg Segal took on the social experiment of photographing people from different social and ethnic backgrounds surrounded by a week's worth of their solid waste. Segal used his own garden to create three different settings meant to suggest water, beach, and forest. According to the artist's statement, "*7 Days of Garbage* is a series of portraits of friends, neighbors, and other acquaintances with the garbage they accumulate in the course of a week. Subjects are photographed surrounded by their trash in a setting that is part nest, part archeological record. We've made our bed and in it we lie" (Segal).

At first sight, Segal's staged photographs and Canogar's photographic collages seem remarkably similar. In both cases, people (many of them family members and personal

Fig. 1.42: Daniel Canogar, *Other Geologies 13*. 2007. 150 x 225 cm.

Fig. 1.43: Daniel Canogar, *Other Geologies 9* (Detail). 2005. 150 x 225 cm.

acquaintances of the artists) lie amid trash and adopt various poses. Even these are not so different, and in some cases, they share the same semantic field. The pregnant woman in Fig. 1.44 and the woman in fetal position in Fig. 1.45, for example, speak the "feminine" lingua franca of "sexy" maternity, coupled with unborn innocence and vulnerability. It would be interesting to know if Segal's model decided on her own to adopt that particular pose, or if she was instructed to do so by Segal. Canogar certainly gave his models precise guidelines. In either case, both Segal's and Canogar's models uncritically conform to cultural expectations of gender roles, two sleeping beauties dozing away in their garbage nests, at the mercy of the male voyeur.

Segal's photographs could have moved into a different direction, and addressed important social issues and differences head on. The photographer himself hints at it, when in an interview with the *Guardian* he observes how "some of the subjects edited their garbage, removing the really smelly stuff, where others were faithful to the concept and brought everything, I even found tampons in one subject's garbage and a hypodermic needle in another's" (Fidler). But Segal doesn't dwell further into the social and cultural reasons for differing attitudes toward trash. He does not identify the social and ethnic background of the "subject" (or subjects) that unabashedly bring used tampons and hypodermic needles to the scene, or of the ones who make sure to "cleanse" or "edit" their garbage before laying and being photographed in it. Instead, Segal goes down the safer and often traveled route of beautifying and eroticizing bodies in close embrace with trash. His photographic series includes childlike and vulnerable females cuddling into fetal positions in the midst of filth (Fig. 1.45) reminiscent of

Canogar's, for example, or defiantly "trashy" Lolitas (Figs. 1.46 and 1.47) showing off exposed flesh. Even a picture that falls within the conventional and perfectly respectful genre of the family portrait invites lecherous gazing. The skirt of elegantly dressed wife and mother slides up the back of her thigh, perking up the generally bland depiction of a stereotypical white upper-middle-class family in the midst of "depurated" garbage, consisting almost exclusively of carefully selected recyclables (Fig. 1.48). The images discussed above perfectly align with the cliché of the dirty female body so deeply ingrained in Judeo-Christian culture. In the same wake, the reference during the interview to used tampons as a particularly repellent—and subversive—component of the trash heap is in no way innocent or casual, nor is it the fact that the tampon appears mentioned in conjunction with the hypodermic needle. The needle stands for the danger of drugs, in the same way in which the tampon stands for the danger of sex, both dirtied and red with blood.

As mentioned before, Canogar's photographic collages are not free either from the intense and deliberate eroticization of the female body and the urge to create "sexually moving" scenes. The composition with the pregnant young woman is one example. Another one is the image of luscious blond hair dramatically standing out against the shiny black background of cascading cassette reels, which brings back countless pictorial and photographic representations of longhaired temptresses (Bornay). Still, Canogar goes a step further than Segal, in the sense that he emphasizes the dark connection between sexuality (Eros), and putrid accumulation (Thanatos). The Spanish contemporary media artist relates modern excess—an excess of consumption that then

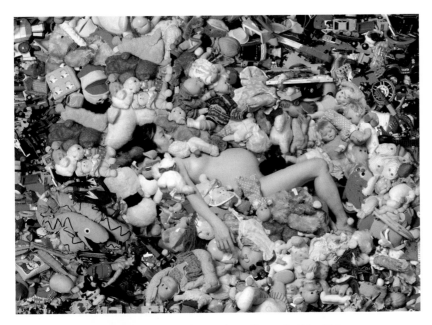

Fig. 1.44: Daniel Canogar, *Other Geologies 1* (Detail). 2005, 150 x 225 cm.

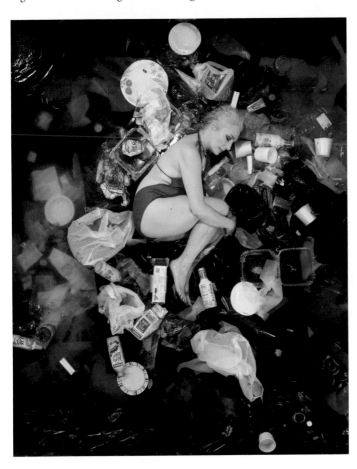

Fig. 1.45: Gregg Segal,
photographic series,
7 Days of Garbage.

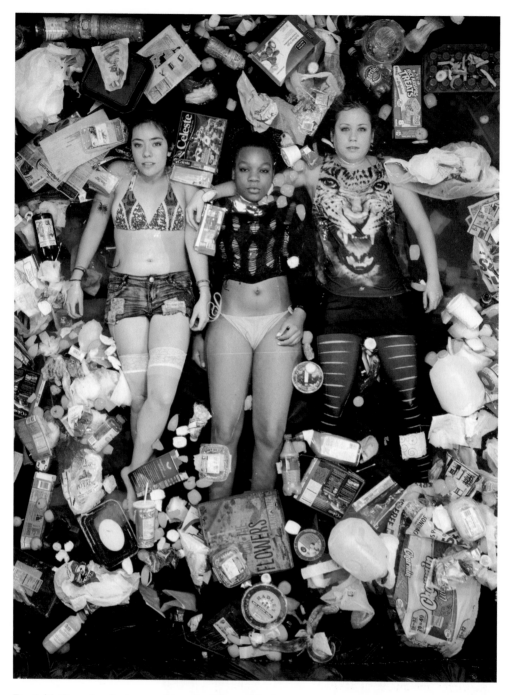

Fig. 1.46: Gregg Segal, photographic series *7 Days of Garbage*.

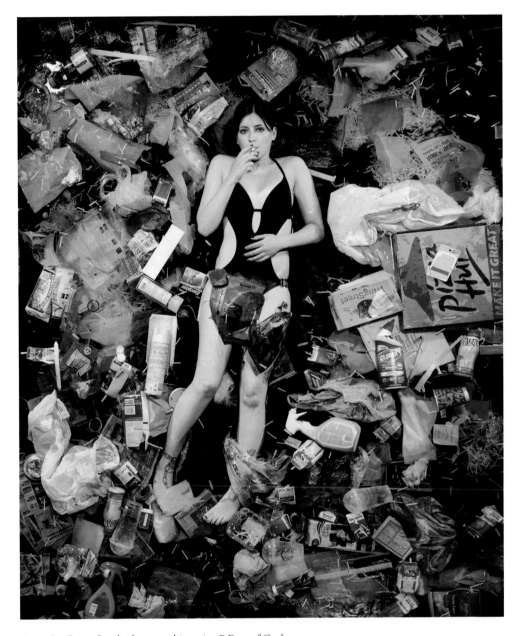

Fig. 1.47: Gregg Segal, photographic series *7 Days of Garbage*.

degenerates into an excess of trash—to *hor-ror vacui*, the fear of emptiness, yet another baroque theme. In fact, in one of his interviews, Canogar refers to the Diogenes syndrome, the pathology of compulsive hoarders, as the paradigmatic illness of savage capitalism. But mostly, and this leads us to our third interpretation of *Otras geologías*, what propelled the Spanish artist to throw naked bodies into landscapes of excreted excess was the painful realization, so evident also in de Pájaro's art, that humans not only

Fig. 1.48: Gregg Segal, photographic series *7 Days of Garbage*.

share the destiny of things (they die and rot; they become trash) but are treated by others as disposable items. As Canogar tells us, he decided to populate *Otras geologías* with nude anatomies when he saw the horrific Abu Ghraib images (Fig. 1.49):

> El origen de la utilización de los cuerpos desnudos forma parte del proceso preliminar de *Otras geologías*, cuando estaba realizando las investigaciones del proyecto salieron las imágenes de la prisión de Abu Ghraib, me impactó el tratamiento del cuerpo humano como un residuo. En las imágenes había unos cuerpos acumulados, formaban una montaña de cuerpos humanos, en concreto estoy pensando en una fotografía donde los cuerpos de unos prisioneros estaban agolpados en el suelo y tenían bolsas de basura en la cabeza.

> (The trigger to use nude bodies is part of the process preliminary to *Otras geologías*. While I was doing research for the project, the images from the Abu Ghraib prison came up on the media, and the treatment of the naked body as residue had a profound impact on me. The images showed bodies on top of each other, a mountain of bodies, and I am thinking about one particular image, where prisoners on the floor had their heads covered with trash bags.) (Ibarz)

The year 2005, when Jordan and Canogar made their trash art pieces public, was the year also when Fernando Botero exhibited his series on Abu Ghraib (Butler; Mitchell, *Cloning Terror*; Sontag) for the first time (Nash) (Fig. 1.50). The obscenity of excess (excessive consumption, excessive trash, excessive violence), and of the disposability of

human life has had a deep effect on the three artists and has also informed the creative production of other well-known painters, sculptures, and media artists working with and on "monumental" rubbish, among them Vik Muniz and HA Schult.

Vik Muniz's famous artistic intervention in Jardim Gramacho, Rio de Janeiro's biggest landfill before it closed down in 2012, also caters to the megasized nature of trash accumulation, in the style of Jordan and Canogar. And like Francisco de Pájaro's street art, Muniz's trash compositions equally acknowledge the powerful link that ties trash to poverty. It is not by chance that the "true" manipulators and collagists of trash in Vic Muniz's monumental trash compositions are the former ragpickers and inhabitants of Jardim Gramacho. However, the emphasis on the trash-poverty continuum has very different aesthetic outcomes and political implications in the case of the Spanish artist and his Brazilian counterpart. De Pájaro's street art is deliberately unpolished and rough, with ugliness invariably overpowering any attempt at artistic embellishment. Muniz's "landfill art," on the other hand, aims at beauty pure and lofty (Kantaris). The ugliness of the primary material (trash) needs to be transcended at any cost and is required to render homage to old masterworks (Figs. 1.51 and 1.52).

Sure enough, Muniz skillfully directs his team of "catadores" (ragpickers in Portuguese), and teaches them how to construe replicas of famous paintings, such as Goya's *Saturn Devouring His Son*, Caravaggio's *Narcissus*, or David's *The Death of Marat* (Fig. 1.52). These "mimicking" collages first lie flat on the ground and, upon their completion, are photographed from a high platform. The end result of this landfill project, known as *Pictures of Junk* (2008) is "a series

Fig. 1.49: Abu Ghraib Prisoner Abuse, Associated Press/ Courtesy of the *New Yorker* (Public Domain).

Fig. 1.50: Fernando Botero, *Abu Ghraib*, 57, 2005. Oil on Canvas, 2009. 12.32.

Fig. 1.51: Vik Muniz, *The Birth of Venus, After Botticelli* (*Pictures of Junk*). 2008. Art ©Vik Muniz/ Licensed by VAGA, New York, NY.

Fig. 1.52: Vik Muniz, *Marat (Sebastião)* (*Pictures of Junk*). 2008. Art ©Vik Muniz/Licensed by VAGA, New York, NY.

of seven images, each produced in two different formats, with 50% of the sales of the larger prints benefitting the Garbage Pickers Association in Jardim Gramacho" (Hunt).

Despite the evident connection of *Pictures of Junk* to poverty and to the victims of poverty and squalor (Muniz used a number of catadores as models for some of its trash collages), Muniz's landfill art is more closely related to the loftiness of Canogar's *Otras geologías* and of Jordan's *Intolerable Beauty* than to de Pájaro's down-to-earth "El arte es basura" urban trash creatures. "Down-to-earth," in fact, is what does the trick, or rather, explains the fundamental difference of de Pájaro's approach to trash. More often than not his "trash people" sit, lie, or crouch on the pavement, and passersby are forced to lower their eyes in order to acknowledge their presence. De Pájaro does not have the privilege of a vertical canvas to show off his art, nor are the viewers of his art allowed to enjoy beauty comfortably displayed at eye level. De Pájaro's art is as realist and immediate as it gets, because it favors "real" horizontality over "stylized" verticality. Poverty and trash happen on the floor; they don't hang from walls. In order to portray (and denounce) poverty, de Pájaro kneels down and smells and touches trash, instead of climbing on a platform, and taking odorless and pristinely clean photographs from above, or even "directing the installation from [a] studio and with the help of a laser pointer" (Hunt). In this aspect, Canogar's approach to trash is very similar to that of Vik Muniz, since he also takes pictures of trash, and uses them to painstakingly construe a giant collage or composition.

Muniz, Jordan, and Canogar favor verticality over horizontality, distance over proximity, cleanliness over dirtiness, the odorless over the smelly, and . . . durability over perishability, though in varying degrees: Canogar, for example, throws away his enormous trash collages once the exhibition is over. As the artist himself explains, "Las fotografías son encoladas directamente en la pared y al acabar la exposición se arrancan de los tabiques y entran en el ciclo de la basura, quería que el proceso fuera éste, son obras efímeras con un carácter de autodestrucción programado desde su existencia" (Photographs are directly plastered to museum walls, and, once the exhibition is over they are torn from the walls and enter the cycle of trash. I wanted the process to be like this, since [these photographic murals] are perishable goods, with self-destruction programmed into their existence) (Ibarz).

Canogar thus is keen on restoring trash to trash, whereas Muniz seems more fixed on permanence and on art's survival and continuity. First of all, his trash installations are lifted from the landfill floor, via photography, and rescued from sharing the destiny of trash/us (which is to lie down, and rot); but more importantly, the permanence of his particular variant of trash art also prolongs the life of art, of high art in particular, and since his own work imitates and pays homage to the works of the great masters.

Verticality, distance, and durability are in many ways the landmarks of high culture and its artifacts. And so are the monumental and the gigantic (Stewart), for to "think big," and to "do big" are the privileges of the rich and powerful. It comes to no surprise that fairly affluent artists (Jordan, Canogar, Muniz) are the ones who embrace vertical, distant, permanent, and monumental, whereas artists of lesser means (de Pájaro) stick to horizontal, nearby, perishable, and small. Certainly, trash shares all these traits (almost all of them), with de Pájaro, and

therefore one could argue that de Pájaro's art is much closer to trash, and an infinitely more accurate depiction and representation of trash than the art of Jordan, Muniz, and Canogar. Trash lies on the floor (is horizontal), is graspable and always around (certainly not distant, although we would like it to be), and it is perishable (or so we hope). But . . . is trash monumental? Trash starts small (as small as the peel of an orange, or even smaller, like a cigarette butt, or a bus ticket distractedly made into a roll), but it grows fast, thanks to the powerful: humans. So if trash becomes huge and monumental it is because of us, because we, mighty colonizers of planet Earth, force it to expand, to move, and to accumulate. In an interview, Canogar speaks not only to the monumentality of trash, but also to its ability to dangerously turn against its creator, and to bury humankind under its pestilent weight. When asked why he uses photography to give expression to the seemingly unstoppable accumulation of waste, he responds:

El medio que he utilizado es el mural fotográfico, que desde mi punto de vista es diferente de la simple fotografía. Con estas imágenes quería llenar la mirada del público. El problema de la acumulación de residuos es un problema a gran escala, por ello era importante hacer las fotografías a gran escala. Al ser unas obras tan grandes, monumentales . . . pretendía dar la sensación de que todos los residuos que aparecen representados en la imagen, se caían encima del espectador.

(The medium I decided to use is the photographic mural, which, from my point of view, is different to photography. My goal with these images was to fill the eyes of the public. The problem of residue accumulation is a problem of big scale, which is why it is important to take pictures that are equally oversized. My photographic murals are so big and monumental because I want to convey the impression that all the residues depicted in the image would tumble down and bury the spectator.) (Ibarz)

Monumentality and movement go hand in hand. Trash grows because it moves from hand to trash basket, from trash basket to trash can and Dumpster, from Dumpster to garbage truck and from garbage truck or barge to transfer station, and, finally, to its ultimate destination point, a dump or a sanitary landfill. Artists look at trash and make it the prime material of their work at all its different stages of growth and travel; Some of them embrace trash when it is small, still discernible (with a face even), and has not yet made it far (de Pájaro; "My Dog Sighs"; "Filthy Luker"; Laderman Ukeles; *Trashcam Project*); others meet trash when it has reached its final destination, is huge, and a landscape (Jordan; Canogar; Muniz); and some even stress the nomadic spirit of trash, its restless nature. Such is the case of German artist HA Schult, the creator of an imposing army of robot-like rubbish "soldiers" that travels the world and takes famous tourist sites by assault (Figs. 1.53 and 1.54).

"Trash People. In twenty containers they roam around the world like refugees of the consumer society. The Trash People are images of us. We produce trash and we will become trash. Today's Coca-Cola bottle is the Roman archeological found [*sic*] of tomorrow," says Schult about his creatures. He stresses their traveling nature, but he also adds a somber accent to it. For "Trash People" are not tourists but "refugees" (refugees of our consumer society) who "roam the word in

Fig. 1.53: HA Schult, *Pyramids People*. Giza, Egypt 2002. Photograph by Thomas Hoepker.

twenty containers." Once let loose, though, and ironically enough, they find themselves among tourists, having their picture taken on the Great Wall of China or in front of the Pyramid of Cheops. But, unlike tourists, who are always on the lookout for new attractions, the same "trash people" come back, again and again. Trash never leaves us and always returns, no matter how far we wish to send trash away. And trash, in de Pájaro's words mentioned before, "is always the same." In fact, Schult's trash sculptures are deliberately built to look alike, with identical body postures and marching in rigid unison.

The monumentality of Schult's trash automatons—the result of sheer quantity, imposing size, and expressionless uniformity— stands in stark contrast to the unassuming airs of de Pájaro's animated trash bags. In both cases the row material is the same, waste, and the initial purpose similar, namely,

to endow refuse with anthropomorphic features. But the ultimate goal is very different and has to do with what aspect of trash (and of society) speaks to each artist. De Pájaro's basic purpose is to denounce poverty, and to establish a crass comparison between the two (interchangeable) entities consumerist capitalism so easily turns a blind eye on and discards: things, the poor. Schult's aim, on the contrary, is to raise awareness about waste as an environmental catastrophe of the vastest proportions, and, true enough, as a dire consequence of savage consumerism. In their acerbic critique of global capitalism, de Pájaro and Schult stand united. Still, in the eyes of the latter, trash is a monumental force that disengages itself powerfully from the floor; it does not loiter but moves decidedly ahead. Schult, Jordan, Segal, and Canogar share the same apocalyptic vision of trash. Garbage, the consequence of our

Fig. 1.54: HA Schult, *Great Wall People*. Beijing 2001. Photograph by Thomas Hoepker.

criminal irresponsibility, engulfs us, invades the planet, and is here to haunt us. Schult's "trash people" are as close as they can get to zombies, and Schult's traveling installation certainly bears an uncanny resemblance to the zombie-film genre.

De Pájaro and Canogar, as well as Jordan and Schult, approach waste from different angles, but the works on trash by the four artists convey a similar mixture of fascination and horror. In Jordan's words, there is "intolerable beauty" in trash, and traces also of a profound humanity, as de Pájaro's "down-to-earth" art (both literally and figuratively), and its deeply compassionate approach to all things (and people) discarded so skillfully brings to the fore. De Pájaro's art meets trash at the preliminary stage of its voyage and life cycle; still an infant so to speak, it is much easier to identify with, and to feel compassion for at that early phase than later on when it has it has grown into monumental danger. But no matter how "small" (and harmless) or how "big" (and harmful), trash, in the works of de Pájaro, Jordan, Canogar, and Schult, showcases two essential traits: it travels, and it is ubiquitous.

As Mexican artists Ilana Boltvinik and Rodrigo Viñas compellingly point out, "trash is everywhere, all the time. We do not cease to produce it, neither does it disappear. . . . It has no clear frontier: soda bottles made in China may wash up on a beach in Mexico or Australia; medical waste from New York may be found in the beaches of Brazil or Iceland. Trash from anywhere can be found everywhere. It is simultaneously global and local" (210, 211). Garbage spills out of bins and Dumpsters, fills landfills to their capacity, and washes up on the beaches worldwide; it piles up against the background of the Pyramids of Egypt, and crowds the Great Wall of China, as Schult's "trash zombies" metaphorize. It is harrowingly omnipresent, a monumental landscape of foul-smelling excess that endlessly repeats itself on all continents.

2

Litterscapes
Topographies and Archives of Waste

Solid refuse accumulates in large-scale open pits and sanitary landfills across the planet, its ever-growing monumentality a source of permanent concern and fascination (Engler; Horne; Nagle, "History"; Humes; Royte). But trash is not born big. It starts petite, and it is the unassuming smallness of garbage that will continue to occupy the pages that follow. The previous chapter emphasized the "moving" nature of urban solid waste and the various ways in which artists "humanize" small-scale trash and thus appeal to our emotions. Equally invested in rubbish at its early stages of growth, this chapter however is less interested in the anthropomorphic nature of small-scale refuse than in its ability to transform space. Litterscapes leave their imprint in urban and natural surroundings, and in both cases they elicit a series of reactions (and actions) among artists and regulators. Litterscapes are often seen as threatening by the latter, and even the former feel the urge to restore order via a number of artistic strategies and interventions. As the second part of the chapter shows, so-called border trash in particular—namely, the castoff belongings of undocumented immigrants found in the desert along the US-Mexico border—generates the compulsive need to (photographically) record, classify, and archive the unwanted and the discarded.

Road Kill: On Street Litter

In her essay "Litterati: A Digital Landfill of Good-Looking Trash," Max Liborion starts by identifying a common feature among trash lovers: "I suspect," she acknowledges, "that like me, urban followers of the *Discard Studies* blog spend a lot of time looking down. There is a lot of interesting trash on sidewalks, roads, and gutters." Baudelaire's famous flaneur in *The Painter of Modern Life* (1863) made it fashionable to look straight ahead into the spectacle of the city. After him (male) urban strollers had no qualms with staring into faces and locking eyes with passersby, nor did the obstacles of walls, buildings, and narrow streets deter their insatiable voyeurism. The straightforward gaze of the turn-of-the-century flaneur can be read as an "urban" and street-level version of the unhindered panoramic gaze of the romantic traveler, used to climbing mountains and towers and to taking in the world entire. Both "ways of seeing"—the panoramic élan of the romantic traveler and the close-up, impertinently scrutinizing gaze of the fin de siècle flaneur—are keen on forcefully apprehending the world, a purpose not far from an act of colonizing violence, as we now understand it. Back then, though, authoritarian and purposeful scopophilia was welcomed as a triumphant badge of "true" masculinity, hence it is to no one's surprise

that "Hans guck in die Luft" (Johnny Head-in-Air), the little boy who walks around looking absentmindedly into the sky in the famous German children's book *Der Struwwelpeter* (translated into English as either as "slovenly" or "shock-headed" Peter, 1845) by German psychiatrist and writer Heinrich Hoffmann, is duly punished for his "unmanly" reveries: rather predictably, he ends up falling into the river and almost drowning.

Roughly two centuries later, however, a new type of intellectual and activist paces the urban landscape, more interested in looking down than straight ahead, or up. Brian Thill, for example (who, like Rachel, the main character in Paula Hawkins's *The Girl on The Train*, is mesmerized with the dirt accumulating in train tracks; see the Introduction), compellingly talks about the almost rapturous

> feeling of gazing down from the subway platform into the wet brown spaces of the train tracks to see what we find there, in the dark places where fetid puddles of assorted liquids mingle with grungy water bottles, soda cans, expired MetroCards, flattened bits of mildewed paper, and other objects smudged and smashed beyond recognition. Unlike the city above us, the platform offers few vistas, and the conventions of city life militate against most engagements with other assembled strangers. The occasional rat skitters across the filth, emerging out of some invisible passageway somewhere beneath us before vanishing again into another equally obscure tunnel just before the train's approach. On the platform I always find myself staring down into the rust-brown garbage pooled down around the

tracks. It's nasty, and I can't look away. (12)

As shown in Chapter 1, Thill is not the only one who "can't look away." Francisco de Pájaro is equally fascinated with garbage and stands out among the artists and thinkers who find inspiration in "low" horizontality and filth. But whereas his main purpose (and that of fellow trash creators such as "Filthy Luker" and "My Dog Sighs") is to animate trash via anthropomorphization, other artists are more interested in garbage as the creator and "painter," of landscapes instead of faces. Sidewalks and crossings, for example, routinely showcase a complex constellation or cartography of discarded small objects (cigarette butts, used tissues, chewing gum, flattened soda or beer cans, etc.) that remain on the streets for long periods of time, and often even melt or dissolve into the pavement. I like to call these tiny littering critters "road kill," since, not unlike the innumerable small animals that fall prey to fast cars and heavy trucks, street trash too "perishes" under the squashing power of wheel tires and shoe soles. The photographic composition in Fig. 2.1 shows an array of litter at different stages of its life on the streets. The rolled-up aluminum lid is evidently still very "young" and unblemished, in comparison to the flattened coke can, the weathered paper cup with its fading colors, the "bleeding" lip gloss tube, the crumpled receipt, and the dirty and rain-drenched plastic bag.

There is a strong sense of "before" and "after" in trash found on the streets. "Litterscapes" are "chronotopoi" (Bakhtin), "time-spaces" drenched in melancholia, similar to the profoundly baroque, painterly genre that focuses with manic intensity on the passage from youthful radiance to sagging flesh. The specter of decay and death portrayed

Fig. 2.1: Filomena Cruz, photographs.
Roadkill Series. Los Angeles, CA.

Fig. 2.2: Filomena Cruz, photograph. *Roadkill Series*. Los Angeles, CA.

with insuperable mastery in Hans Baldung Grien's *Three Ages of the Woman and Death* (1510), and in Gustave Klimt's *The Three Ages of Woman* (1905) also looms over garbage, in the same way in which it looms over humans. There is one fundamental difference, however: whereas organic matter (human and nonhuman) dies irrevocably, not all trash—in fact, very little of it—perishes. Take the crushed plastic cup in Fig. 2.2, for example. It is difficult—almost impossible, truth told—not to fathom that it will ultimately dissolve and disappear. It is crushed already, and useless. Surely it will further fall into pieces, exposed to the hurried violence of many oblivious feet stamping on it, and will eventually add to a pile of rotting garbage somewhere? That is our hope.

But hope is short-lived (much more so than trash), for the fact remains that plastic waste will survive us all. Scientists across the board have tested the impact of photodegradation on plastic (plastic does not biodegrade, but it does photodegrade, although at an exasperatingly slow pace), and have come up with a life span of five hundred to one thousand years for the common polyethylene bag handed out at grocery stores. This is only an approximate prediction, since plastic has been around for only fifty years. The real message behind these speculative numbers though is that trash is ultimately "immortal," and closer to cockroaches than to humans in its uncanny ability to survive.

Probably the first one to officially confirm and attest to the fact of the immortality of trash was inaugural "garbologist" William

Rathje, whose archeological diggings in the landfills of Arizona during the 1980s showed that garbage—and not only plastics, but also perfectly biodegradable artifacts, such as newspapers—could be recovered from the ground in almost pristine condition. In sanitary landfills, trash is compressed so tightly that oxygen below the surface is scarce, thus remarkably slowing down the process of decomposition. Trash mummifies, literally, and even on the streets and under the sun, litter often dries out and hardens into different degrees of "fossilization" (Figs. 2.3 and 2.4). In certain instances, garbage literally melts into the pavement and pigments it tattoo-style, as particularly the third image of the series in Fig. 2.3 and the two images in Fig. 2.4 exemplify.

The transformation of urban litter into "contemporary fossils" has drawn the attention of Mexican art collective TRES.[1] Probably inspired, at least partially so, by Rathje's influential "garbology," artists Ilana Boltvinik, Rodrigo Viñas, and Mariana Mañón create *Chicle y Pega: Constelaciones de fósiles contemporáneos* (It is chewing gum, and it sticks: contemporary fossil constellations) in 2012, a project that focuses on chewing gum stuck to the pavement in Mexico City's "centro histórico" (historical center). Chewing gum blobs continuously attract dirt—Boltvinik calls them "una especie de imanes receptores" (a type of receptive magnet; Rodríguez)—and eventually fossilize into multilayered and blackish conglomerates. Fossilized chewing gum blobs, according to Boltvinik, Viñas, and Mañón, not only are "visual and aesthetic modifiers of the urban landscape" but also operate as "registers of human transit," and as "dust and pollution indexes" (Sánchez).

Not unexpectedly, TRES's intervention brought to light a number of data, some of them anecdotal, others more substantial.

Fig. 2.3: Filomena Cruz, photographs. *Roadkill Series.* Los Angeles, CA.

Fig. 2.4: Filomena Cruz, photographs. *Roadkill Series*. Los Angeles, CA.

We know, for example, that chewing gum blobs are remarkably dirty creatures, infested with bacteria (around fifty thousand to seventy thousand of them). Madero Street alone in Mexico City's "centro histórico" that served as one of the bases of operation for *Chicle y Pega* is peppered with approximately 770,000 chewing gums (an average of seventy chewing gum pieces per square meter), and each piece of chewed gum is stepped on by up to two million people. Only forty-five days after Madero Street was repaved and reopened as a walk street in 2010, 8,441 chewing gum blobs already sullied the freshly inaugurated concrete and marble pavement. The municipal district had to buy ten chewing-gum-remover machines, but these were able to lift only between two thousand and twenty-five hundred chewing gum pieces from the ground during the period of 2010–2012, not to mention the fact that to remove chewing gum costs five times as much as to produce it (Páramo).

TRES generally looks at litter—and in this particular case, at chewing gum—from an interdisciplinary perspective. It resorts to "la etnografía—con una perspectiva de pepenador—*para encontrar y sistematizar los chicles en la vía pública*, [la antropología], *para entender costumbres y su relación social*; [la arqueología] *para extraer información cultural*;

[la química] *para encontrar vestigios e información biológica*; y . . . la restauración, *para encontrar metáforas urbanas de las constelaciones encontradas*" (to ethnography to find and systematize chewing gums tossed on public spaces, in the style of "pepenadores" or ragpickers; to anthropology to understand certain habits and its social implications; to archeology to extract cultural information; to chemistry to search for biological traces; and to restoration and conservation to further delve into urban metaphors construed around street refuse) (Círculo A).

Needless to say, TRES's rich multidisciplinary approach is fieldwork based, and active engagement with the community is another of *Chicle y Pega*'s distinctive landmarks. As a first step, TRES readily embraces the figure of the "pepenador" (urban ragpicker or scavenger) and compares its modus operandi—searching, observing, collecting, classifying, systematizing—to that of an ethnographer. And as a second step, it stages a short-term artistic intervention, where a segment of the pedestrian street is cordoned off as if it were an archeological site, and a team of "scientists" embark in the laborious cleansing, restoration, and categorization of "chewing gum constellations" (Fig. 2.5).

It is important to note that, whereas for Thill "looking down" seems to come

Fig. 2.5.1: *Chicles en restauración #1*, intervención en sitio específico, calle Madero, Centro Histórico, CDMX. TRES (Ilana Boltvinik, Rodrigo Viñas, Mariana Mañón), 2012.

Fig. 2.5.2: *Chicles en restauración #2*, intervención en sitio específico, calle Madero, Centro Histórico, CDMX. TRES (Ilana Boltvinik, Rodrigo Viñas, Mariana Mañón + Javier Cuervo), 2012.

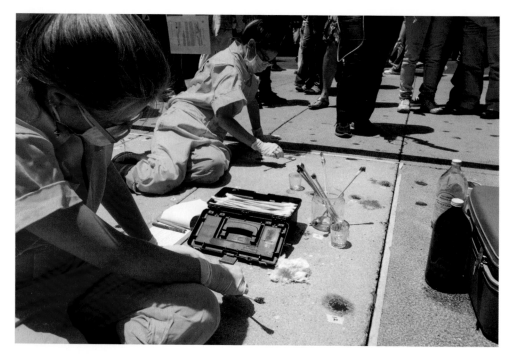

Fig. 2.5.3: *Vista final de intervención #1*, intervención en sitio específico, calle Madero, Centro Histórico, CDMX. TRES (Ilana Boltvinik, Rodrigo Viñas, Mariana Mañón + Javier Cuervo), 2012.

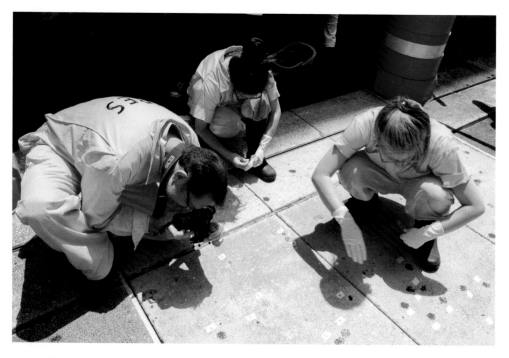

Fig. 2.5.4: *Vista final de intervención #2*, intervención en sitio específico, calle Madero, Centro Histórico, CDMX. TRES (Ilana Boltvinik, Rodrigo Viñas, Mariana Mañón + Javier Cuervo), 2012.

Fig. 2.5.5: *Chicle #142*, proceso de clasificación de chicles, intervención en sitio específico, calle Regina, Centro Histórico, CDMX. TRES (Ilana Boltvinik, Rodrigo Viñas, Mariana Mañón + Javier Cuervo), 2012.

Fig. 2.5.6: *Morfología del chicle*, lápiz y tinta sobre papel 20 x 14 cms. TRES (Ilana Boltvinik, Rodrigo Viñas, Mariana Mañón + Javier Cuervo), 2012.

naturally and as the response to a very personal urge, for TRES it is learned behavior, and the result of careful observation of the modus vivendi of ragpickers. TRES implicitly acknowledges that the poor have always been "looking down," not because of some aesthetic infatuation with debris, but because they need to do so in order to survive. Thus TRES's intention is not only to raise awareness about waste and consumption, but also to shed light on the disenfranchised, in this particular case, on the figure of the pepenador and his or her trade.[2]

Finally, a third and perhaps less apparent goal is to show city dwellers, via art, that litter too, even of the smallest kind, contributes to the dynamism and transformation of the urban landscape. Cities, often seen and treated as living organisms in literature and film, have not only organs—Emile Zola's vision of a central market as the city's digestive

Fig. 2.6: Ben Wilson (aka Chewing Gum Man), 2008.

system in his novel, *Le Ventre de Paris* (*The Belly of Paris*, 1873), or Walter Ruttmann's filmic use of opening windows and shutters as the eyes of a city that awakens to daily life in *Berlin: Die Sinfonie der Grosstadt* (*Berlin: Symphony of a Metropolis*, 1927) are just two paradigmatic examples—but also an epidermis (the biggest organ of all). Trash thus soils—and wounds—the city's "skin." Some of the dirt leaves permanent, tattoo-like imprints or hardens into crusts, while other times litter is washed off from the urban complexion. In any case, TRES's approach to "chewing gum marks" is as "medical" as it is "archeological." The scientists-artists that painstakingly swab and treat "chewing gum tumorations" conceive of large urban enclaves as unhealthy organisms that need to be cured through cleansing, much in the spirit of nineteenth century's obsession with the hygenized city and body (Carter; Cox; George; Laporte; Latour; Pisani; V. Smith).

Ben Wilson, a British street artist widely known as "the Chewing Gum Man," also focuses on that particular piece of urban refuse, this time as found in the streets of London. Wilson's oeuvre is part of an increasingly popular street art subgenre that favors the minuscule over the monumental (artists such as Pablo Delgado, Slinkachu, and Isaac Cordal come to mind) and that, like the art pieces of TRES, Francisco de Pájaro, "Filthy Luker," and "My Dog Sighs," are inspired by what happens on the ground. Not unlike the artists from TRES, Wilson too searches the streets for chewing gum, crouches or even lies on the pavement, and spends hours working on spat-out waste. But instead of trying to "clean" blackened chewing gum and to bring it back to its original (and mostly pink) glory, the British artist aims at turning it into something entirely different. Wilson is a self-taught artist, who since 2004 has spent countless hours

painting microscopic scenes and landscapes on chewing gum blobs transformed into tiny canvases (Fig. 2.6).

Wilson never alters the shape of the bubblegum; to the contrary, he seamlessly integrates shapes and contours into his art (Figs. 2.6, 2.7, and 2.8). And in order to preserve both (the original shape of the bubblegum blob and the mini-paintings on it) the artist has even created his own recipe that turns soft gum into a paintable and remarkably resistant and durable surface:

> Find a piece of discarded, spat-out chewing gum. Heat it with a blowtorch. Then I apply a lacquer into the bubbling gum. That stabilizes the gum itself. Then I put one coat of acrylic enamel on the melted gum followed by a second coat. I make sure the whole thing is dry and rock hard. Then I paint the picture. Then I put a clear car lacquer over the top. Then I apply heat again. And you have a picture that can be rained on and walked on. It can even be under a puddle of water. It's an invention. You then have a gum pic and the discarded chewing gum has been transformed. (Sadler, "Part I")

As all artists engaged with rubbish, Wilson is fascinated by the power of art to convert the banal and the discarded into an object of sheer beauty. But beauty doesn't mean anything to him (in fact, beauty is no better than trash, and in this he fully agrees with Francisco de Pájaro's proclamation, "el arte es basura," art is trash), if it is not inextricably attached to a profound sense of solidarity and compassion. Not unlike TRES's *Chicle y Pega*, Wilson's "gum pics" engage with and create community. He not only generously shares his "secret formula," he also welcomes specific commissions from his public. In his

Fig. 2.7: Ben Wilson (aka Chewing Gum Man), 2008.

two-part interview with the Little London Observationist blog, Wilson publicly apologizes "for all the pictures I haven't done yet. I haven't been able to do them because my father died last year and around that time, I lost a toolbox I had for years. I lost about four request books with about 200 requests. So all of those people will think I didn't care" (Sadler, "Part I"). More importantly, Wilson recognizes the importance of anchoring his artistic practice to a specific place and neighborhood. Although one can find his art in various areas within London—the images, for example, in Figs. 2.7 and 2.8 come from his extensive intervention on the Millennium Bridge, where he created "a trail of 400 mini-artworks" (Holdsworth)—Wilson prefers to create his art where he grew up (Barnet) or where he currently resides (Muswell Hill). Painting on discarded chewing gum gives Wilson and the members of his

Fig. 2.8: Ben Wilson (aka Chewing Gum Man), 2008.

community a sense of place and a feeling of connectedness. As he points out in his interview for the Little London Observationist, "when you are working, you go with the place. . . . I am doing work that's for people. It's about social cohesion. Every time I do a picture for a different person, it's making links between people" (Sadler, "Part I"). And in a conversation with Julia Elmore, Wilson explains: "I know a lot of shopkeepers, road sweepers and local police. And as I walk down the street, every few steps I think of a picture I have to do for someone. I have all this in my head, which makes me feel closer to the place and the people." Sure enough, many of Wilson's pictures carry the names of the people (not only locals, but also passersby and tourists, as in Fig. 2.7), who request a chewing gum painting from him.

One of TRES's findings through its project *Chicle y Pega* was that one encounters more spat-out chewing gum in places where people stand and wait, such as street crossings or bus stops. Wilson also identifies such spots and patiently adds color and a narrative to them. By doing so Wilson not only engages in an act of memorialization but celebrates moments of pause, reflection, and communion in the midst of the frantic rhythm of a megalopolis, in the same fashion in which he readily identifies traces of the countryside—minisimulations really of a lost, slow-paced Arcadia—while crouching or kneeling on the sidewalk. Take what he calls "urban tumbleweeds," for example: "Since I have been working on the pavement, I see balls that blow along. It's all people's hair mainly, but it can pick up anything as it's rolling along. It's relatively light and the size of a tennis ball. It picks up old cigarettes butts, bits of rubbish, Rizlas, anything really. It blows around. When you're working,

you see how hair gets caught in little crevices. This is an "urban tumbleweed" (Sadler, "Part I").

Wilson shares the belief with Mexican London-based street artist Pablo Delgado that "sometimes small things can have the strongest impact and become the most personal as you have to really get up close to them and ignore the distractions of the surroundings" (Wood). Similarly, the British artist feels a fascination comparable to the one felt by Spaniard Isaac Cordal (yet another artist whose miniature art pops up on the London streets) with the nooks and crannies of city streets, where green patches suddenly emerge from the pavement. Reduced size, slow tempo, semihidden vestiges of nature that only eyes fixed on the ground are able to discern are the landmarks of an artistic urban corpus doubly engaged in environmental activism and community-building efforts. Wilson's spat-out and painted-on chewing gum pieces epitomize a nostalgic longing, with romantic and bourgeois undertones, for (stubbornly idealized) nature, for what is small (even hopelessly cute) and therefore manageable, for an unhurried existence where meaningful reflection and a sense of community seem still possible. Wilson's "decorated" trash is trash à la Biedermeier, in other words, it is quaint domesticity and provincial calm suddenly transplanted into the streets. It is as if a Victorian lady had suddenly and inexplicably decided to give away her pricey bibelots, and to throw them onto the masses, as one throws candy at children. Only, these are bibelots and candies made out of trash. And it is trash, ultimately, according to artists like Wilson, that "humanizes" (and to a great extent also "domesticates") fierce industrial production. Wilson's art is an intriguing (or perhaps not so intriguing) mixture of

Fig. 2.9: Jason Kronenwald, *Gum Blonde XI*, 2004, Chewed bubblegum on plywood sealed in epoxy, 24 by 32 inches. Photo by artist.

Fig. 2.10: Jason Kronenwald, *Gum Blonde LVIII*, 2008, Chewed bubblegum and gum wrappers on plywood sealed in epoxy, 16 by 22 inches. Photo by artist.

radical environmentalism and conservative holding-on to middle-class paraphernalia and art, such as "gum bibelots" and "gum pics" that would look pretty on Biedermeier furniture, and enhance the children's "room with a view" in a Victorian home. Wilson's quaint "tackiness" (the German word *Kitsch*, and the Spanish concept "cursi," are perhaps more fitting here; Gómez de la Serna; Olalquiaga; Valis) stands in stark contrast to Jason Kronenwald's POP "*mauvais goût*" (Figs. 2.9 and 2.10). Both artists use bubble gum as their raw—and only—material, but whereas Wilson caters to one end of the chain of capitalism, waste, Kronenwald caters to the other end, serial production and consumption. And while Wilson finds isolated spat-out chewing gum here and there, Kronenwald produces it in great quantity; in

fact, he employs a number of assistants—"a team of chewers," one article calls it (Spooky)—whose sole task is to continuously and mechanically spit out generously salivated amounts of sticky "dough." With it, Kronenwald then literally "kneads" portraits of female celebrities, from Marilyn Monroe, Dolly Parton, Paris Hilton (Fig. 2.9), and Britney Spears, to Hillary Clinton and Lady Di (Fig. 2.10). Kronenwald's "Gum Blondes," are all gum (or plastic), but, rather ironically, of the unaltered kind. Unlike Wilson, who submits bubblegum to a complicated process and adds color it, Kronenwald never dyes his kneaded portraits. The various hues and tones come from the different kinds of chewing gum. Kronenwald likes the "natural" look of his gum blondes and shuns makeup.

Repetition, Context, Nature: The Ontology of Urban Trash

It is important to note that not only commodities—such as Kronenwald's serially chewed gum beauties—but also waste products are obstinately redundant when it comes to materials, shapes, and colors. Tossed collapsible metal tubes (as the ones reproduced in Fig. 2.4), but even more so spat-out bubblegum, discarded plastic cups (Fig. 2.2), plastic bags, plastic forks (Fig. 2.12), and latex gloves (latex also takes an inordinately long time to decompose—Fig. 2.11), repeat themselves ad nauseam across continents. Repetition strongly appeals to humankind. The allure of the serial and the indistinguishable is irresistible (as irresistible as gum blondes) and reveals itself in the triumphant sense of wonder around twins that are born truly "identical" and in the media frenzy around successfully cloned "sheep Dolly," but also in the lasting fame of Andy Warhol's famous Campbell's Soup can painting.

In the realm of the discarded, though, repetition has more complex connotations than in the area of production and consumption. For one, garbage is repetitive and overwhelmingly so, yes, but never identical. Trash—unlike blondes made out of on the spot-chewed bubblegum, newborn twins, freshly cloned sheep, or tomato soup just arriving from the canning plant—has "lived," and life has left indelible marks on its once pristine "skin." Even abandonment and decay "attack" rubbish differently. Fig. 2.11 shows two discarded latex gloves—one blue, one white: there is variance right there—"moving" and arranging their "fingers" in quite different ways, and conveying opposite emotions. The white glove seems relaxed, or at least resigned to its "thumb-less" fate, whereas the blue glove seems miserable, its fingers mutilated and violently distorted. The plastic forks in Fig. 2.12 tell a similar

Fig. 2.11: Filomena Cruz, photographs. *Roadkill Series*. Los Angeles, CA.

Fig. 2.12: Filomena Cruz, photographs. *Roadkill Series*. Los Angeles, CA.

story to the latex gloves in Fig. 2.11. One is only slightly damaged, the other has lost all its skewers, some of them still lying around. "Crime" and mutilation seem recent, and a dark spot eerily mimics the fork's original shape, a phantom limb that still hurts.

Trash is "diverse" in its repetitiveness, because life has shaped it and infused it with emotion, and also because litter does not happen in a void. This, in fact, applies not only to isolated pieces of litter here or there, but also to large-scale waste and mega-trashscapes. Landfills and trash heaps are all very similar, with their predictable share of dirty diapers, stained mattresses, and plastic bags, but radically different also, not only because time has aged, deformed, and mutilated all these discarded artifacts in various and divergent ways, but because each landfill—each pile of trash, wherever it happens—showcases refuse in infinitely changing and capricious combinations that are history-laden and emotionally charged.

As Jeff Ferrell puts it, "the jumbled juxtaposition . . . of discarded items . . . are absurd in their own right: in the trash pile, discrete dimensions of people's lives collapse into one another, the long sweep of cultural history compresses into the present, and fine distinctions between old silver cups and aluminum cans, office supplies and sports gear, get lost" (18).

Also, and even beyond massive accumulation of rubbish, there is an ever-changing "context" to trash, very different from the serial monotonousness of capitalist production and consumption, and of supermarket aisles and shelves lined up with soulless tomato soup cans. Take beach trash, for example, one of the shameful realities of our contemporary world, and a crime against the environment. So as to make this even more apparent, more often than not washed up pieces of discarded plastic densely intertwine with algae—note the plastic fork (yet another plastic fork!) who mistook them for

Fig. 2.13: Filomena Cruz, photographs. *Dangerous Beauty Series*. Venice, CA.

linguini—or silently and guiltily mourn the death of birds (Fig. 2.13).

Images, many of them particularly forceful and heartbreaking, of beach trash in close and often deadly embrace with marine nature and fauna are widespread and easily "googleable"—Chris Jordan's film project and trailer *Midway: Message from the Gyre*, and particularly the film stills of the plastic-filled bellies of dead albatross, have shocked the world—but the equally frequent and recurrent phenomenon of nature

and trash becoming close companions (and strange bedfellows for some) on city streets and sidewalks has been barely documented and largely ignored by the art milieu (Fig. 2.15). One notable exception is Catalan artist and activist Ester Partegàs, whose 2005 installation, *Life Is Tremendous*, reproduces the common scene of trash littering urban greenery (Fig. 2.14). According to the gallery description where Partegàs's piece was first exhibited, *Life Is Tremendous* is "a sculptural simulation of an advertisement stand. The sculpture's enameled structure, made of wood, text, and paper, is supplemented by handmade trash sitting in a flower basket. While the mismatch between the upbeat, over-the-top advert and the austere structure and dark tones of the stand suggest the failure of corporate intent, Partegàs also suggests unforeseen spaces of personal agency and appropriation" (Foxy Production).

The description portrays a viewer (like the museum visitor on the image) once again accustomed to looking up or ahead rather than down, a modus vivendi that somewhat contradicts the artist's own practice. Increasingly, and more notably so in her most recent works, Partegàs focuses on trash, and her eyes search the ground, instead of scanning the urban skies for billboards and corporate advertisement paraphernalia. The fact alone that the artist put so much effort into making trash look "real" in all its staged artificiality, speaks to Partegàs's deep interest in trash as an essential part of reality, and to the all but ancillary role garbage plays in her art, as does the rather enigmatic "slogan" "Life is tremendous," a literal translation, I suspect, of Spanish or Catalan, "la vida es tremenda," a common exclamation uttered among Spaniards and Catalans to express dismay about the harsh realities of life. "La vida es tremenda," not only because

of the exploitative practices of aggressive corporate marketing, but mainly because of the criminal irresponsibility with which we relentlessly soil and destroy nature. The gallery description of Partegàs's 2005 installation fittingly points to "the mismatch between the upbeat, over-the-top advert and the austere structure and dark tones of the stand," but, surprisingly, no mention is made of the profusion of trash littering the "flower basket," nor of the rich complexity of colors, textures, and shapes that meaningfully enrich and complicate the lower section of the installation piece. Trash and nature are a fundamental part of the piece, with their own aesthetic, ideological, and political gravitas, and certainly there not only to merely enhance the simplicity of the stand. Rather than a backdrop or a "flat" character with nothing to say, nature-soiling trash stands out as the vivid and direct consequence of capitalism and the depredatory marketing practices that create unbridled consumerism coupled with limitless waste production. Thus the advertisement stand becomes the mirror image of the accumulated trash below, the part of the story that nobody wants to disclose or read, because it would make one realize, against one's will, that "life is tremendous" indeed.

Artists invent very little and never really create from scratch, since the world has everything they need, both in the shape of things and of ideas. Artists know how to look, however, and when they set their eyes on the ground, the "nature-garbage combo," recreated by Partegàs and overlooked by critics, lies there ready for them, openly displayed on the streets (Fig. 2.15). Like beach trash, urban trash too is drawn to nature, and like the beach, the city also is a consummate artist. The picture series in Fig. 2.15 portray the discarded artifacts as they were

Fig. 2.14: Ester Partegàs, *Life Is Tremendous*, 2005. Courtesy of the artist and Foxy Production, New York.

Fig. 2.15: Filomena Cruz, photographs.
Roadkill Series. Los Angeles, CA.

Fig. 2.15 (continued)

found by the photographer (me, or Filomena Cruz rather, since this is my nom the plume as a trash artist and collagist), the beauty of the discarded attuned to nature stark and undeniable. There is subtleness, a breeze-like cadence, reminiscent of Oriental aquarelle paintings, in the delicate curvature of the tea-bag string and in the meandering of the red drinking straw. Beauty also comes from the mirroring effects of trash (the dark blotch on the pavement—probably one more spat-out and many times stepped-on bubblegum—and the twig "mimic" and prolong the shape of the red lollypop), and, more importantly, from the uncannily harmonious conflation of two seemingly opposite concepts, the urban and the natural. Both city and nature generate waste (trees and plants shed twigs, flowers, and leaves, passersby toss tea

bags, can lids, and chewed candy), and both nature and city mirror each other and fold into each other on the pavement (or on the beach). The golden leaf delicately embedded into the brightly pink chewing gum in the last picture of the series is a particularly masterful example of symbiotic and artistic serendipity.

The Taxonomy of Trash: The Archive and the City

Trash is beautiful. Trash is ubiquitous and immortal. Trash is repetitive—the natural consequence of the monotony of global production and consumption—but trash is also stubbornly diverse and idiosyncratic: time corrodes and fossilizes rubbish in different ways, and spatial context—such as

nature-litter encounters on sidewalks and shores, or the unexpected and poetic/ dystopian landscapes that result from "combining" and piling up garbage—routinely modifies and enriches its meaning and countenance.

Trash is also a challenge to humankind, not only because it soils our planet, but—for reasons this time more philosophical than environmental—because it openly defies our uncontrollable urge to impose order and taxonomy on the world. Artists have essayed various attempts at "organizing" and even archiving trash, often with an ironic smirk on their faces, for the point they all want to make ultimately is that trash is indeed unclassifiable.[3] Still, they keep trying, as Alice Bradshaw's online Museum of Contemporary Rubbish (MoCR) discussed in Chapter 1 cogently shows. Other examples are Jeff Ferrell's found "two old fifteen-drawer library card catalogue cabinets" in *Empire of Scrounge* (86), and Nelson Molina's East Harlem collection *Treasures in the Trash Museum* ("One Man's Trash").

After quitting his job as a tenured professor at "a large Arizona university" (1) in 2001, cultural criminologist and urban ethnographer Jeff Ferrell "settles down in [his] old stomping grounds of Fort Worth, Texas" (1). With a meager income coming only from book royalties, and "a gap of eight months or so until [he] might or might not locate the next academic position in the fall of 2002" (1), Ferrell makes the following, rather unconventional decision: "Given my long-standing personal and scholarly interest in the often illicit worlds of scrounging, recycling, and secondhand living, [I decided to] survive as a Dumpster diver and trash picker" (1). Sure enough, and as the book on his scavenger existence, *Empire of Scrounge*, amply documents, Ferrell is able to secure a living by collecting trash. Thus,

early in 2002, Ferrell rigs "an old, fifteen-dollar black-and-white Schwinn bicycle with a secondhand front basket and some extra bungee cords for the back deck, and [sets] out mostly on this bike, other times on foot, to see what [he] could find" (2). And what he finds one afternoon, "rolling the Mistletoe Heights neighborhood" and "already carrying a large load of copper wire and extruded aluminum" (89), is first "a pile of six or eight cardboard boxes sitting on the curb between two expensive homes . . . mostly full of books" (86), and then, only "two blocks down the street, . . . two old fifteen-drawer library card catalogue cabinets" (86). He quickly cycles back home, gets his old truck, and

> struggles to load [the cabinets] into [the] truck bed; sturdily built from oak and oak veneer, they are all I can handle. But I do get them home and, installed in my shed, they make ideal containers for categorizing and storing scrounged items. In fact, a month later, the little labels I've made out of scrounged paper and slipped into the brass holders on the front of each drawer reflect something of the empire of scrounge, and its range of salvageable objects. They read: old gas valves, brass doorknobs, door lock parts, drill bits, files and rasps, springs and spacers, switch plates, sockets and socket wrenches, writing pens, staplers and staples, light bulbs, auto parts, window locks, old handles, bar/rack mounts, gun supplies and bullets, flatware, small glassware, hand tools, baseball cards, and eyeglasses. (86–87)

The first thing one can't fail to notice when confronted with Ferrell's supposedly "organized" cabinets is that they are all but that. A loose jumble of mostly metallic objects and tools, the actual contents of the

cabinet drawers could not be more different from their prior "cargo," namely, the pristine and regimented order of yellowed paper cards blindly obeying the rigid dictates of the Library of Congress. Scavengers give discarded artifacts a second life, as is commonly said, but one that forces reclaimed rubbish to radically "reinvent" itself. Or perhaps not? After all, the discarded books that Ferrell retrieved from the boxes only two blocks away from the library cabinets had all been authored by males (Elliot Liebow, William Foote Whyte, Herbert Marcuse, John Dos Passos, William S. Burroughs, Dietrich Bonhoeffer, Friedrich Nietzsche, Henrik Ibsen, Martin Heidegger, Gabriel García Márquez, and Billy James Hargis), and it is not farfetched by any means, alas, to imagine that the library cards in those old cabinets also housed a predominantly male cohort. Which makes us ponder if the 2006 cabinet inventory is so different after all from the one dating back probably to the 1940s and 1950s: Ferrell's reclaimed trash is clearly a treasure to a hefty number of males, but less appealing to women. Studies in the newly emerging field of waste management and gender have shown that the perception of trash and the value attributed to it is heavily conditioned by gender, which means that men and women look very differently at a pile of trash, which in turns affects their scavenging styles and their selection and recycling patterns (Furedy; Muller and Schienberg).[4]

Order is relative, and the concept and definition of an archive exasperatingly fluid and open ended. But what remains a fact, and becomes vividly apparent in this "library-cabinet-transplanted-into-a-shed case study," is that the artisanal manipulation of artifacts, and perhaps even more so of objects rescued from destruction and oblivion, influences taxonomy, and probably contributes

to a more sophisticated archival system. To manipulate an object means to get to know it better, and thus to get a more accurate sense of what category it really pertains to. Knowledge—profound knowledge—comes from a broad engagement with the senses. Seeing improves through touching, and vice versa. And emotion enhances the intellect: Ferrell knows "his trash" (and how to best classify and archive it), because he is emotionally, intellectually, and physically engaged with it. He made an effort to see it—trash is invisible, and only people who want (or need) to see it, see it: society's poor and disenfranchised, city administrators, urban ethnographers, scholars, and artists—and then took further pains to rescue, repair, and classify it. Heart, mind, and hands (probably in that order) are all involved in the process, and, admittedly, also male pride and the sense of accomplishment that comes with the tangible success of making (or remaking) things:

At the same time as describing the second life of cupboards and filing cabinets, writing materials, photographic equipment, lighting fixtures, tools and time-pieces, Ferrell details the "little configurations of skill and practice" that are required to work scrounged goods into usable or profitable forms. Here he uses the language of workmanship to convey both the intimacy and the craft that underscore the scrounger's relationship with material waste. Items that are not immediately usable or sellable are subjected to "skinning and harvesting, stripping and ripping" as the skilled scrounger separates the objects into different gradations of value. Doorknobs are "skinned" to detach the valuable brass shell from the much less valuable steel or tin interior. Television antennas are "ripped and clipped" using

wire cutters to harvest their extruded aluminum components from their steel mounting plates and bolts. Wire is "stripped" of its plastic exterior to reveal the shiny, valuable copper by pushing the knife blade along a taut length of cable. (O'Brien, 110)

Overwhelmed by the "inundating surplus of objects and materials (the majority of them not 'trash' in any conventional sense, but useful, functional, desirable, many times unused and unmarred)," and utterly mesmerized by the "magnificent . . . eruption of scrounged objects from trash bins, trash piles, and city streets" (17), Ferrell feels "tempted, in hopes to communicate . . . the magnitude and variety [of trash], to report it as one long list, one long stream-of-consciousness epic beat poem of waste and discovery" (17):

Hammered aluminum serving trays, sterling silver baby cups, clock radios, soft clubs.
 Old lamps and new.
Video cameras, video tapes, pornography, piles of CD's and cassette tapes,
 baby doll shoes, silver candle holders.
Antique mirrors and antique picture frames, old family photos, old hand tools and new
 power tools, skate boards.
Watches, jewelry, and ash trays.
Baseballs, softballs, basketballs, tennis balls, plastic Easter eggs.
Waterproof crystal clocks and big black coffeemakers.
And the money—mostly coins, and no need to wade a fountain.
Coins, coins and dollar bills and five-dollar bills in the streets, in the gutters.
Pennies mangled by traffic still spend.
Liberian five-dollar bills and a Bank of Ghana note in an old
 suitcase, pennies and dimes and quarters in the
 intersections, settled to the bottom of garbage
 bags, in discarded purses, in the
 drawers of old dressers on the curb.
Cameras: the Olympus at the bottom of a garbage bag,
the old mid-century
 Fotron III still in its curved leatherette case.
 Telephoto lenses, film canisters.
Clothes to clothe me and my friends and folks at the shelter.
Nieman-Markus sweaters, little silk scarves.
Polo suits and Henry Grethel, dress shirts, jeans, shoes.
 Oshkosh for the kids.
File cabinets, turquoise chairs, Vermont Maply Syrup and bottles of booze.
Cut glass door knobs and Mardi Gras beads and boxes of bullets.
Books-trashy paperbacks, clothbound first editions.
A bejeweled book on Italy, circa 1907.
License plates, Texas 1949, Mississippi 1969.
Fishing rods, fishing reels, and a little blue Tiffany & Co. box.
More toys than I can haul home. (17)

Ferrell's epic chant on trash would have filled fifty pages of his book, if it had not been for his editor's insistent advice to reduce it to one page. But even such a small portion of it suffices to highlight the two countercurrents—the constant push and pull—that define the relationship of humans with their own, self-inflicted filth. *We want to control it; it wants to be free* (Sigmund Freud's reflections on anal retentiveness come in handy here). One would imagine that the poem's sole purpose (as explicitly announced by the author) is to render homage to limitless overflow and *Mischmasch* absurdity, in the same way in which the main goal of the episode on the scrounged library card cabinet supposedly was to present the other side of the story, namely that there are means indeed of storing, classifying, and therefore containing excess.

However, the freedom song soon gives way to constriction and either conscious or unconscious attempts at taxonomy, in the same fashion in which the promise of order turns sour when it comes to the library cabinet. Labels carefully slid into fancy brass holders on drawers do not dispel the sense of chaos, nor does the jumbled and versified accumulation of things discarded convey any sense of unbridled liberty. Ultimately, Ferrell's poem is a "sensible" list clinging to the draconian principles of capitalist organization, not the free flowing of Surrealist *écriture automatique* or the hilariously illogical, crazed, and over-the-top accumulation of debris. It is an inventory more set on rational classification than inebriated with free association. A half-assed poem, in sum, that looks more like a sterilized store with commodities carefully arranged on shelves and by aisles than the stinky mess of a dump. Everything appears as carefully grouped and matched: Video equipment ("Video cameras

and video tapes"); Sporting goods ("baseballs, softballs, basketballs and tennis balls"); Cameras ("the Olympus at the bottom of a garbage bag, the old mid-century Fotron III still in its curved leatherette case./ Telephoto lenses, film canisters"). Even the money ("mostly coins, and no need to wade a fountain./Coins, coins and dollar bills and five-dollar bills in the streets, in the gutters./ Pennies mangled by traffic still spend./Liberian five-dollar bills and a Bank of Ghana note in an old/suitcase, pennies and dimes and quarters in the intersections, settled to the bottom of garbage bags, in discarded purses, in the/drawers of old dressers on the curb") has been lumped together in the text, so that it becomes difficult for the reader not to picture a bank instead of a poetic creation.

Ferrell's poem is squeaky clean, never malodorous: that says it all. Ferrell is not a poet, or a romantic; he is a tinkerer and a pragmatist. He does not like the old and useless in trash, but the hidden promise of the still new and functional. Ferrell is not in love with trash, but enamored with his skilled self. Discarded objects are toys ("more toys than I can haul home") and boys, overgrown ones included, love toys—and tools: "old hand tools and new power tools"—to futz with.

Nelson Molina's collection *Treasures in the Trash Museum*, has a very different approach to trash retrieval. A sanitation worker in Manhattan, New York, Molina has collected his trash items for over twenty years, saving it from landfill death. But, unlike Ferrell, he does not manipulate discarded artifacts, nor does he try to find buyers for them. He "just" keeps and collects and classifies them, because doing so in great part legitimates his own work and elevates his sense of worth. Molina's social and professional standing is very different from Ferrell's.

Being a sanitation worker for roughly a quarter of a century is certainly not the same as being a professor and scholar who, primordially for research purposes, chooses to become a Dumpster diver during a meager eight-month interlude between academic jobs. Mierle Laderman Ukeles was the first artist—or "maintenance artist," as she proudly likes to call herself—who became painfully aware of the profound stigmatization and "invisibility" of sanitation workers.[5] Hence, her famous artistic intervention *Touch Sanitation* (1977–1980), where, for a whole year, she shook hands with over eighty-five hundred sanitation workers, while greeting each of them with the phrase, "thank you for keeping New York City alive." Like the myriad of sanitation workers whose work Laderman Ukeles publicly admires and honors, Molina also keeps his neighborhood alive by cleaning it, but then he goes one step further and lovingly arranges its trash trophies. Molina's collection and preservation practices take waste management to a new level. Sanitation workers are now the restorers and keepers of urban memory. Eric Grundhauser's "Treasures in the Trash Collection" describes it:

> Secreted away on the second floor of the MANEAST11 garbage truck garage is an ever-growing collection of strange items that have been plucked from the trash, and while it is not open to the public it is populated by their stuff. The collection was started by a single sanitation engineer by the name of Nelson Molina who started plucking treasures from his route over 20 years ago with the simple intention of giving his corner of the garage a little flare. However his hoarding quickly caught on as some of his fellow coworkers began adding weird little pieces to his collection. Everything from exotic lamps to fake flowers to pieces of pop kitsch are carefully extracted from the deluge of upper Manhattan waste, but everything that is admitted into the collection is approved by Molina. The museum is not organized in any formal way but Molina tends to group the pieces by size, general theme, and color making it seem like more of a hoard than a collection. "Stealing" things from the trash for personal use is a big no-no in the world of sanitation, but since the whimsical collection is for the private viewing of the workers, Molina's lovely hoard has been allowed to remain. Anyone wanting to take a look at this treasure trove of lovely cast-offs can get in touch with the city to request access, but sanitation workers are allowed any time.

Molina's one-of-a kind museum is not only the puzzling repository of contemporary Manhattan's throwaway frenzy, but a therapeutic retreat center endowed with strong healing properties. It grants restricted access to outside visitors but is open anytime for sanitation workers, making it a space to reminisce, to congregate, and to revel in a sense of community and shared experiences. And, as is the case routinely with archives and collections, it is a shrine to memory where powerful individuation takes place. When an object becomes "useless" and inert, and when production and consumption are replaced by nonprofitable contemplation, it becomes an "individual," something (somebody, really) with its (his or her) own idiosyncratic features. Even "serial" objects retrieved from what I like to call "Jurassic e-waste" (like the writing machines from Molina's collection in Fig. 2.16) turn into "little people" with aging bodies, a past,

Fig. 2.16: Allison C. Meier, photograph taken at Trash Museum.

and a story to tell. Discarded objects that become collectibles thus are disenfranchised and abandoned creatures rescued from the margins. They awaken our empathy, but mostly, they fuel self-compassion. Irrevocably, we see ourselves, and our own, marching-toward-death lives, in them.

It is important to note though that self-recognition is possible only if the mirror we put in front of us is clean, for we dread (and this is deep-seated fear) that a surface covered with filth will obscure our image, and make us as unrecognizable and repellent (to ourselves and others) as putrid corpses or decomposing garbage. Thus, the painstaking effort Molina devotes to cleaning and carefully grouping his pieces "by size, general theme, and color," as Grundhauser notes. Traditionally, the less affluent, and particularly the ones that hold "dirty" jobs, have cleaned up and dressed for Mass and

festivities because cleanliness and "proper" attire restitute their dignity and their social legitimacy (their visibility, in brief), if only for a day or even just for a couple of hours. Partly, Molina sanitizes and arranges his collection for the same reason. And, for the same (or perhaps diametrically opposite) reason, *nonchalant* aristocrats routinely dress down for public events (their self-assured gravitas certainly does not precariously depend on textiles), and sophisticated artists from the haute bourgeoisie choose to haphazardly fill a museum space with trash and to call it "ART," with capital letters. Examples are many, starting with Gerard Deschamps's various and not always successful attempts during the 1960s at exhibiting his "own soiled underwear, often resembling shriveled flesh" or female lingerie "wrapped into bulky assembled forms" (Whiteley, 116), or, more recently, the installation *The Greater*

Fig. 2.17: Filomena Cruz, photograph. Santa Monica, CA.

Rubbish Vortex, whose base—just a garbage pile—is made with "four years' worth of curators Margaret and Christine Wertheim's domestic plastic trash" (Institute for Figuring; see Fig. C.1 in the Conclusion). Another example is Enrique Jezik's *Reubicación de Materiales* (*Materials Relocation*, 2006), an exhibition space intervention during which five dump trucks entered the gallery space one by one and unloaded rubble and other construction materials on the floor.

Artistic interventions built around trash piles à la Wertheim and Jezik immediately indicate that we produce too much rubbish and that it soils our planet. But the photograph in Fig. 2.17 transcends the meaning of trash (in this case, the "refuse" homeless people so often carry with them in shopping carts) and its effect on our surroundings. Here, trash relinquishes its literality and becomes a symbol for something else. As in the case of Francisco de Pájaro's street art, it speaks directly and unabashedly of poverty and social inequality (and only tangentially about

the environment), but it says more than that. The message it ultimately conveys is that the momentarily absent owner of the shopping cart and its contents is "dressing up," and embracing the values of dominant bourgeois society in order to gain some degree of legitimacy. Look, his or her carefully arranged belongings say, I am not dirty (and therefore, I am not bad), I am only temporarily out of luck, I don't belong on the streets. In fact, I know how to keep my "home" clean, and I am away now because I am either working, or looking for a job. Like the *Treasures in the Trash Museum*, the precarious but pristine dwelling of the homeless is all about belonging, self-worth, and dignity. It is all about "fitting in." There are not too many rebels or philosophers among sanitation workers and the disenfranchised. Only very few rise (or fall rather) to the level of Diogenes of Sinope, the Greek philosopher and cynic, son of a banker, who voluntarily and defiantly embraced poverty and filth, earned a living as a beggar, often slept in a

big ceramic jar on the streets of Athens, and made a point of defecating and masturbating in the open.

The dream of upward mobility and social status becomes apparent not only in the meticulously folded and stored possessions of a homeless person in Fig. 2.17, but in the growing number of fully operational electrical appliances that are left for grabs on sidewalks and curbsides (Figs. 2.18 and 2.19). The sign squeezed between the handle and the freezer compartment ("Works well") and the one glued to the TV screen ("I work!") are boastful proclamations of wealth that barely hide the tragedy of cruel abandonment underneath so much arrogance and privilege. Once again, reality imitates fiction, for (not unlike the still functional but outmoded domestic appliances/characters in the popular 1987 American musical comedy-adventure film *My Brave Little Toaster*), "real" discarded refrigerators and TVs also make it pristinely clear that they work, never died on their owners, and therefore don't belong in the dump. The TV in Fig. 2.19 certainly is as alive and loquacious as the little toaster and protagonist of the aforementioned film, when it advertises the rich variety of shows it will bestow on the merciful soul willing to put a roof over . . . its screen. Just take me home, the TV is saying, grab the remote control (as you see, it is included), and you will be able to watch "cooking shows, porno, *Family Feud*, *Sesame Street*, football, boxing, *Judge Judy*, *Property Brothers*, *The Dog Whisperer*, *Game of Thrones*, Netflix and documentaries, *Home Shopping Club*, *Shark Tank*, and more! (Not on flat screen, though.)

Thill perceptively suggests that often,

waste is an orphan object . . . , exist-
ing somewhere outside of both the

free-floating state and [landfill] entomb-
ment, at least for a time. Sometimes it lodges. It begins to establish itself in the neighborhood; it starts to accumulate squatter's rights. It is clearly garbage but it isn't going away as garbage is supposed to. The trash familiar troubles the line between our endlessly transient waste, blown here and there, and our cold stor-age. It threatens to become a fixture. . . . [Waste] spread[s] [its] fetor far from home, because in truth [it has] no home, in the same way that all undesired things lack a home. (23)

The refrigerator and the TV in Figs. 2.18 and 2.19 certainly appear to us as orphans, unwanted artifacts about to turn into a "fix-ture" on sidewalks (Krotzer Laborde). They don't have a home, but, not unlike runaway children sleeping on the streets, they continu-ously project the powerful image of an un-happy and frigid household onto others. The home that doesn't want them anymore lies heavily on their back and slows down their movements. It makes us pause also and forces us to look at these tragically oxymoronic snail-creatures (runaway children, discarded appliances) weighted down by a house stuck to their memory (and feeding ours), but that ultimately refuses to provide shelter.

Unavoidably, the discarded comes with a narrative fueled by the trauma of aban-donment, and always opens a window into a time (the past) and a place (a home) that is no more. Expelled and orphaned arti-facts, however, see, and live, beyond preterit times. They paint the present in stark colors and, ironically enough, offer a vivid and un-failingly accurate picture of the interior to which they have no access. For in the dull white surface of the outmoded, "homeless" refrigerator we immediately recognize the

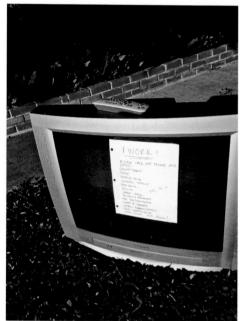

Fig. 2.19: Filomena Cruz, photographs. Los Angeles, CA.

Fig. 2.18: Filomena Cruz, photographs. Venice, CA.

gleaming silvery shine of stainless steel and the sleek lines of state-of-the-art appliances, and in the clumsy bulkiness of obsolete TV design littering the streets, we fathom the fashionable slimness of flat screen technology. As Guido Viale cunningly observes, "trash constitutes a world of its own," but it is one that is "complex and symmetrical to the world of merchandise" (quoted in Vergine, 11).

The mirroring nature of the unwanted and the excluded, and the cunning ability of outsiders to grasp and transmit with minute detail what is happening behind walls, is not a new phenomenon; in fact, it is one of the most clichéd as well as stubbornly effective strategies of melodrama and kitsch (the orphaned boy, shivering in the cold, his bare feet deep in snow and his stomach tied in hungry nots, catapults the reader through a warmly lit window and into a lavishly furnished room, where the rich boy indolently plays with his toys and lazily stretches and yawns in the glow of a burning fireplace, etc.). But, although the discarded appliances in Figs. 2.18 and 2.19 are hardly original when they speak the language of melodrama, they do strike a less trite cord when they lead the audience back from waste to consumption. Intriguingly, or perhaps not so intriguingly, the connection between massive serial production, patterns of consumption, and waste generation remains tenuous in cultural and artistic representations and is also noticeably absent—at least in an explicit and deliberate fashion—from museums and archives of trash. It is present, though, in "real" objects, such as the discarded TV and refrigerator, two perfectly functioning pieces that should not be trash (that, technically speaking, *aren't* trash, since they remain operational), but that become trash because the pattern of

relentless consumption declares them obsolete and thus useless: garbage, in brief.

Just by standing aimlessly on the street, discarded but operational home appliances—and precisely because they are discarded *and* operational—powerfully speak of the dizzying cycle of production, consumption, and excretion.

And so do two very concrete artifacts—a trash container and a shopping cart—when they manage to find each other, something that, in truth, occurs quite often. Filomena Cruz was able to take a number of "portraits" of the odd couple during my frequent LA strolls (Figs. 2.20, 2.21, and 2.22 are only three examples out of many), but artistic depictions of that particular motif remain scarce. Cruz identified one painterly depiction of this particular motif or trashscape, buried underneath of a jumble of "bad art" in an obscure thrift store somewhere in

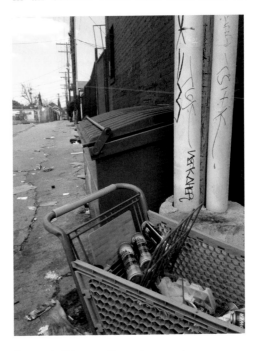

Fig. 2.20: Filomena Cruz, photograph. Los Angeles, CA.

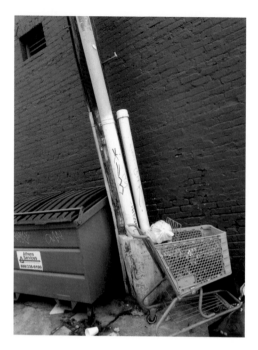

Fig. 2.21: Filomena Cruz, photograph. Los Angeles, CA.

Fig. 2.22: Filomena Cruz, photograph. Los Angeles, CA.

downtown LA (Fig. 2.23), and one artistic photograph, tinted with burlesque undertones (Fig. 2.24). In the painting (Fig. 2.23), the direct correlation between consumption and the generation of waste remains tenuous at best. A toppled-over trash can and the shadowy silhouette of a shopping cart on a deserted beach speak more eloquently of poverty and homelessness than of consumerism, and so do Cruz's pictures (Figs. 2.20, 2.21, and 2.22). Gregg Segal's photograph (Fig. 2.24), on the other hand, which is part of a whole series with the "trash clown" as the protagonist (Feinberg), is more adroit at linking consumption to excretion. The close proximity of the shopping cart to trash glued to a costume has the unexpected effect of diluting its "garbagy" nature. Suddenly, the discarded items (a soda can, a water bottle, a cigarette pack) look very similar to the commodities in the paper bags. By the same token, the just-purchased items seem less reassured in their value, and the downward trajectory into rubbish dangerously near.

Border Trash: Archiving Immigration

The various photographic reproductions, paintings, archives, inventories, and museums discussed above have shown that refuse (a) is inextricably engaged in a (routinely silenced and ignored) affair with consumption (Figs. 2.20, 2.21, 2.22, 2.23, and 2.24); (b) reflects on itself, and also on the lethal effect it has on the planet as mighty invader and colonizer (Ferrell; Wertheim; Jezik); (c) often turns into the repository of collective memory (Bradshaw; Molina); and (d) speaks volumes of social inequality, exclusion, and the dream of upward mobility (the *Treasures in the Trash Museum*; the "oxymoron" of a tidied homeless "household" in Fig. 2.17; the discarded but working electrical appliances

Fig. 2.23: Filomena Cruz, photograph of an anonymous thrift store painting. Los Angeles, CA.

Fig. 2.24: Gregg Segal.

in Figs. 2.18 and 2.19). In all these examples, efforts at representing and archiving are geared toward the trash that litters the urban landscape and leaves marks on the city's epidermis. Other archives and representations, however, collect and depict refuse found in (liminal or transitional) natural settings, such as national borders and frontier landscapes. So-called border trash (also known as "desert trash" or even "migrant trash") becomes the sought-after "collectible," for example, in (1) Jonathan Hollingsworth's reasoned inventory of rubbish left behind by undocumented immigrants trying to cross the deserts of southern Arizona (*Left Behind: Life and Death along the U.S. Border*, 2012); (2) the archive of discarded migrant goods and use wear that serve as the basis for the ethnographic and archeological study of undocumented immigrants' border-crossing ordeal in Jason De León's "Undocumented Migration Project" (UMP); (3) photographer Thomas Kiefer's *El Sueño Americano Project*; and (4) photographer Richard Misrach and composer Guillermo Galindo's artistic intervention *Border Cantos*, about objects lost and found along the northern US-Mexico border.

Popular culture, particularly films and video games, have consecrated the image of the desert as giant dumping ground/cemetery, filled with the postapocalyptic remnants of transportation technology gone obsolete. "Monumental" desert trash (rusty monster trucks with missing wheels, abandoned RVs with broken windows and shreds of curtains swaying in the hot wind, twisted and charred metal structures of unidentifiable origin) haunts our imagination, and our reality. Thill notes how "in Sophie Fiennes' *The Pervert's Guide to Ideology*, the camera lingers longest on the emaciated carcasses of enormous airliners being slowly sunblasted

into oblivion in the Mojave Desert" (53). He is quick also to point out that

> the desert, as everyone knows, is where *they* bury things: the bodies of informants, NSA data collection centers, half-empty master-planned communities. Forcibly emptied of its native inhabitants in the nineteenth and twentieth centuries, the great southwestern deserts of the United States have since then been filled with nuclear test sites and toxic waste dumps, while the steady erosion of living wages has seen the great American desert become yet another site of astonishing suburban encroachment, as people flee the coasts and city centers they can no longer afford or abide. (53)

The new population, however, of "the great American desert" doesn't consist only of suburbanites looking for more affordable housing: hundreds of immigrants from Mexico and Central America traverse the desert daily, set up and later abandon their clandestine and transient camps, and leave behind a steady wake of litter. "In some canyons [around Otay Mountain, California] it looks as if hundreds of Hansels and Gretels have scattered trails of trash behind them, marking the route from Tijuana," the first sentence of Carey Goldberg's article "Scenic Mountains Scarred by Illegal Crossings" reads.

The "garbage crumbs" left behind by migrants stand in stark contrast to the large-scale refuse that "monumentalizes" the desert, in the form of giant truck carcasses, whole planes corroding in the sun, or toxic waste dumps surrounded by a stubborn aura of imminent danger. In comparison, "border trash," as it is often called, seems tiny and unassuming, similar in that regard to the inconspicuous litter that soils the urban landscape.

Anti-immigrant sentiment, however, hiding underneath the cloak of (pseudo)environmentalist discourse, is quick to aggrandize desert refuse, adorn it with landscape-transforming properties, and proclaim it an alienating topography. "Desert Trash: Illegal Immigrants' Impact on the Environment" (Oakes, 2007), "Illegals Immigrants Leave Tons of Trash in Arizona Desert, Devastating Environment" (May, 2010), "Mounting Border Trash Proves Alien Invasion Alive and Well" (Guzzardi, 2012), "Illegal Immigrants Trashing the Environment along Southern Border" (Pavlich, 2011) are only some of the numerous headings that "litter" the digital domain, and that provide a frantically xenophobic visual inventory of border trash topographies. Riverbeds, clearings, and makeshift paths across the desert suddenly trade "native" earthen tones for the "alien" colors of desert garbage (Figs. 2.25 and 2.26).

Mexican-born and Brooklyn-based artist Alejandro Durán's photographic oeuvre also emphasizes the landscape-transforming power of refuse. His trashscapes, staged in defense of ecology, albeit without xenophobic undertones, create "other geologies" (to use Daniel Canogar's apt term) remarkably similar to the ones frantically photographed by anti-immigrant "environmentalists" (Fig. 2.27).

Environmentalists, xenophobes that pose as ecologists, and artists whose work is infused by ecological ethics, such as Alejandro Durán, all apocalyptically agree that trash not only soils our planet, but is in fact acquiring geological proportions: waterways not only "carry" refuse but actually become rivers of trash; and garbage patches soiling the ocean grow into islands and even continents. Still, and beyond this basic assumption, Durán's trashscapes have very little to do with the litterscapes left behind by undocumented immigrants. For one, the selection of materials is radically different, and so is the imprint time has left on color and texture. Durán's monochromatic plastic refuse has been photo edited into shiny perfection, to the point that the gleaming red river made of beach buckets, shovels, and rakes seems to be flowing back to the store, instead of following its "natural" course to the landfill (Fig. 2.27). Durán's trash is oxymoronically "new" and pristine, whereas desert trash is old and worn and showcases different stages of decomposition and decay. Thus, as opposed to Durán's gleaming beach plastic, desert trash's unequivocal fate is the dump/morgue. In "an extract from [her] research diary, which [she] wrote on [an] evening after [she] participated in [a] so-called 'trash-hunt'"(16), Vicky Squire offers the following vivid description of a desert trash site:

A bit more exploring, off track (though tracks are not clear in this part of the desert), and we stumble across a large mass of what the activists call "trash." I estimate it is about 20 m squared, a mixture of old and new "trash." Along the way we have seen quite a few backpacks and water bottles, but not like this. Everything is bleached out in the desert—all the "trash" is the same color, grey-blue, washed out, and full of dust. This stuff is the same, but it also includes lots of fresh and bright colors on top. Newer backpacks, newer clothes. . . . Toothbrushes; deodorant; washing powder; cheap yet solid backpacks. Food wraps, beautifully embroidered. Empty water bottles, black and translucent. A leather belt. Children's shoes, warped by the sun. Sanitary towels. Underwear; jeans. Black bin bags. So much stuff. Fresh garlic—to keep the bugs and creatures away. (16)

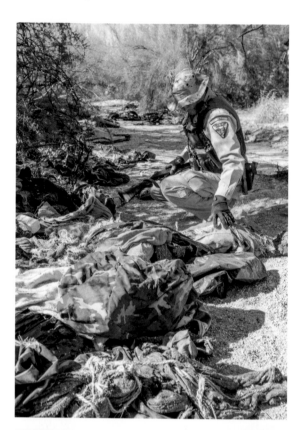

Fig. 2.25: Sonoran Roam, Courtesy of Bureau of Land Management. Arizona State Office (Public Domain).

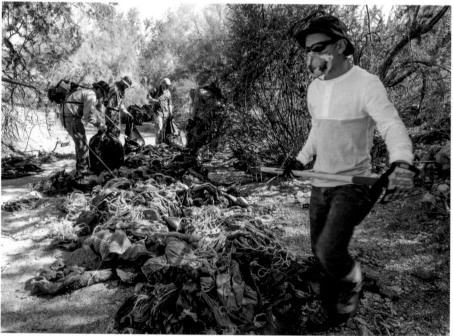

Fig. 2.26: Sonoran Roam, Courtesy of Bureau of Land Management. Arizona State Office (Public Domain).

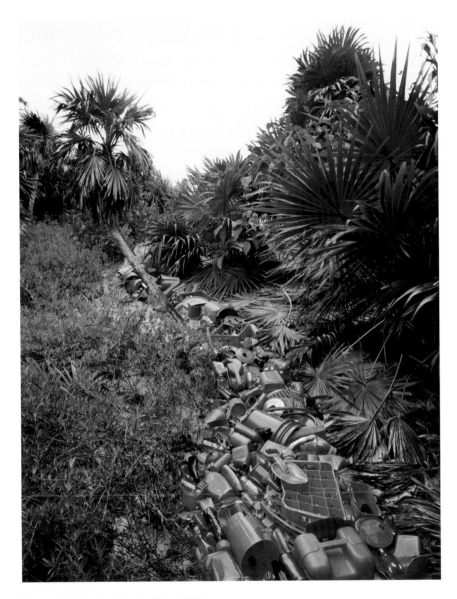

Fig. 2.27: Alejandro Durán, *Vena*, 2011.

Jason De León also includes a contemporary inventory of border crossing paraphernalia in one of his articles. According to him, "the goods now associated with border crossing include camouflage and dark-colored clothing, specialized water bottles, first-aid equipment (e.g. gauze, muscle cream, pain relievers), high-salt content foods, hydration

beverages, religious objects (e.g. prayer cards, votive candles), and many other items" ("Undocumented Migration," 324). Finally, as Squire explains, "migrant belongings are often piled in a heap, most likely at a pick up point where coyotes guiding migrants across the desert ask (or demand) that migrants leave behind anything that will identify them as

migrants" (16). Once again, the transformation of landscape and topography is the result of brutality. Topography-altering trash piles are the result of the imposition of coyotes, and a silent witness to abuse, where migrants are called "dirty," instructed to abruptly leave behind their unsavory past and experiences as desert crossers, and to "clean up" for the new country. As one of Squire's interviewees recounts,

> we think that people would walk the trail North, they'd hide out there, they'd wait for the car, or the SUV or whatever, to pick them up, on Arivaca Road, and the coyote would say: "alright you've just been walking through the desert for like a day and a half, let's try and look like we weren't; so everybody brush your teeth, put on your deodorant, put on your extra set of clothes that we told you to bring and drop all your shit right here, 'cause we are gonna pack as many of you into this Ford Expedition, or whatever, as we can." (16)

Violence—violence against the environment, in the case of mighty, nonbiodegradable plastic found on the beach; violence directed primarily against immigrants (and only secondarily against nature), as mutely but eloquently voiced via desert trash—is where Durán's artistic photographs and Squire's documentary diary entries find common ground. But beyond that, their paths diverge, for whereas Durán's main point is the powerful immortality of plastic and its effect on the environment, Squire's central tenet, and that of desert trash, is the frailty and death of disenfranchised humans. Two images of shoes (Figs. 2.28 and 2.29) will further contribute to elucidate the difference, and, more important, to identify the complex

semantics of archiving and artistically representing border trash.

Alejandro Durán's pink plastic sandals and slippers on a rocky beach in Fig. 2.28 are not as pristine as the red plastic in Fig. 2.27. In this case, signs of age and wear and tear, as well as the corroding effects of the ocean are clearly visible, and a sense of abandonment and sadness permeates the carefully selected and arranged "scene," reinforced by the small, naked doll foot on the lower left corner of the picture (Fig. 2.28). Sadness also dominates the photograph in Fig. 2.29, which portrays a pair of worn sneakers, one of the numerous immigrant belongings that anthropologist Jason De León has retrieved from the Sonoran desert as part of his "Undocumented Migration Project" (UMP). These migrant shoes, "recovered in the Tumacácori mountains," and repaired with the help of "a bra strap and cord to reattach the soles to the uppers" (*Land of Open Graves*, 181), are a compelling testimony of survival fueled by fear and desperation. As De León further explains,

> a shoe found in the desert that has holes worn through the sole suggests that a person's feet experienced intense trauma from walking, while a shoe whose sole has separated from the upper and that has been subsequently repaired with a bra strap indicates that the owner was desperate to keep her footwear functioning so that she could continue moving. . . . Those who can't keep up with a group because of blisters or worn-out shoes are often left behind, which can be a death sentence. (*Land of Open Graves*, 181)

For De León, "knowing of these phenomenon of abandonment, and then recovering destroyed or haphazardly repaired

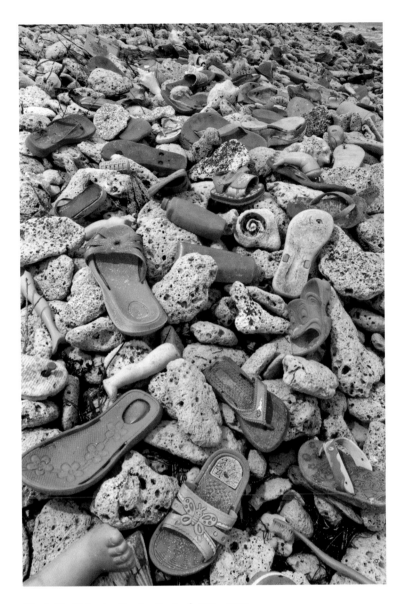

Fig. 2.28: Alejandro Durán, *Sueño de Niña*, 2010.

shoes in the middle of the desert can often be an emotionally challenging moment of archeological interpretation" (181). Thus, here we are confronted with two types of "collecting" and representing practices, one that is (relatively) painless, and one that not only is openly painful, but also aims at artifacts that bear the signs of the suffering of others. Granted, Alejandro Durán's ongoing series *Washed Up: Transforming a Trashed Landscape* is a somber reflection, openly acknowledged in his statement as an artist, on the alarming "reality of our current environmental predicament," and on "a new form of colonization by consumerism, where even undeveloped land is not safe from the

Fig. 2.29: Michael Wells, "Undocumented Migration Project."

far-reaching impact of our disposable culture." But when Durán explores the shores of Sian Ka'an, Mexico's largest federally protected reserve, in search of plastic debris, and when he organizes the found pieces by color, creates landscapes with them, and finally immortalizes the new geologies of garbage in pictures of breathtaking beauty, he is not suffering; or, to put it more accurately, the direct experience of trauma does not become an essential component of his collecting and art-making practices. De León's approach, on the other hand, is very different. Instead of looking for more of the same (more pink sandals; more red, and blue, and green, and yellow pieces of plastic, in different shapes, washed up on the shore), his gaze fixes on highly individualized and specific objects found in the desert and near the US border, such as a battered pair of female sneakers, or a water bottle "with a cover made from a denim pant leg and a handle made with a tree branch" ("Undocumented Migration," 339) (for photographic representations of migrant water jugs, see Figs. 2.34 and 2.44). And, instead of looking for generic similarities and subcategories (beach shovels, for example, or bucket-type containers of a particular color), De León searches for what makes each artifact unique, namely, the marks of personal struggle and pain, and the marks also of "modification": as De León explains, "migrants will make alterations to various items to improve their function [hence, the water

bottle wrapped in denim mentioned above], repair damage or add some additional use or level of meaning to an object" ("Undocumented Migration," 337–38). De León thus "borrows and expands upon the archeological concept of 'use wear' (i.e. modifications made to objects as a result of being employed in specific tasks) [to] demonstrate how an analysis of the worn and deposited items in the desert can provide a new understanding of the shared system of crossing techniques, as well as the intimate and often painful relationships between people's bodies and the tools they rely on" ("Undocumented Migration," 326).

De León then points out that "hiking across the desert is physically challenging and often leaves biological stains on objects" ("Undocumented Migration," 336). These "biological traces," as De León calls them, include "sweat, urine, feces, menstrual blood, skin and hair," and "many of the better preserved archeological items bear these marks of human activity," such as "salt-incrusted stains on shirts and backpack straps resulting from sweating, socks and bandages soiled by blood-filled blisters, and urine drenched clothes resulting from loss of bladder control related to physiological stress associated with hyperthermia" ("Undocumented Migration," 336). De León makes the very important observation that, although many of these traces are visible, "some of them are only identified through odor," and that "aromas provide a different type of somatic insight that may not be visible with other forms of use wear" ("Undocumented Migration," 336). "In the context of border crossing," De León concludes, "the pungent aromas of sweat, feces and urine conjure up images of physical pain, discomfort and suffering" ("Undocumented Migration," 337).

Not unlike Mexican morgue artist Teresa Margolles, who engages her audience with the odor of blood and rotten bodies as part of her installations, De León too insists on the importance of smell, particularly that of sweat, feces, and urine, as powerful indicators of physical suffering and emotional trauma. And, similarly to Teresa Margolles's art, De León's archive of "suffering" immigrant artifacts is one of a kind, for it shuns the methods of "cold" inquiry, "scientific" archival, and even artistic creation based on distance and detachment. The unapologetic physicality of De León's odor-dense archive and research method within the context of his "Undocumented Migration Project" certainly clashes with "sanitized" archives built around the border crossing experience, such as Jonathan Hollingsworth's book *Left Behind: Life and Death along the U.S. Border* (2012). Conceived and merchandised as a (noncomprehensive) photographic inventory, it contains big-format pictures in color of "personal effects found with remains and stored [at the Pima County Forensic Science Center], as well as personal effects left behind in the desert" (7). The foreword to the book, authored by Greg L. Hess, MD, the chief medical examiner of the Forensic Science Center, states that "Pima County, Arizona, faces the unique problem of addressing the issues associated with being the location with the highest documented number of migrant deaths in the United States" (7). From 2001 to 2011, the foreword further reads, "1,911 foreign nationals who have died in the deserts of Southern Arizona have passed through the doors of the Pima County Forensic Science Center" (7), and the personal belongings found on the deceased migrants—ID cards (probably fake, the forensic examiners conclude); combs; bills (mostly Mexican pesos); religious items

Fig. 2.30.1: Jonathan Hollingsworth, *Left Behind*, Lockers, Pima County Forensic Science Center, Tucson, Arizona.

such as crucifixes, rosaries, and prayer cards; lighters; watches; pencils; notes with addresses and phone numbers; and wallets emptied out of their contents—are now kept in so-called sleeves, a series of pouches of clear plastic suspended from hangers and stored in orange-colored metal lockers (Fig. 2.30).

The book recreates the trajectory, step by step, of bodies entering the facility, from the moment the "recovery van" arrives to the scene and transports the deceased to the Forensic Science Center, to the point when all that remains from the unidentified border crossers is a forensic case file kept in a binder, and a limp sleeve holding a few belongings crammed into a locker. Thus, the photographic depictions of the process are organized according to the following sequence, and with the following captions:

Recovery van; receiving room gurneys; receiving area office; Map of the cooler, left side. (Numbers in red are new cases awaiting autopsy. Parallel blue lines are suspected border crossers. Parallel yellow lines have come from the hospital); autopsy room; autopsy table; autopsy room sink; autopsy whiteboard (with the following column of organs written in indelible ink and capital letters on the left side of the board: HEART; L. LUNG; R. LUNG; LIVER; L. KIDNEY; R. KIDNEY; R. L. ADR; SPLEEN; PANCREAS; THYMUS; THYROID; BRAIN; RV; LV; T; A; M; P); John Doe, ML 11-1845; Remains of ML11-1658 awaiting anthropologist's examination; cooler [the photograph of the cooler occupies two full pages]; John Doe's clothing; plastic sleeve sealer and personal effects tags; lockers containing sleeves of personal effects from the previous five

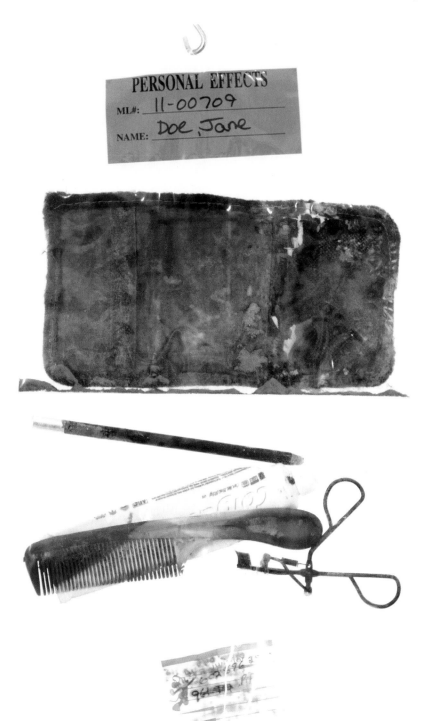

Fig. 2.30.2: Jonathan Hollingsworth, *Left Behind*, Lockers, Pima County Forensic Science Center, Tucson, Arizona, Personal Effects, ML# 11-00709, Doe, Jane

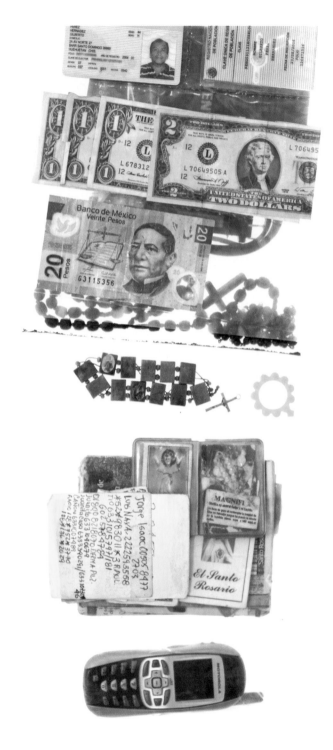

Fig. 2.30.3: Jonathan Hollingsworth, *Left Behind*, Lockers, Pima County Forensic Science Center, Tucson, Arizona. (unidentified sleeve).

years [this photograph also spreads over two full pages]. (11–27)

The photograph of the locker initiates a new chapter or series, entirely devoted to the sleeves, thirty-three in total. The last sleeve contains only a handwritten note in Spanish, with no translation into English provided (85) (Fig. 2.32). The next picture (another spread, 86–87) shows a broad panorama of the desert, with two "US Border Patrol trucks on hilltop overlooking the border fence, outside Nogales (88)." Suddenly, the book takes us out of the Forensic Science Center, and back to the desert. Still, we "safely" remain within the boundaries of the law, and of law enforcement, thanks to a "reassuring" sequence of pictures that show not only the two border patrol trucks in the spread, but also, in two subsequent images, the straight and seemingly endless line of the border fence ("Eastern view of United States-Mexico border at Nogales," 88), and the imposing platform of a "Border patrol observation tower" against the backdrop of a glaringly blue sky (89). Only after these images does the book venture out into the desert. This new section includes a two-page spread of "[migrant] tracks in an arroyo" (90–91); a second spread showing a clearing, among green bushes, in Arroyo, Green Valley (92–93), with a caption that explains that "during the winter months, daytime temperatures can swing from 70° F by day to just below freezing at night" (95); and a third picture of a "'lay-up site' [with] a discarded backpack (94). Although the book keeps text to a minimum, this last image, interestingly, generates a lengthy commentary. Titled *Green Valley*, it reads as follows:

Green Valley, 24 miles south of Tucson, is a common pick-up spot for border crossers, at the end of what is a roughly

40-mile journey for individuals who have crossed in Nogales. Shura Wallin, co-founder of Green Valley/Sahuarita Samaritans, which provides aid to border crossers in distress, led me to a "lay-up" spot where *coyotes* (paid guides) instruct border crossers to wait for pick-ups, which will then take them to holding houses in Tucson, Phoenix, and beyond. Before loading into packed cars or vans, the crossers are only permitted to bring what will fit in their pockets. Every other week, Wallin and her volunteers travel to various locations to collect the backpacks, clothing, blankets, and water bottles found in the desert floor. All items that can be recycled are taken to Mexico and re-distributed to border crossers who have been deported. (95)

The next six pages of *Left Behind* showcase twelve pictures (two on each page) of "personal items found in Green Valley" (96–101) (Fig. 2.31). I could list them in order, and describe them in the "scientifically" detached fashion a forensic examiner would have done it: a jacket; a pair of sneakers; eight empty water bottles; a backpack; a blue long-sleeved T-shirt; three backpacks; a glove; a pair of jeans; a can; a backpack and a water bottle; two water bottles; a sneaker.

However, the inventory above offers only an incomplete picture of reality. Instead, it is Jason De León's archeological technique of "use wear" and his closer look at biological marks and traces that tells the more profound truth of border trash as silent witness of human tragedy. Thus, what anthropologists à la De León, but also the different artists and activists, routinely see in objects left behind (either voluntary or often times also by force) is probably this: a jacket, one arm limply stretched on the grass, the other bent, with a phantom hand touching a phantom

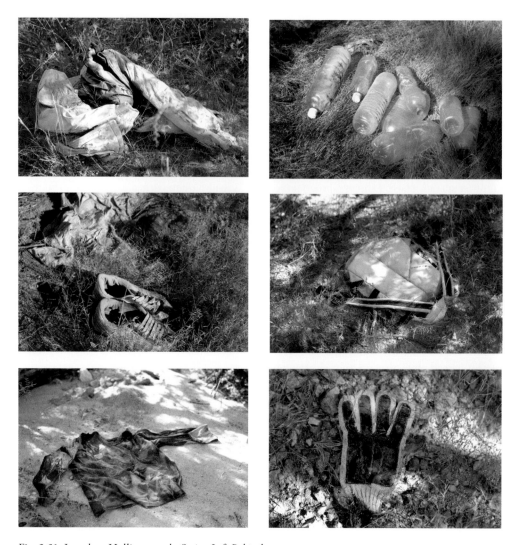

Fig. 2.31: Jonathan Hollingsworth, Series *Left Behind*.

chest; a pair of sneakers, leaning against each other in search for comfort, one primly laced, the other undone. A heap of empty water bottles, showing different degrees of use and decay, some with terse plastic skin gleaming in the sun, others wrinkly, and encrusted with dirt, some cup-less, others tightly closed, and all of them empty and dry; the corpse of a backpack, face down and with spread-out straps; a rich-blue shirt,

open armed and broad chested, a wearable map with its sandy mountain ranges, deep canyons, and expansive valleys, a map of the desert on which it lies (Fig. 2.31.5); three "dead" backpacks, this time "face up," two of them marked with names/brands on their foreheads, the third one a baby-blue "Jane Doe" (Fig. 2.31.7); a woolen glove, its stocky fingers rigid and sweating in the sun; a denim iguana, looking at us fixedly

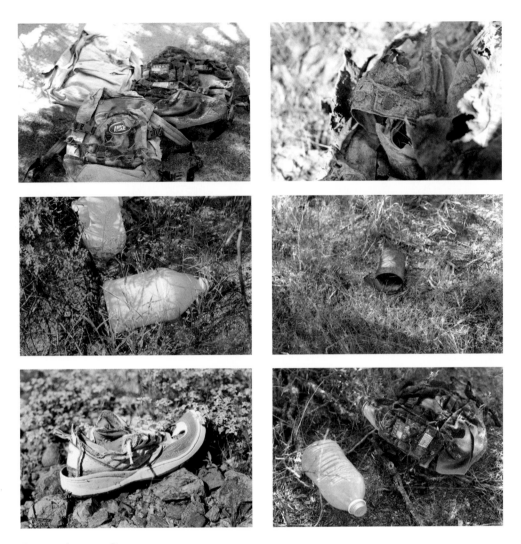

Fig. 2.31 (continued)

with button eyes and a gaping mouth (Fig. 2.31.8); a rusty can, all by itself, a fossil by now left to its own devices, and yet another deceased couple, his name "Tommy" (although probably not American, despite the flag), the name and nationality of his mate, unknown; two water bottles, one seemingly resting (or dead), the other badly injured, though still standing; and a shoe, always a shoe.

But never the same shoe: this is precisely the difference between De León's deeply engaged border archeology, and Hollingsworth's more detached forensic photography. The latter's white-and-tan sneaker in Fig. 2.31 is very similar to Durán's pink sandals in Fig. 2.28—in the sense that it too appeals to the generic (one more "dead" sneaker; one more piece of immortal plastic), as pars pro toto of two overarching themes,

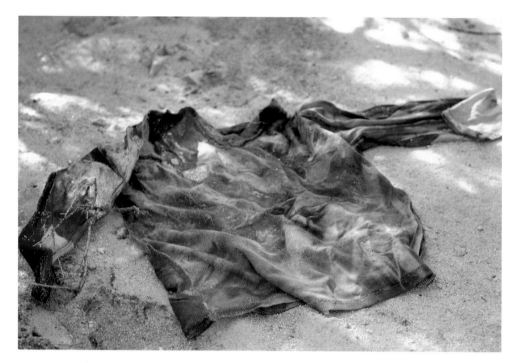

Fig. 2.31.5: Jonathan Hollingsworth, Series *Left Behind* (detail).

Fig. 2.31.7: Jonathan Hollingsworth, Series *Left Behind* (detail).

Fig. 2.31.8: Jonathan Hollingsworth, Series *Left Behind* (detail).

undocumented immigration and environmental pollution—and, by the same token, as far as ever possible from De León's bra-strap-and-cord-repaired shoes (Fig. 2.29). De León's writing exudes compassion for individual suffering and is keen on painstakingly individualizing (and thus humanizing, as I attempt to do with my description of found migrant objects above) the artifacts that accompany the undocumented immigrants during their journey across the desert. Hollingsworth's book, on the other hand, pursues a different and somewhat complementary goal, which is to stress the institutional apparatus around forensics. In the midst of the thirty-three John and Jane Does whose scarce personal belongings hang from photographed sleeves, only three names stand out, that of the forensic examiner, that of the photographer, and that of the cofounder of Green Valley/Sahuarita Samaritans. The work of the latter, Shura Wallin, even merits a long description (the only one in the book accompanying a photograph; 95), whereas the compassionate words in Spanish left behind in a note by John Doe ML 11-01569 (Fig. 2.32) remain untranslated. The letter begins with a sentence and an arrow: "it is 20 minutes from here," the sentence reads, and the arrow then points to the right direction. "Thank you," the note continues, and it then politely addresses the patrol officers as "señores oficiales." "In the main ravine," the letter explains, "there are two dead men. I am doing this favor because I feel pity for them, I just ran into them by accident. I am leaving this little note with the arrow, and the stone painted red" (85).

esta 20
minuto

Gracias

Señores oficiales
en el sanJon Grande
esta 2 hombres Muerto
Ago este fovor. da lastama
de ber
de casbalidad para en
es. Rumbo Asi. puedo
dejar este papelito
donde indica la Flecha
con las piedra pitada de.
Rojo.

Fig. 2.32: Jonathan Hollingsworth, *Left Behind*, Lockers, Pima County Forensic Science Center, Tucson, Arizona, Personal Effects, ML# 11-01569, Doe, John.

One of De León's motivations to initiate his "Undocumented Migration Project" in 2009 was to "collect robust data on the migration process that could provide a counter narrative . . . to 'Choose Your Own Adventure' books for American Consumption." These books, De León contends, are the ones written by "privileged journalists running across the desert with their passports in their back pockets while chasing migrants . . . , gonzo journalists who [head] down to the border and [team] up with some overly trusting Mexicans who let these people shadow them as they [head] for El Norte" (*Land of Open Graves*, 11). Certainly, De León's adoption of the archeological concept of "use wear" as a way of contesting simplistic and incomplete narratives around undocumented migration is one particularly poignant example, but there are others. Art in particular, and its ability to put together "counterarchives," is yet another effective practice, or set of practices, keen on creating a new awareness around the border-crossing experience and its artifacts. Take Thomas Kiefer's *El Sueño Americano* project (2015). Kiefer, who from 2003 to 2014 worked as a part-time janitor/landscaper at the US Border Patrol Facility in Why, Arizona, had a chance during those years to witness the relentless transformation of migrant belongings into trash. He soon began questioning the practice, implemented by the border patrol authorities, to deprive migrant detainees from their possessions, and decided to retrieve the discarded items. His collection thus, as he describes it, is constituted entirely of

> the personal effects and belongings of people apprehended in the desert by U.S. Border Patrol agents that were subsequently seized, surrendered, or forfeited as they were processed at a U.S. Customs and Border Patrol facility in southern Arizona. During the course of intake, this property was considered non-essential and discarded. These personal effects and belongings represented their choice of what was important for them to bring as they crossed the border to either start or continue their life in the U.S. (Kiefer)

The procedure at the US Border Patrol facility in Why, Arizona, is chillingly straightforward: articles considered potentially harmful, such as shoelaces, or simply deemed "non-essential personal property" (for example, soap bars, gloves, billfolds and wallets, dental paste, spoons and forks, combs, phone chargers, earphones) "are disposed of during intake." But often, among these "non-essential" personal items, Kiefer would find pictures of children, Bibles, rosaries, and love letters, which only made his increasingly anguished question more pressing: Who has the right to decide what is "essential" or not? Who has the right to systematically deprive apprehended migrants from the belongings that accompanied them during their painful journey across the desert? Driven by these questions and a strong moral imperative, Kiefer started rescuing, collecting, archiving, "collaging," and, ultimately, photographing his migrant artifact compositions. Like Durán, Kiefer would look for items of the same kind, establish subcategories, and only create "monothematic" inventories and collages. But, unlike the former, the latter would make sure that the different migrant belongings retain their distinct traits and identities, instead of blending, for example, into a sea of combs, or a confusing avalanche of cell phones, Chris Jordan–style.

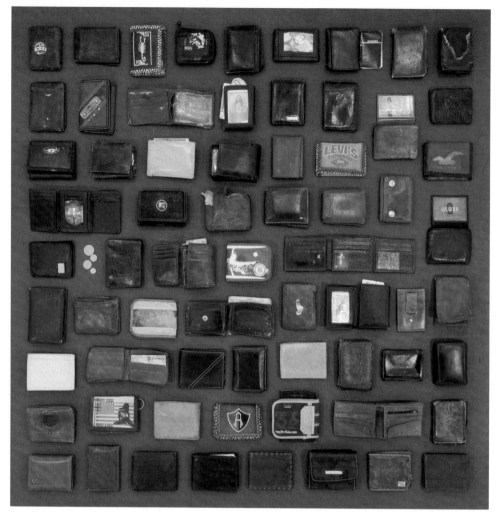

Fig. 2.33: Thomas Kiefer, *Billfolds and Wallets*, 2014.

Kiefer's ultimate goal is to raise aware-
ness of the migrant experience by preserv-
ing the artifact's unique idiosyncrasy (pars
pro toto, once again, of the identity of his
or her former owner) through contrast and
comparison with other distinct identities.
Many of these, an agglomeration of "non-
essential belongings" filling the Dumpsters
of the border patrol facility, eloquently speak
to the high numbers of immigrants that go
through its doors, and from there, either
back across the border, or into a prison cell.

Hence, Kiefer's orderly inventories not only
are built around the basic structuralist prin-
ciple that meaning derives from opposition
and comparison but also deliberately cater to
baroque horror vacui. More often than not,
migrant artifacts fill his photographs to ca-
pacity (Figs. 2.33 and 2.34). The wallets and
billfolds that cram the photograph in Fig.
2.33 showcase both quantity (the tight rows
clearly suggest that the "wallet procession"
continues beyond the limits of the picture),
and "quality," meaning the dense traces of

Fig. 2.34: Thomas Kiefer, *Water Bottles*, 2013.

pain, suffering and dreams lost that perme-
ate worn and blemished leather and synthetic
"skin." Whereas the passing of time and the
imprint of use are the main transformers
of materiality in the "wallet picture" (Fig.
2.33), the "water bottle picture" (Fig. 2.34)
speaks a more complex language. Here,
manual dexterity and artisanal ingenuity
further add to the traces of "personalized"

suffering. Immigrants have learned from
border-crossing oral tradition and from
their own experience that clear water bottles
often glint and glare in the merciless desert
sun, thus alerting patrol officers (De León,
Land of Open Graves, 160). They have also
have come to realize that to cover bottles in
clothing not only serves as necessary camou-
flage but keeps the water cool and, equally

important, makes handling and carrying less cumbersome (De León, "Undocumented Migration," 339).

The neat rows of wallets and water bottles are complex, and even disturbing in their mixed messages (Figs. 2.33 and 2.34). On the one hand, they remind the viewer of the aesthetics of naive paintings, where chaos invariably turns into amiable harmony. It is a testimony also to the work of the janitor, whose task—as that of naive art; as that of law enforcement—is to clean, to rearrange, and therefore to restitute order. Art, maintenance, and the law share an authoritarian, if not violent streak: they begin by declaring the world chaotic and then intervene forcefully. Photojournalism has made us sadly familiar, not only with the unspeakable horror of piles of dead corpses, but even more frequently with the no less horrific "after picture" of corpses orderly displayed in rows, and that precisely—the oxymoronic monstrosity of death and violence neatly arranged—is what Kiefer's wallet and water bottle lines disturbingly suggest; for in them we fathom not only the line-up once more of migrant artifacts turned into forensic evidence vertically stored in sleeves, but the seemingly endless rows of chained migrants awaiting deportation, and, even more horrifically, the rows of dead migrants waiting to be cremated.

Not all, however, of the photographs of Kiefer's series *El Sueño Americano* choose the linear arrangement for the display of migrant artifacts. The photograph in Fig. 2.35, for example, shows a brownish-grayish pell-mell of heavy-duty male gloves. The open "hands" (many of these gloves are photographed palm-up and with wide-spread fingers) convey a sense of vulnerability and danger. Outstretched gloves/hands emerging from the pile seem to be frantically crying for

help and also eerily remind us of mutilated limbs and of scenes of carnage. But they also directly hint at manual labor, and the harsh working conditions migrants encounter at both sides of the border. Undocumented immigrants are predominantly manual workers, their hands as rough and callused as the hardened and dirt-encrusted surface of the gloves shown in Kiefer's photograph, and as disposable.

The manual workers and gloves/hands that the border patrol authorities send back and, ultimately, throw away are the same hard-toiling workers/hands that adroitly managed to create a wrap for their water bottles (Figs. 2.34 and 2.44). The artisanal (a makeshift cover) and the industrial (plastic) accompany migrants during their harrowing journey across the desert. Pockets and backpacks contain handmade rosaries and hand-embroidered food wraps (remnants of a rural world border crossers are trying to leave behind) but also cell phones and headphones. The latter, found in great numbers amid other discarded "non-essential" migrant possessions, inspired Kiefer's photograph in Fig. 2.36. Here, headphones create entangled constellations, an eerie reminder of starry nights in the desert, when temperatures plummet, and migrants, fearful of revealing their whereabouts, don't dare to light a fire.

Kiefer's artistic approach to migrant artifacts is straightforward and without complication. For him, discarded migrant objects are so heavily charged with intrinsic meaning and tragedy that he sees no need in complex ideation or manipulation. For deep semantics to shine through, most objects, Kiefer thinks, simply need to be distributed in rows, as is the case of wallets (Fig. 2.33), water bottles (Fig. 2.34), but also of combs, soap bars, silverware, and baseball caps,

Fig. 2.35: Thomas Kiefer, *Gloves*, 2013.

whereas the life and "soul" of other artifacts become more apparent if displayed in piles (gloves—Fig. 2.35) or entangled ensembles (headphones—Fig. 2.36).

Photographer Richard Misrach's initial approach to discarded immigrant belongings is even less interfering than Kiefer's: A regular visitor of the US-Mexico border since 2009, and at the first stage of his artistic involvement with the border-crossing experience, he simply took pictures of desert trash as found, with little or no intention to tamper with it. As Misrach explains in an interview with *California Sunday Magazine*,

> All (my) photographs are about found objects—shotgun shells from a Border Patrol shooting range, a soccer ball, a boot, a Spanish translation of *Doctor Zhivago*—that are banal but laden with meaning. I'm always on the lookout for the anomalous. Early in 2014, about an hour from Brownsville, Texas, I found a girl's tweezers, a ball, two Bibles, and a child's tennis shoes. Along the border, you're constantly stumbling across discarded migrant's clothes, but what made this time so eerie was that all I found were children's items and clothes. It wasn't until several months later, when I heard the news reports about the wave of unaccompanied children crossing the border, that I understood what I saw. Whenever I go to the desert, I discover things that are unusual. I may not know what they are, but I know a potent narrative will follow in the months ahead. ("*Border Signs*")

Misrach thus introduces an important variation to Kiefer's photographic inventory,

Fig. 2.36: Thomas Kiefer, *Earphones*, 2015.

and, in general, to the orthodox interpretation of archival knowledge. For him, border artifacts do not necessarily or exclusively speak of the past but become "traces of the future, objects whose meanings are not clear when . . . [photographed], but that emerge over time, signaling a new historic moment" ("*Border Signs*"). Hence a battered soccer ball, for example, not only stands for that particular migrant child that left it behind at the border but is a "trace," avant la lettre, of the collective and new phenomenon of thousands of Central American children

escaping violence and sent to migrate without the protection of adults (Fig. 2.37).

Before Misrach, Susan Harbage Page, also an artist photographer interested in border trash, had already challenged conventional archival practices. In her own words, her *US-Mexico Border Project*

is an intervention—at once aesthetic, archaeological, and archival—into the spaces and objects associated with the great migration north across the Rio Grande and into the United States. Since

Fig. 2.37: Richard Misrach, *Stranded Soccer Ball*. Tijuana Estuary, San Diego, 2013. © Richard Misrach, courtesy Fraenkel Gallery, San Francisco, Pace/MacGill Gallery, New York and Marc Selwyn Fine Art, Los Angeles.

2007 I have photographed the possessions left behind by migrants crossing the U.S.-Mexican Border near Brownsville, Texas, and Matamoros, Mexico, and west to Laredo and Eagle Pass, Texas. Migrants swim across the Rio Grande and then quickly change from wet clothes into dry clothes and disappear into the general population. If stopped by the Border Patrol, they are asked to empty their pockets of everything non-essential. (Harbage Page)

Like Kiefer, Harbage Page is deeply moved and disturbed by the intense combination of pain and hope that radiates from the discarded artifacts that others (in this case, the border patrol) determine as "non-essential." "Images of a deflated inner tube dropped by the road," as she eloquently puts it, "a wallet mired, its contents spilling into the mud, footsteps revealed in soft earth, and river-wet clothes wrung, wadded, and cast aside document ordinary things possessed with extraordinary associations of flight, hope, panic, determination, and fear" (Harbage Page). In order to preserve the tightly condensed symbolism of discarded and found artifacts, and to reinstate meaning to objects deemed "non-essential," *US-Mexico Border Project* goes a step further than Misrach's straightforward photographic series, or even than Kiefer's "orderly" inventory of the "American dream." First, the artist "photographs the objects in situ as [she] finds them," but then she "ship[s] them back

to [her] studio where [she] rephotograph[s] them in a studio setting, tag[s] them and number[s] them and place[s] them in an archive," with one main objective in mind, namely, to create an "anti-archive" that "subverts the traditional concept of the archive. (See note 3 of this chapter for a more detailed definition and discussion of the concept of "anti-archive" by Harbage Page.) Instead of saving the objects of the rich and famous it holds the objects left behind by unknown migrants heading north. The objects placed in a gallery setting become "reliquaries" (Harbage Page; Figs. 2.38, 2.42, and 2.43).

Harbage Page's project is an ongoing one. Not content with photographing in situ, rephotographing in a studio setting, tagging, and archiving, the artist is now planning on creating "a searchable online database of the studio images" of the five hundred objects currently housed in her "anti-archive." In the meantime, Misrach's initial project around discarded immigrant belongings has moved away also from in-site photographing and documenting and is continuously evolving, although into directions very different from Harbage Page's own artistic practices. In 2011 Misrach became familiar with Guillermo Galindo's work, a visual artist and composer who builds musical instruments with found objects left behind at the US-Mexico border. Since then, Misrach has routinely provided Galindo with the artifacts he photographs at the border, and in 2016, the San Jose Museum of Art housed the exhibit *Border Cantos*,

a haunting cross-disciplinary exploration of the US-Mexico border developed by photographer Richard Misrach and composer Guillermo Galindo. This collaboration (the first of its kind for both

artists) premieres monumental, engulfing photographs shot in the borderlands by Misrach, alongside ingenious musical sculptures that Galindo handcrafts from objects Misrach retrieves—a shoe, a water bottle, a comb. The multi-faceted exhibition brings together photography, sculpture, graphic music scores and sound to create a visceral, nuanced portrait of place—and the people who traverse and patrol it. (Stone)

No less eager than Kiefer or Harbage Page to unearth the semantic potential of objects lost and found along the northern US-Mexico border, Misrach and Galindo nonetheless move well beyond simply collecting, arranging, or even "anti-archiving" refuse. In one of their collective pieces, called *Zapatello*, for example, one found shoe does not trigger the need to look for more of the same (shoes in this case), as would have been the case with Durán's "trashscapes" (Figs. 2.27 and 2.28) and Kiefer's serial compositions (Figs. 2.33, 2.34, 2.35, and 2.36). Rather, it serves as an excuse and a tool to build an elaborate musical instrument, "inspired by Leonardo da Vinci's device, "known as the martello a camme, a mechanized hammering machine" ("*Border Signs*"; Fig. 2.39). As the artist himself explains, "I substituted the hammer with a shoe and a glove found at the border. Both are activated by a crank, which incorporates human-shaped targets, used by the Border Patrol, as gears. A donkey jaw and a bull's horn function as stops. At the bottom is a tire, also found at the border, which I turned into a drum by covering it with rawhide skin. When you turn the crank, the shoe and the glove alternate beating the tire" ("*Border Signs*").

The "zapatello" is probably one of Galindo's most sophisticated pieces. However, all

Fig. 2.38.1: Susan Harbage Page, *Girls Love Shoes*.

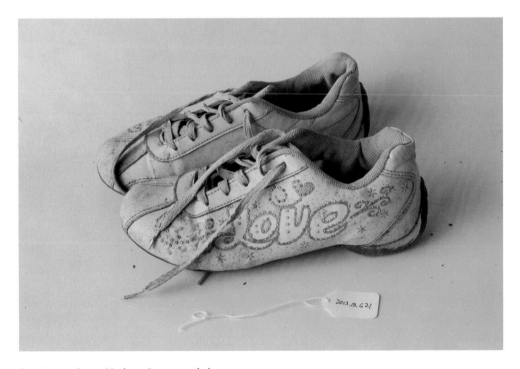

Fig. 2.38.2: Susan Harbage Page, untitled.

Fig. 2.39: Guillermo Galindo, *Zapatello*, 2014. Courtesy of the artist, photo by Richard Misrach, Based on Leonardo da Vinci's *Martello a Camme*—a mechanized hammering machine; tire, boot, glove, wood blocking, used in the construction of the border wall; donkey jaw, bull horn and rawhide, 70x38x76 inches.

the instruments of the collection honor one basic tenet inherited from the pre-Columbian world, namely, that "there is an intimate connection between an instrument and the material from which it is made" ("*Border Signs*").

Thus, when Galindo invents and creates his "shell piñata"—"a soccer ball-shaped metal piñata based on a West African shaker called a shekere, which has either beads or seashells woven into a net covering the surface. I, instead, attached empty shotgun

Fig. 2.40: Richard Misrach, *Shell Casings #32*, near Gulf of Mexico, Texas, 2014.

shells from a Border Patrol shooting range" (see Misrach's photograph, Fig. 2.40)—he is literally (and deliberately) weaving the violence and tragedy of the border-crossing experience into the fabric of the "shell piñata" and into the music it puts to "border songs" (Fig. 2.41).

Three discarded artifacts, a brassiere, a comb, and a water jug, are part now of the collections and installations of artists eager to raise awareness about the border crossing experience (Figs. 2.42, 2.43, and 2.44). The approach to these artifacts, however, is quite different and thus begs the question if it also elicits divergent reactions from the audience. One cannot but notice, for example, that Harbage Page's "tagged" objects are remarkably similar to the equally tagged belongings kept in lockers in the

Pima County Forensic Science Center. Not unlike the worn wallets and rusty watches the latter stores in clear plastic sleeves (Fig. 2.30), the artifacts of Harbage Page's *Border Project* also bear the traces of different layers of violent intervention. Left to "die" in the desert, the battered corpses of a red brassiere and a black comb (a female and a male?) are photographed at the scene; later collected, tagged, photographed again; and (anti)archived. Harbage Page is keen on emphasizing that this process "elevates" desert trash and thus grants it the same treatment otherwise reserved for art. However, what Harbage Page seems to overlook is that her inventory of tagged border remains is much more powerfully evocative of a morgue and of the collection of bodies (tags dangling from big toes) that fill its freezing chambers

Fig. 2.41: Guillermo Galindo, *Piñata de cartuchos* (*Shell Piñata*), 2014. Courtesy of the artist, photo by Richard Misrach, Sheet metal, border patrol shell casings, 17x30x30 inches.

than of museum deposits zealously guarding their (equally tagged) treasures.

One could argue that what makes Harbage Page's *Border Project* effective in its severe condemnation of border violence is not the declared intention of the artist—that is, to "elevate" (or lower) migrant trash to the category of art—but, ironically, exactly the (unintended) opposite, namely the "lowering" of the often tragic migrant experience and life to a merely "dead" object, a nameless corpse only worthy of an identification tag.

The water jug in Fig. 2.44 stands in stark contrast to the brassiere and the comb in Figs. 2.42 and 2.43. Not only it is not

tagged, but it is also handmade (or semi-handmade), whereas the other two discarded belongings are factory born, with no traces of posterior alteration or manipulation. As De León points out in his important insights into "modification" as a crucial component of the migrant experience,

before and even during a crossing event, migrants will make alterations to various items to improve their functions, repair damage or add some additional use or level of meaning to an object. . . . Although border crossers prepare themselves by bringing an assortment of food, clothing and first-aid materials, issues often

Fig. 2.42: Susan Harbage Page, untitled.

Fig. 2.43: Susan Harbage Page, untitled.

Fig. 2.44: Richard Misrach, *Agitanques*, 2013, © Richard Misrach, courtesy Fraenkel Gallery, San Francisco, Pace/MacGill Gallery, New York and Marc Selwyn Fine Art, Los Angeles.

arise that require ad hoc ingenuity. For example, many find that they are unable to carry a heavy water bottle over long distances and may fashion handles for these bottles, using backpack straps or materials found in nature (e.g. a tree branch). . . . It is also common to see people sew covers for their bottles using pant legs or t-shirts. ("Undocumented Migration," 337–39)

Water bottles are a leitmotif and recurrent artifact in the works of many working with border trash, such as Kiefer (Fig. 2.34), Misrach (Fig. 2.44), Galindo, and De León, for obvious reasons, since water is crucial to migrant survival, and the lack of it, the cause of many of border casualties. But the artistic and politically engaged fixation with the

water jug goes beyond its life-saving properties, for what makes it particularly appealing to art and to anthropology is its (semi) handmade nature. The fact that it bears the personalized imprint of the migrant has a powerful effect on our emotions, an effect similar to that of worn shoes that barely hold it together, and that is why shoes also rank first, together with "modified" water bottles, as detonators of awareness-raising compassion.

But more important even, "modified" water bottles speak to the skill and dexterity of ancient native craftsmanship, in syncretic combination with modern international industrial production and knowledge. Migrant water jugs are complexly hybrid artifacts. Made of industrially produced plastic, and camouflaged under a hand-sewn

cover, it is the latter (the artisanal, made-in-Mexico wrap, and not the "foreignness" of its factory-made content) of the water jug, however, that strongly appeals to Galindo. Artists such as Kiefer, Harbage Page, even Misrach, take up photography and therefore side with US-born technology and industrial seriality: they go for the "plastic," whereas Galindo goes for wood and cloth and favors the artisanal method instead. Not only does he "see" the artisanal and what is preindustrial and handmade in the water jug, but he honors the work of the migrants by becoming an artisan himself. As he explains, "Richard found this jug near Ajo, Arizona, last year. Most of the jugs discarded along the border are black in order to avoid the reflection of the sun or flashlights at night. This one was wrapped in a towel, probably to keep the water cold. I filled the jug with gravel so that it could be used as a shaker" ("Lost—Then Found").

Galindo's only goal is to stay obsessively close to the object, so as to fully breathe in the life of he or she who made it his or her own. Thus in lieu of "distancing" himself from border trash (by photographing it, for example, or by concentrating on what happens to it once it falls prey to the violence of highly technologized and institutionalized border security and forensic science), Galindo makes sure that he becomes physically and spiritually enmeshed with border crossers and their discarded belongings. He modifies the water jug with his hands, as did its former owner, and builds a musical instrument that gives voice to the lives of migrants by validating their past, their origin, and the rural and pre-Columbian roots of their culture. In Galindo and Misrach's collaborative work and artivist interventions, the act of effectively retrieving, "detrashing" and recycling found objects becomes also a resolute attempt at historical recovery.

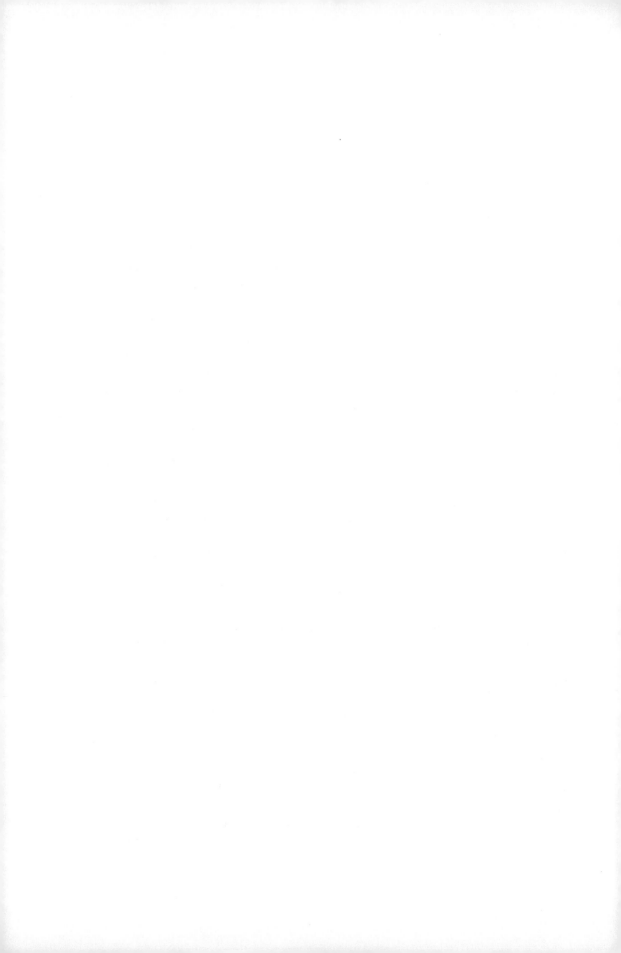

3

Dumpsterology

A Cultural History of the Trash Container

While the previous chapters reflect on refuse that litters streets and borderlands unbridled, this chapter moves from scattered debris to "stored" rubbish, or rather, from content to urban trash containers. Dumpsters in particular are the site—a hospice of sorts—where trash is allowed to "rest" and linger before its final demise and journey to the sanitary landfill. Dumpsters frequently offer discarded artifacts a "second chance" because they resemble other intermediate loci and occurrences, such as halfway houses, thrift stores, swap meets, and garage sales. But Dumpsters are much more than "just" a treasure chest to environmentally conscious Dumpster divers and junk lovers, or even a means of survival for the homeless and destitute. As the pages that follow show, Dumpster semantics is particularly complex and multilayered and moves freely from the tragic ("body found in a Dumpster" will elicit countless news and images on Google) to the playful (in the form of so-called Dumpster art, for example) to the soberly pragmatic, with a bourgeois flair to it: Dumpsters turn into curbside swimming pools, luscious front yards, and perfectly functional "microhomes."

More importantly, and throughout all their multifarious transformations, Dumpsters retain, and even accumulate, strong philosophical meaning and transcendence. For a repurposed Dumpster, no matter how clean or sanitized, will always hint at its opposite, namely, its dirty origin. Trash will haunt the Dumpster with original sin–like persistence; the content for which it was made will never cease to beleaguer the continent. Though Dumpsters usually come in rectangular form (the shape of coffins also), in essence and at the level of symbolism Dumpsters—particularly "recycled" ones—are perfectly round. More poignantly so than other artifacts, "reborn" and cleansed Dumpsters carry within them the ghost of decay and death. They are a powerful reminder of how life unavoidably circles back into nonexistence, how all that is alive is ultimately discarded.

Dumpsters are not only densely packed with existentialist and philosophical meanings. They are also deeply political, and a type of "urban furniture" that eloquently bespeaks social inequality and marginality. For one, Dumpsters routinely populate the back alleys of American cities, and around back alley Dumpsters, activities happen (or are imagined to happen) that would be out of place on the sidewalks of more "reputable" thoroughfares, from loitering, Dumpster diving, and camping out for the night, to drug consumption and traffic, and even rape, murder, and the disposal of dead bodies. More often than not, however, the two worlds (the proper and the marginal and even sordid) exist only a few feet apart.

(Like so many urban homes, mine too, for example, is sandwiched between a present-able front street—in this particular case, a walk street—deemed perfectly safe—and a far shadier back alley, graffiti and Dumpsters included.) In some ways, the front street/back alley structure mimics the domestic interior, where common living room areas demand proper behavior and even attire, while more private and less confessable practices take place in "back spaces," such as bedrooms and bathrooms. More-over, the back/front opposition can be easily read as a horizontal version of the upstairs/downstairs genre now made so famous by the award-winning TV series *Downton Abbey.* Back alleys, no less than servant quarters, are the domain of the lower classes and are the spaces (like kitchens, basements, and adjacent back outer areas) where one deals with dirt and the discarded, and also where food is available, and where the needy and the destitute can still their hunger.

In *Empire of Scrounge: Inside the Urban Underground of Dumpster Diving, Trash Pick-ing, and Street Scavenging* (2006), Jeff Fer-rell constantly points to the essential mar-ginality that is at the core of the urban trash world. When he decided to research the "empire of scrounge" he entered "a far-flung, mostly urban underground populated by . . . illicit Dumpster divers, homeless trash pick-ers, independent scrap metal haulers, activ-ist recyclers, alternative home builders, and outsider artists" (3). This marginality, Fer-rell further notes,

> is spatial as well: the spaces and situa-tions that make up the urban scrounger's scattered empire quite literally form the margins, define the borderlands, between the city's social and cultural worlds. In a shared apartment house dumpster,

the leftovers of private lives coalesce into a dirty public collectivity—and if a scrounger later retrieves some of these leftovers, they may in turn become the foundation for someone else's little home or apartment, or for another's temporary shelter under a bridge or overpass. In the back alley trash bins of commerce, the item that was yesterday a valuable and marketable commodity today transmogri-fies into devalued trash, and often a free-for-the-taking treasure; in the commercial alley, the bright front stage of the shop or shopping mall gives way to a backstage of cigarette breaks, trash piles, and uncer-tain access. (3)

Borderlands are porous. There is a steady back and forth between the front and the back, the "center" and the margins, and, more importantly, a persistent transforma-tion takes place on scrounging grounds, where commodities become trash and trash becomes reusable again, and where the lim-its between the legal and the illicit, the use-ful and the useless, and the public and the private remain consistently blurry. Once again, trash has brought to the fore its in-herently dynamic and generative nature. But as the following sections show, dynamism also permeates the Dumpster or trash bin, not only its contents. For one, Dumpsters are mobile entities from their inception, more often than not provided with wheels, and/or with contraptions that allow for easy lifting. Dumpsters roll and fly, thus contradicting the pervasive image of static urban (and unsightly) fixtures permanently anchored to the ground. Also, heavy metal trash containers not only move but are inces-sant generators of activity around them, the paradigmatic locus around which marginal-ity accumulates and evolves. Furthermore,

as artifacts dense with multilayered meanings, Dumpsters have been very successful at inspiring artists, who have in turn diverted, amplified, and enriched their semantics. Dumpsters have moved away from their original and intended role as trash containers in yet another significant fashion: often identified as a crime scene in the press and digital media, the composite Dumpster-plus-back alley has also found its way into popular culture as clichéd dumping ground for human remains. Finally, urban trash bins have evolved throughout time: in all its rectangular simplicity, a Dumpster is an ingenious and culturally significant technological device that stands firmly on a documented origin—it was invented and created in 1930 America—and has a rich history to tell.

The Origin of the Dumpster: Trash Management in Postwar America

In an article recently published in the *Huffington Post*, Clair Fallon notes that "the word 'dumpster' sounds so perfectly suited to its purpose that it hardly seems necessary to question its origins. But that would be a mistake," the columnist immediately adds, since "the real story is even more linguistically charming. The dumpster broke onto the scene in 1936, part of a brand-new patented trash-collection system that introduced the basic concept of the modern garbage truck, with containers that could be mechanically lifted and emptied into the vehicle from above. The system, invented by future mayor of Knoxville, Tennessee, George Dempster, took its creator's name, and the Dempster-Dumpster was born."

The invention of the Dumpster as we know it today, however, does not start with the deliberate intent to respond to the increasing sanitation crisis plaguing American cities during the 1930s. In fact, it was construction and the eagerness to build during these years—and not the need to get rid of all things useless and discarded—that brought about the first metallic containers susceptible of being hoisted via a hydraulic lift (Fig. 3.1).

As Eric Voytko explains, during the early 1930s, George Roby Dempster, born in 1887 to Scottish and Irish immigrants

> formed a construction company with his brothers back home in Knoxville. It was during this time that Dempster developed a novel device for the lifting and transporting of portable storage containers. . . . The first Dempster Dumpster lifts were employed by the family company on their construction sites, and consisted of a hydraulic hoist mounted to a motor truck whereby open top buckets could be engaged, lifted and transported. The device also allowed for emptying of the shallow buckets by simply tipping them as they were held in the raised position by the hoist. First patented in February 1935, the device began to attract the attention of rival operators and before long *Dempster Brothers Incorporated* was in the truck equipment business.

Very soon, however, the Dempster brothers envisioned the great business opportunity of applying the revolutionary hoisting system of their company to urban sanitation purposes. It was a more developed model, namely the "larger and now fully enclosed containers with hinged bottom dumping" that caught the attention of the sanitation authorities, and in 1937 Knoxville became America's first "Dumpster City" "with the purchase of a single Dumpster truck and

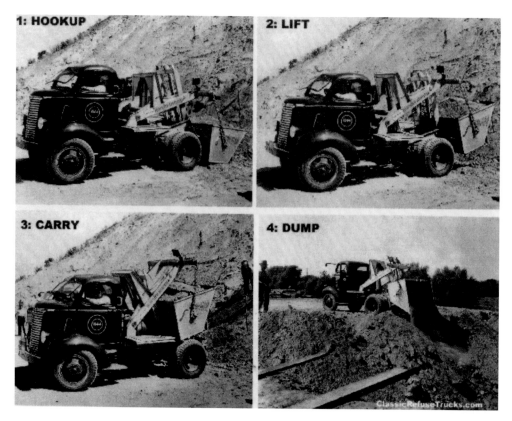

Fig. 3.1: Eric Voytko, *ClassicRefuseTrucks.com*.

eighteen containers of two cubic yard capac-
ity each. Not only did the system generate
favorable public response; the city also cut
collection costs by more than half compared
to the old method of open dump trucks.
One driver could now pick up, empty and
return each container without the need for
any additional men. The containers sealed
out insects and vermin, and sealed in refuse
from wind and weather" (Voytko).

The "fortuitous marriage of 'dump' and
'Dempster'" (Fallon) as trademarked brand
name is charming proof of the ingeniousness
of the company's founders. The latter cer-
tainly understood the importance of words
(and images), and, in fact, the Dempster/
Dumpster emporium became such to a
great extent thanks to a savvy and relentless

marketing campaign that inundated the
public with profusely illustrated brochures,
routine advertisements with photographs
in the press (Figs. 3.2 and 3.3), and even a
twenty-two-minute-long silent film from the
late 1940s.

Domestic refuse and technological ad-
vancement in waste management (such as
the one effected by the crucial invention of
the Dumpster) is inextricably tied to histori-
cal circumstances, and both a consequence
and a symptom of the latter. During World
War II, for example, the country was anxious
to support the troops overseas, and wasteful-
ness in general, particularly the squandering
of food, was considered an unpatriotic act,
with an abundance of colorful posters and
announcements containing slogans such as:

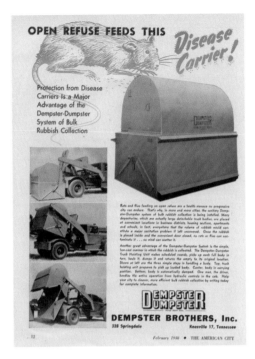

Fig. 3.2: 1948 Ad Dempster Dumpster Bulk
Rubbish Collection Avoid Rats Art, 1948.
American City Magazine (Municipal Journal).

Fig. 3.3: 1948 Ad Dempster Dumpster Bulk
Rubbish Collection Avoid Rats Art, 1948.
American City Magazine (Municipal Journal).

"Lick the Platter Clean: Don't Waste Food";
"Food is a Weapon. Don't Waste it"; "Help
Win the War on the Kitchen Front"; "Join
the Ranks: Fight Food Waste in the Home";
"Food is Ammunition—Don't waste it";
"Can all you Can: It's a Real War Job!"; "Be
Patriotic! Save Sugar"; "Homemade Bread
Wins the War"; "Save Bread and You Save
Lives; Save Potatoes and You Save the Coun-
try"; "The Kitchen is the Victory. Eat less
Bread"; "Save a Loaf a Week. Help Win the
War"; and so on. Naturally, the concerted
and nationwide "patriotic" effort to save
and not squander had the added benefit of
generating less refuse. Things were about
to change quickly, though: with increas-
ing prosperity and the spectacular growth
of mass production during the late 1940s
and the 1950s, the American faith in the

pragmatic and moral value of thrift would
soon loose traction. Industrial designer and
mass production advocate Gordon Lip-
pincott's 1947 statement in defense of un-
abashed consumerism and against what he
perceived as the ingrained instinct to hang
on to what may be old but still works elo-
quently signals a crucial change in economic
behavior: "Our willingness to part with
something before it is completely worn out
is a phenomenon noticeable in no other
society in history. . . . It is soundly based on
our economy of abundance. It must be fur-
ther nurtured even though it runs contrary
to one of the oldest inbred laws of humanity;
the law of thrift" (quoted in Elrod, 504).
 Sure enough, the film commissioned
by the Dempster brothers to promote their
revolutionary Dumpster emporium cogently

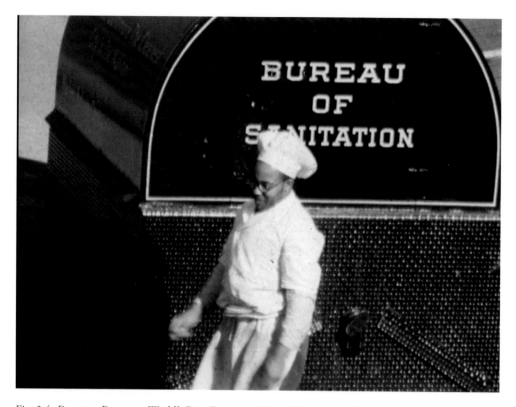

Fig. 3.4: *Dempster Dumpster*, World's First Dumpster Waste Management Promo Film. Photographs courtesy of Periscope Film LLC.

documents the all-important shift in economic behavior signaled by Lippincott. A cheap and amateurish production in the form of a silent film—the silent film era was well past its prime; in fact, 1935 was the year of the last silent movie produced by Hollywood—it nonetheless manages to offer an accurate portrait of America's quick transitioning from an economy of thrift to one fueled by escalating consumerism, and does so by looking at it from the rather unconventional angle of garbage disposal. The film starts with a "Dempster Dumpster" standing on the street in the city of Baltimore, Maryland, and a cook with a chef's hat on opening the lid and throwing food waste into the garbage container. Immediately after, yet another kitchen employee, also dressed in a

cook uniform (though this time without the chef hat), is shown throwing out the trash, followed by two employees doing the same but wearing an apron instead of the full cook attire (Figs. 3.4, 3.5, and 3.6).

Sequences made of recurrent actions are one of the preponderant narrative devices of the film. They certainly cater to the fascination of the silent film genre with only slightly varying repetition, but they do much more than just copy a style, or render nostalgic homage to a dying-out genre. For one, repetitive sequences aim at showing how the generation of waste is an ongoing process that essentially never stops, and how the rapid accumulation of trash demands an equally never-ending flow of departing and arriving Dumpsters. In fact, the film makes

Fig. 3.5: *Dempster Dumpster*, World's First Dumpster Waste Management Promo Film. Photographs courtesy of Periscope Film LLC.

a point of emphasizing the dynamism and thus efficient "modernity" of the new waste disposal system by continuously assimilating it to yet another technological wonder, the car—it is not by chance that one of the first scenes of the film showcases a Dumpster "parked" on the curbside, near a stationed automobile—and making Dumpster-lifting trucks seamlessly blend in with city traffic.

Modern times require modern solutions. The Dempster/Dumpster promotional film builds on the fact that society has moved well beyond the war economy of thrift, and that the new patterns of eager consumption not only generate more refuse but also bring to the fore the need for a more efficient waste management infrastructure. Hence, the emphasis in the film on comparing the quick-paced

and clean Dumpster method with an obsolete system that not only is decried as tediously slow, but also remarkably dirty and a potential health hazard. Sure enough, two further sequences of repetitive actions—one on the streets, the other one in a fish market—stage and overemphasize the messy and highly inefficient system of trying to haul trash onto open-topped trucks already overloaded with garbage. Furthermore, a series of close-ups of open bins filled with discarded fish heads make us literally smell the stench and wish for a better way of disposing of rotting organic matter.

The sequence of old-fashioned (and thus slow and unhygienic) waste management practices stands in stark contrast with yet another sequence that functions as a succinct

Fig. 3.6 *Dempster Dumpster*, World's First Dumpster Waste Management Promo Film. Photographs courtesy of Periscope Film LLC.

visual manual of instructions. It offers close-ups of the Dumpster and the lifting truck to highlight its simple and effective workings. The new waste management device is portrayed as a technological wonder, and, in fact, technology and an apology of science closely tied to masculinity is one of the main guiding principles of the promotional film. Throughout the latter, male engineers, managers, and operators closely supervise the lifting of Dumpsters and their transportation to the municipal dump. The binary male expert (or occasional curious male bystander) plus Dumpster in action further endorses the scientific validity of the new technological device, and its contribution to a well-planned economic growth placed in the hands of male intelligentsia (Figs. 3.7 and 3.8).

Dumpsters are versatile—the film emphasizes how they can take care of the garbage generated in restaurants, big markets, and even big apartment complexes—and aim at increasing efficiency. As the accompanying article to the promotional video explains, "the significance of the Dempster Dumpster system [is that it] reduced the cost of commercial and residential waste and garbage removal by 75%. That 75% savings from garbage removal still applies to this day and affects most people around the world" (Periscope Film). Hygiene is yet another of the main points highlighted in the promotional materials, and, rather predictably, the film makes sure to tie hygiene (or the lack thereof) to childhood. A scene shows children playing on the streets among filth and even using trash cans as toys and hiding places,

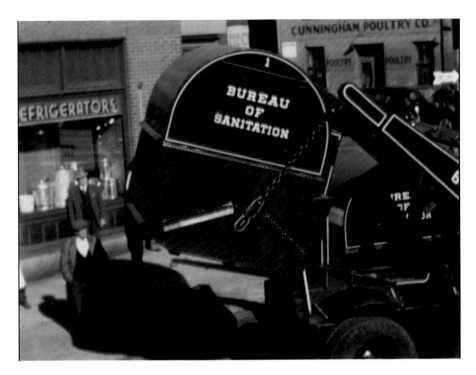

Fig. 3.7: *Dempster Dumpster*, World's First Dumpster Waste Management Promo Film. Photographs courtesy of Periscope Film LLC.

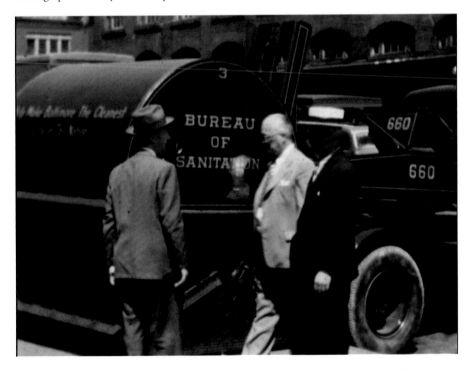

Fig. 3.8: *Dempster Dumpster*, World's First Dumpster Waste Management Promo Film. Photographs courtesy of Periscope Film LLC.

followed by a second scene where a gleaming Dumpster with elegantly rounded contours—reminiscent of a vintage Mercedes—makes its appearance. Sure enough, the street cleans up miraculously, but it also empties out of children: the camera focuses on a lonely little girl furtively disappearing into a building.

Staged images like these—of an urban landscape increasingly devoid of people—foreshadow the massive exodus from the city center to the suburbs that characterize affluent postwar America. In fact, not only people but trash too becomes a suburban creature that wanders farther and farther away from urban enclaves. Dumpsters do not remain on the streets for long. Once filled up, they are expeditiously hauled onto a truck (a new empty Dumpster immediately takes their place) and transported to the dump. The film is eager to emphasize this point and to show how quickly technology controls garbage accumulation by first packing it in tightly sealed metal containers and then moving it out of the city. Sure enough, printed brochures and advertisements in the press also insist on the dynamic efficiency of the "traveling" Dumpster and its powerful contribution to urban hygiene. Here is how one of the advertisements published in the magazine the *American City* in February 1948 describes the new technological prodigy (Fig. 3.2):

> Rats and flies feeding on open refuse are a health menace no progressive city can endure. That's why, in more and more cities, the sanitary Dempster-Dumpster system of bulk rubbish collection is being installed. Many depositories, which are actually large detachable truck bodies, are placed at convenient locations in business districts, housing sections, apartments and schools, in fact, everywhere that the

volume of rubbish would constitute a major sanitation problem if left uncovered. Once the rubbish is placed inside and the convenient door closed, no rats or flies can contaminate it . . . no wind can scatter it. Another great advantage of the Dempster-Dumpster System is the simple, low-cost manner in which the rubbish is collected. The Dempster-Dumpster Truck Hoisting Unit makes scheduled rounds, picks up each full body in turn, hauls it, dumps it and returns the empty to its original location. Shown at left are the three simple steps in handling a body. Top, truck hoisting unit prepares to pick up loaded body. Center, body in carrying position. Bottom, body is automatically dumped. One man, the driver, handles the entire operation from hydraulic controls in the cab. Help your city to cleaner, more efficient bulk rubbish collection by writing today for complete information.

There is a deliberate rhythm to trash management, as there is in the carefully orchestrated movement (a dance almost) that seamlessly leads from production to consumption to ejection. And it was the main goal of the Dempster brothers to partake in that dance, and to show that their revolutionary invention did not happen in a void, but was part of a whole system that greatly contributed to the efficacy and complexity of burgeoning capitalism, a capitalism, that, as the film is quick to show, has all the faith in technological progress, but comes across also as hygiene minded, democracy friendly, and environmentally conscious. For one, Dumpsters are useful and accessible to all. As to prove it, the initial scene shows the different culinary strata (from chef, to presumably sous-chef, to aproned kitchen helpers) making use of the trash container

(Figs. 3.4, 3.5, and 3.6). What the film fails to depict, however, is women making use of the Dumpster. Women appear on the screen only admiring the impressive tandem of Dumpster and hauling truck from afar during a demonstration at a school. This is not surprising, since clearly the Dempster brothers tightly adhered to the unwritten but unbendable rule of the times that while females manipulate (and generate) trash as part of their kitchen duties, it is "the man of the house" who takes the trash out. In fact, filmic materials of the 1950s meant to train families in hygienic practices and proper domestic trash management—*Your Garbage Problem—Garbage from Shopping to Landfill* is one example—unfailingly stress the gendered nature of trash handling and put emphasis on the inside=female / outside=male divide.

The scene called "Taking the Story to the School Children Is Part of the Sanitation Program" in the Dempster brothers film shows children, men, and women admiring the Dumpster hauling system, and a pseudomilitary faction of uniformed little boys picking up litter from the school ground. The next scene takes us to the city outskirts. Sequential images of a disease-carrying swampland; children playing in the brackish waters; mountains of trash; Dumpsters unloading even more garbage; and giant bulldozers leveling the rubbish and the foundation dirt that covers it culminate in a placidly green landscape, or, as the promotional text reads, in "beautiful fields like this for future parks and playgrounds" (Fig. 3.9).

The Dempster brothers not only knew how to build and commercialize Dumpsters and to revolutionize the waste management system. They also had a keen understanding of postwar America and were able to build a fortune precisely because they fully

embraced capitalism, not only its money-hungry technophilia, but also its "moral" values. The obsession with cleanliness as a sign of a morally and financially sound country; the idealization of nature, coupled with its savvy manipulation (parks are born out of accumulated and leveled trash; urban planners create suburbia sold as countryside); the emphasis on children as the epitome of innocence, but also as the future of a consumer-friendly nation—all of it perfectly fits into the belief system of the Dempster Company and cleverly informs its promotional brochures and advertisements in the press and in film. Not surprisingly, the latter ends with a close-up of a fruit-and-vegetable stand in a street market, as to signal and celebrate a profitable and perfectly round cycle: production and consumption generate trash, but garbage, when in the hands of an efficient waste management system, seamlessly leads back to producing and consuming, and all this happens without altering the "natural" order of things: with the help of trash, technology is able to bury an old swamp and to reclaim new land, and on that land, products fit for human enjoyment and consumption will grow.

Dumpster Diving: From Agnes Varda to Jeremy Seifert

The optimistic and self-assured picture painted by the Dempster/Dumpster emporium and its protocapitalist propaganda during the late 1940s and early 1950s is very different from how garbage accumulation is viewed today. The "garbage problem," to paraphrase the title of the documentary on domestic hygiene and waste management mentioned above, has acquired gigantic dimensions. The worry nowadays is not only the flies that trash attracts, thus "spreading

Fig. 3.9: *Dempster Dumpster*, World's First Dumpster Waste Management Promo Film. Photographs courtesy of Periscope Film LLC.

Fig. 3.9 (continued)

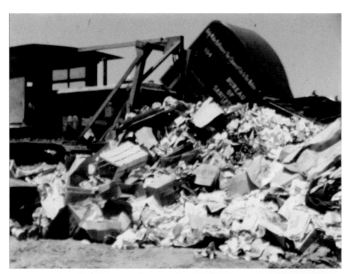

contamination and disease," or "the rats who feed on open refuse" and become a "health menace that no progressive city can endure," as the promotional advertisements of the Dempster Company sternly caution (Figs. 3.2 and 3.3): the real concern is the sheer quantity of refuse developed countries generate, in direct proportion of the volume of production and consumption, and the increasingly longer distances garbage has to travel before reaching a sanitary landfill. The concept of the nearby municipal dump that allowed for the quick and easy transportation to and from trash containers is a thing of the past, as is the original conception of the Dumpster as a hygiene-conscious receptacle, where trash remains sealed and out of reach, and leaves its prison only when released at the dump. The contemporary urban imaginary conceives of Dumpsters as open structures indeed, with trash not only entering its smelly interior but also exiting it in frequent intervals. This is not the world anymore of well-to-do technophilic businessmen who think of smelly trash as containable and of Dumpsters as being as hermetic as sardine cans, but the universe rather of uncontrollable refuse and overflowing trash bins at the mercy of destitute scavengers, environmentally minded Dumpster divers, and street artists alike.

Agnes Varda's award-winning documentary *Les Glaneurs et la Glaneuse* (*The Gleaners and I*, 2000; see Call; Fischer; Hesler; Kendall, "Cinematic Affects," Utopia Gleaners) sheds incisive light on the contemporary reality of overflowing Dumpsters and of garbage (rural and urban) that stubbornly refuses imprisonment and transportation. In fact, the French film director reverses preconceptions by depicting commodities as encaged, and discarded objects as free. In a scene that repeats itself, with slight variations, on three occasions throughout the

documentary, Varda, who is traversing the French countryside by car, makes a point of filming the giant lorries that crowd the French highway system and transport goods hidden in their oversized truck boxes. Moreover, by creating a frame with her fingers and pointing it toward the passing trucks, she not only forces the viewer to focus on the truck boxes (and to ponder about the nature and sheer amount of products it stores and transports) but further emphasizes the cage-like, enclosed structure of the massive containers on wheels. This recurrent scene stands in stark contrast with other, equally repetitive images, where unwanted and unharvested vegetables lie scattered and up for grabs on the fields, and where trash spills from Dumpsters and accumulates on the streets.

Uncontained garbage, the "dystopian" reality that the Dempster brothers were so eager to remedy, acquires a very different meaning in Varda's documentary. For the French director, garbage is not just a commodity that has lost its value and thus needs to be carefully sealed and then discarded, but a "habitat," a place infused with hospitality that invites human beings in, and ultimately constitutes a modus vivendi, a way of being in the world. Trash as habitat comes to fruition once the theatrics of production and consumption have reached an end. In the fields, heavy machinery is in charge of the harvest, and in the city, weekly and sometimes even daily farmers' markets display their products on the street. But after the harvest is completed, and after farmers and vendors have packed their stalls away, solitary figures slowly approach the "trash" left behind. Gleaners painstakingly canvas harvested patches of land in search of half-buried potatoes, and urban scavengers rescue the still edible apple or tomato from a heap of rotting food. The film's powerful

and poetically infused images certainly speak of the criminal wastefulness of developed countries and economies, as well as of the many destitute who capitalism generates and then throws away, one more "commodity" declared obsolete (Bauman). But Varda's reflections go further than that. They shed light on gleaning as a way of life that is firmly based on long-standing knowledge and experience endorsed by the law from early times on and amply recorded in history and art.

In fact, both law and art are essential components of Varda's masterful reflection on rural gleaners and urban scavengers. It is not by chance that *Gleaners and I* starts and ends with a work of art, and that four different pictorial representations on the figure of the "glaneuse" or female gleaner appear at regular intervals during the film. One of the first scenes shows Jean-François Millet's famous oil painting *Des Glaneuses* (*The Gleaners*, 1857), and almost immediately after a second though lesser-known painting fills the screen, namely, Jules Breton's *La glaneuse* (*The Gleaner*, 1870). In her musings, Varda points to the collective nature of gleaning. She also highlights that Millet's *Des Glaneuses* is a widely known painting that has been reproduced ad nauseam in popular encyclopedias, whereas the tropos of the solitary female gleaner, as represented in Breton's piece, is a much less common occurrence in the history of art. Sure enough, and as if to pay homage to the historical fact, Varda's documentary concludes with yet another image of gleaning as a communal practice, this time represented in Edmond Hédouin's *Les glaneuses fuyant l'orage* (*The Gleaners at Chambaudoin*, 1897).

The fourth painting that appears in the documentary is an amateur piece that Varda finds in a thrift shop by pure chance and while filming the documentary. What is interesting about that particular rendition is that it is a capricious composite of Millet's *Des Glaneuses* and Breton's *La Glaneuse*, in other words, of gleaning as both a communal and a solitary practice. In fact, the painting should be read as a fitting mise en abyme of the documentary, since the latter derives its meaning from a rich variety of the two models. Varda's film is remarkable in its interpretation of gleaning as a practice that is still well and alive in contemporary France. But what makes it even more relevant is that it moves from the countryside to the city and identifies many instances of collective and solitary gleaning in the midst of Paris. Not unlike the deserted fields in rural France, urban Dumpsters, and trash sites too, turn into veritable "habitats," lived spaces that showcase the imprint of a particular modus vivendi. For Varda, discarded objects have the power of gathering around them whole systems of knowledge of which the status quo remains stubbornly oblivious. Capitalism caters to the upright entrepreneur and "doer" and pays little attention to all those who instead of standing straight live their lives bending over castoff potatoes on the fields or accumulated debris in the cities. But again, for the French director both rural gleaners and urban scavengers stand on, and generate wisdom, with their way of life. Her documentary shows a group of young outcasts who defy the law by Dumpster diving and trespassing, but in the process they uncover a far bigger crime, namely that of unscrupulous business owners who don't mind throwing out perfectly edible food items and even drowning them in bleach, so that nobody can retrieve them from the trash containers. Varda also carefully observes the movements of a lonely scavenger who every day roams among the leftovers of a farmer's market and busily chews on leafy vegetables. When she finally decides to interview him,

the subject of her curiosity turns out to be a highly knowledgeable chemist whose skills allow him to put together a perfectly healthy diet from what trash has to offer. The camera follows the scavenger to where he lives, which happens to be an immigrant shelter in the outskirts of Paris. Here, he spends the evenings volunteering as a French instructor.

Agnes Varda's filmic work has always shed a compassionate light on the lives of outcasts, as *Sans Toit ni Loi* (*Vagabond*, 1984), a documentary that reconstructs the life of a young female drifter after her death, cogently shows. But with *The Gleaners and I*, Varda goes a step further: her attention and compassion now center on objects, and the camera becomes obsessed with the beauty of the discarded and the unwanted. Very much in tune with Sygmunt Bauman's thesis in *Wasted Lives: Modernity and Its Outcasts* (2004), *The Gleaners and I* is a profound reflection on all that capitalism both generates and then rejects, be it a lonely drifter (like Mona, the protagonist of *Vagabond*), a solitary scavenger, a gypsy encampment, a community of gleaners or Dumpster divers, or simply an oddly shaped tuber. Throughout the documentary, farmers and gleaners alike point to the fact that big companies and supermarkets won't accept "misshapen" fruits or vegetables. Potatoes, for example, one of the leitmotivs of the documentary, will pass the test of "normalcy" (as well as the process of normalization) and be deemed apt for consumption only if they are medium-sized and uniformly round and compact. While following the gleaners on the fields, Varda discovers a number of heart-shaped potatoes. What makes them unappealing and "unsellable," however, is precisely what attracts the attention of the film director. She starts collecting them and, even more importantly, carefully watches, photographs,

and films the effects of decay. "I like to film rot, leftovers, waste," Varda states while pointing her digital camera to the rotting potatoes (Fig. 3.10).

Time, and the effect it has on things, is continuously present in Varda's documentary, and for good reason, since it is the passing of time precisely that makes trash happen. The fate of commodities is to irrevocably turn into garbage, to the point that over each gleamingly new product the phantom of its demise already looms. The aisles of commercial centers and supermarkets are dumping grounds *avant la lettre*, where the can already announces that it will rust, and the lettuce proclaims that it will wilt. Rot and decay, however, we tend to link with nature, so it is easier for us to imagine a wilted lettuce leave than a rusted can, and it is even more difficult to imagine a broken TV when surrounded by brand-new sleekness. Varda is aware of modern humankind's reluctance to predict decay when it comes to man-made objects, hence her pedagogical exercise of taking the viewer first out of the city and into the fields, to watch potatoes rot, and only then back into the urban landscape, to stand before piles of broken furniture, discarded TV's, and soiled mattresses. There is a constant back and forth in *The Gleaners and I* that takes the viewer from the city to the countryside, and back from the rural environment to the urban enclave. Urban scavenging is interpreted in the film as a continuation of rural gleaning, but at the same time the documentary also highlights the heavy influence of industrialization and serial production on contemporary agriculture: fruits and vegetables are subjected to a predominantly mechanized selection process that demands homogeneity and sameness in the appearance of the product, to the point that one could easily imagine a recreation of

Fig. 3.10: Agnes Varda, *The Gleaners and I*, Zeitgeist Films Ltd.

Andy Warhol's piece, with perfectly aligned identical tomatoes substituting for his famous Campbell's tomato soup cans.

Agnes Varda chooses the exactly opposite path, which is to collect the discarded and useless, and to reject the normative and still functional, and does so with deliberate redundancy, for with her camera she rescues not only artifacts, rural and urban, but also the people who glean and scavenge. In fact, in their marginality and "uselessness," discarded objects become the mirror and exact replica of the social outcasts that retrieve them from harvested fields and urban Dumpsters. Varda creates or, rather, highlights the redundant and replicating universe of all things, and all people, discarded. Moreover, within that universe, she stresses the seamless continuity that leads from the rural to the urban (and vice versa) but also firmly anchors the present to the past. One of the anchoring devices is art; the other is the law. As I pointed out above, nineteenth-century pictorial portraits of gleaning and *glaneuses* embellish the documentary in four different occasions, but lawyers, too, monopolize the screen at rhythmic intervals. The first lawyer to appear stands on a cabbage field in full professional gear, penal code in hand. He not only readily declares that gleaning is a perfectly legitimate activity as long as it happens after the harvest but also points out that it is an ancient practice, and that he has found legal documents dating as far back as 1554 that endorse it. The "rural" lawyer paints a jocular figure who despite his solemn attire seems to feel at ease amid cabbages. His defense of gleaning as

a long-standing practice is keen on empha-
sizing that the motivation for canvassing
the fields in search of castoff vegetables and
fruits can be other than hunger or hardship.
Surely, one is allowed to do it "just" for plea-
sure, since to experience pleasure, the lawyer
contends, is also a need that deserves to be
satisfied within the bounds of the law.

Once the documentary has established
that gleaning as a current rural practice has
the blessings not only of history and the
arts but also of the law, Varda directs her
camera toward the urban landscape once
more and now focuses on the legal impli-
cations of scavenging. In front of a pile of
bulk refuse on the streets of Paris, a female
lawyer this time, also in regalia and equally
holding on to the penal code, declares that
"the law of gleaning does not apply to these
objects. *Res derelictae* are ownerless things,
since the owner's intention has been clearly
expressed: they have deliberately abandoned
them. Only the penal code deals with their
status and says this property cannot be sto-
len since it has no owner. Those who take
the object become its legal owners. This ac-
quisition is unusual, since it comes from no
one. Once taken, the objects belong to them
irrevocably."

The redundant world of rural and urban
discarded items and social outcasts depicted
by Agnes Varda in her award-winning docu-
mentary is very different from the hygienic
utopia that the Dempster brothers built
around their revolutionary invention. The
closely sealed and efficiently traveling trash
containers of the affluent 1950s in Amer-
ica have given way to the phenomenon of
the lingering, open, and often overflowing
Dumpster, a piece of urban furniture that
is certainly much more than just that. For
as *The Gleaners and I* compellingly shows,
Dumpsters and their surroundings are often

a veritable habitat, the site and generator of
a highly complex world and modus vivendi
that maintains a precarious equilibrium be-
tween the public and the private. The dictum
of the French law, namely, that garbage is *res
derelictae*, an ownerless thing "that cannot
be stolen since it has no owner," seems pris-
tinely logical but has generated heated legal
debates nonetheless on American ground,
and around the very specific issue precisely
of the contents of urban Dumpsters. In Jer-
emy Seifert's documentary, *Dive! Living off
America's Waste* (2009), one of the featured
Dumpster divers somewhat humorously
states, "Never penetrate into something that
is not yours," which unavoidably makes us
ponder about the link between garbage and
property. According to French lawmak-
ers, trash has no owner, but American law
is less definite about it. For Joan Gross, for
example, it brings up the question of "when
an item ceases to be private property. Does
ownership transfer from the individual or
business or the waste management company
the instant an item is thrown in the dump-
ster, or is there a period of non-ownership
from the time it is disposed to the time it is
picked up?" (197–98).

What makes Dumpsters particularly in-
triguing is precisely the possibility of "a pe-
riod of non-ownership," and thus their abil-
ity to live (and fester) between worlds, the
world of the public and the private, and the
world of legality and subversion. Garbage
exists at the fringes, particularly at its early
stages, when it is still transient, and hasn't
arrived to its final destination, the landfill.
Landfill policies in the United States are
very clear: scavenging is strictly forbidden,
but these norms do not apply necessarily to
Dumpsters, or to what Ferrell perceptively
calls "little theaters of the uncertain and the
absurd," trash loci that "stage here and there

morality plays along the lines of marginality and illegality" (14). Indeed, trash is not "just" trash, but a semantically laden urban artifact or setting that invites "suspicious" activities (such as littering further, loitering, scavenging, Dumpster diving, or worse) and more often than not elicits the intervention of the law.[1] According to Ferrell, the American urban landscape showcases three primordial theaters of the absurd, namely, (1) the road itself, paved with litter (such as "pennies, quarters, lead wheel weights, small auto parts, lost tools, music CDs, aluminum cans, bits of copper pipe and wire, and other assorted detritus of urban movement"; 18); (2) the "curbside trash pile"; and (3) the Dumpster.

Ferrell points out that "in comparison with other scrounging theaters, streets are distinctive for their dispersion of lost or discarded items along a trajectory of movement" (18). But even more "static" and less scattered trash scenarios, such as the curbside trash pile, are not immune to transformation and dispersion. According to the author, "curbside trash piles tend to emerge out of two temporal dynamics, one regular, the other not" (19). In many American cities, the trash collection agencies function according to a regulated system and designate certain days for the disposing of "boxed, bagged, or stacked refuse on the street" (19). But then, as Ferrell notes,

> a second sort of curbside trash pile reflects not on regularity but disruption. These piles are the residues of significant life changes, many of them sudden: divorces, breakups, kids sent off to college, renters running out of rent. As such, these trash piles offer, in comparison to the twice-a-week trash piles, magnificent accumulations of discarded goods; sudden

tragedies, breaks in social continuity, can leave much of a person's material history piled up on itself. Because of this, curbside piles often incorporate also the material residues of shared meaning, fragments of emotion lost and found: bronzed baby shoes, diplomas, wedding photos, ticket stubs, old newspaper clippings. . . . Curbside piles at their extreme become material postmortems, life histories of relationships, accomplishments, and accumulations left at the edge of the street or alley. (20)

Ferrell thus implies that there are only two kinds of curbside piles, the neatly "boxed, bagged, or stacked" ones that follow state regulation, or the disorderly mess that sudden and unexpected life events leave behind. However, trash is, by nature, rebellious and resistant to containment. Neatly packaged debris for once invariably attracts the curiosity and the intervention of passersby, and more often than not castoff goods compressed in boxes or bags will end up strewn on the pavement. Also, trash is much more than the remnants (or "material postmortems," as Ferrell calls them) of sheltered domestic lives where there is money to bronze baby shoes, earn diplomas, and commission wedding pictures. The homeless, too, generate "trash," the worn sleeping bag and the heap of clothing on a corner, fleeting traces of yet another night spent on hard pavement. In any case, it is the nature of trash to spill over, and to expand, even when kept in what Ferrell sees as the "third theater of the scrounging," the Dumpster. Dumpsters, according to him, "denote a degree of permanence in the empire of scrounge, a relatively fixed point in the worlds of consumers alike, a receptacle into which trash can be tossed and from which it can be extracted" (20).

Trash is an unstoppable force, and its "degree of permanence," as Ferrell puts it, only relative. Garbage relentlessly moves from the inside to the outside, from behind walls into the streets. It has a seemingly unquenchable tendency to spill out, with literally hundreds of images of overflowing Dumpsters, for example, populating the Internet (see images of trash overflow in Figs. 3.15, 3.16, 3.17, and 3.18). One can only imagine the dismay of the Dempster brothers, had they lived to see the fate of their phenomenal invention, but one has to ask also, where lies the fascination with garbage that gets out of hand? Agnes Varda saw the abundance and unpredictability of nature in the garbage excess of the city and celebrated it as a life-generating habitat, and as both a repository and a source of meaningful knowledge. Even the law, in the form of two affable French lawyers placed in the midst of a cabbage field or in front of a garbage pile on a Parisian street, defended the usefulness (and beauty) of uncontained garbage, and the right to benefit from it.

Slavoj Žižek exhibits a similar degree of "trashfilia" in the very much quoted segment of Astra Taylor's documentary *Examined Life* (2008), where the Slovenian philosopher is shown pacing the grounds of a busy garbage transfer station, and passionately defending the need of openly acknowledging garbage in all its stinky materiality, instead of frantically trying to make it disappear from quotidian life. This, however, is not how (Western) society normally reacts when it sees trash on the streets, or Dumpsters filled to the brim (and beyond) with festering garbage. Its reaction is not to ponder about the nature and reason for existence of the discarded, or to extract wisdom from it or even beauty, but to try to control it and vanish it from view, Dempster brothers–

like. Images of overflowing Dumpsters are appealing to many because they facilitate moral judgment and subsequently act as an open invitation to exert power. Trash is not good; it needs to be removed. Or, as in the case of Dumpster divers, trash is not good; but it can attain redemption via recycling and reuse.

Although these two approaches could be interpreted as radically different and even opposed to each other—one defends the removal and destruction of refuse; the other believes in its "ecological" transformation and rehabilitation—both instances nonetheless are similar in their efforts of making garbage invisible, and, as I argue in the pages that follow, in their support and reaffirmation of the family unit as a motor of production, consumption, and ejection that keeps the capitalist machinery going. In his widely watched documentary *Dive! Living off America's Waste* (2009), film director Jeremy Seifert starts by denouncing the excess of waste that Western societies, and in particular the United States, generate. Standing in front of a group of Dumpsters, documentarian/actor Seifert holds up four different cardboard signs that state in big, black letters that "every Year in America we throw away 96 Billion Pounds of Food"; "3,000 pounds of food per second"; "11,000,000 pounds of food per hour"; and "263,000,000 pounds per day." The documentary then proceeds according to a simple pattern, where world misery and national poverty (the film displays stock images of hungry children from developing countries living in squalor and among trash, and of the homeless that populate the American urban landscape) are shown at regular intervals and serve as a backdrop to the Dumpster-diving practices of Seifert's own family (dad, mom, and a toddler boy). It is not clear,

however, what the rhythmic alternation of specificity (in the form of the consumption and food-recycling patterns of one small family unit of three in Los Angeles, California) and universality (in the form of "generic" world hunger and national poverty as portrayed in stock photos) is supposed to accomplish in the documentary. The obvious response is that the visual reminder of how pervasive and extensive hunger is worldwide will make the monumentality of wastefulness seem even more outrageous and criminal, and any effort at fighting it, no matter how small, even more compelling and necessary. However, there is a profound and disturbing dissonance between the reality of famine in the world and what the film presents as a possible solution, not only because Dumpster diving is *not* the panacea that will remedy hunger and poverty, but mainly because of how Dumpster diving (and even world poverty) are portrayed in the documentary. To resort to decontextualized stock images to talk about worldwide hunger and pain is already a highly problematic practice, as Susan Sontag's essay *Regarding the Pain of Others* so compellingly brings to the fore. But what makes it even more troublesome is the use of such images as background to a practice consistently portrayed as a leisurely sport and a fun outdoor adventure (Figs. 3.11 and 3.12).

To sugarcoat what is perceived as abject or dirty (such as sex) with humor is a common practice within Judeo-Christian tradition and also expands to the representations of refuse and filth in Western culture. Scatological humor is a signature trait of the Garbage Pail Kids trading cards, for example, and quickly finds its way into Seifert's documentary. In fact, in the latter, garbage manipulation not only adopts a jocular tone (in stark and frivolous contrast with the depiction of "real" poverty and need) but, even more noticeably, quickly turns into child's play. Dumpster diving is a thrilling adventure that requires a certain degree of fitness and dexterity, and the overcoming of physical obstacles. Men turned into boys excitedly venture into the night, canvas the darkness with flashlights, jump over fences, and eagerly dive into Dumpsters. White men, that is. Filmic and textual representations of Dumpster diving not only predominantly portray such practices as an adventure or an extreme sport but make sure to center around white characters, for theme and plot would turn into something entirely different if the main actors were to be dark skinned. Read the sentence I wrote above, and that I transcribe again below, with a Latino or an African American male in mind ("men turned into boys venture into the night, canvas the darkness with flashlights, jump over fences, and eagerly dive into Dumpsters"), and witness how in no time Dumpster diving metamorphoses from a harmless and even uplifting tale into a somber account of delinquency and violence. Playfulness and humor would rapidly vanish, and give way to fear and a sense of danger. Moreover, "men turned into boys" probably would need to be replaced by its exact opposite, "boys turned into men," for if male Latino or African American youth were to be found Dumpster diving, chances are that they would be perceived and judged as grownup men rather, engaged in suspicious activities. This hypothetical (though rather probable) incident stands in stark contrast to a "parallel" scene in Seifert's documentary. The camera shows a policeman approaching a Dumpster diver and engaging in friendly conversation with him. The police officer politely reminds the white male scavenger that he is trespassing private property and then grants him ten

more minutes to finish up his hunt for edible treasures. The episode concludes with the police officer and the Dumpster diver shaking hands amicably.

Dumpster-diving literature—be it in the form of documentaries, written narrative accounts, or guides—is less "harmless" than it appears, in its obstinate adherence to whiteness and white male privilege and its seemingly willful ignorance of how the color of the skin radically changes the meaning and consequences of urban scavenging. It is also quite oblivious or indifferent to the fact that more often than not it replicates patriarchal gender roles and even reaffirms the capitalist structure that it aims at dismantling. Despite its location in Los Angeles, *Dive! Living off America's Waste* portrays or rather mimics a rural world. This is very common in Dumpster-diving accounts, where the activities around urban scavenging remind us of hunting and harvesting practices (as Varda's documentary eloquently emphasizes), and where the nostalgic longing of the fairly well-to-do (male) urbanite for a more "natural" and physically exerting mode of sustenance come to the fore. In Seifert's documentary, these elements and their patriarchal underpinnings are taken to the extreme. Seifert himself as the main actor is the vigorous and untiring provider for his family. After his nightly Dumpster diving/hunting excursions, he comes back proud and laden with goods, and it is his wife's arduous role to carefully sort through the items, and to discard what is not edible. (We never see the wife, or any other female character, for that matter, engaged in Dumpster diving, or even outside of the domestic domain.) Like a movie from the 1950s and 1960s, *Dive! Living off America's Waste* too showcases a generously stuffed refrigerator (living proof that the man of the house is a good provider)

and often portrays the family sitting around the dinner table, or having friends over at barbeques where the Dumpster diver hero proudly grills scavenged steaks.

"Recycling" or reusing garbage as represented in Dumpster-diving literature will not end endemic famine, for it does not attack the core of the problem, namely, savage capitalism as the tireless promoter of global social and economic inequality. In fact, filmic documentaries à la Seifert further reaffirm the capitalist modus vivendi, by insisting on the principles of relentless acquisition and amassment. Soon, the small group of Dumpster divers featured in the film and whose center of gravity is Seifert's nuclear family of three will keep a donated oversized freezer in the garage to store all the excess of scavenged food. Not unlike supermarkets and food stores, homes of Dumpster divers too become an homage to accumulation and seemingly endless variety and choice. Moreover, urban scavengers often gleefully showcase their findings, and it is fascinating to observe how their artful arrangements of recovered commodities eerily mimic the way in which stores organize and display their goods (Fig. 3.13).

Dumpster bounty has even found its way into art. Artist Aliza Eliazarov puts together still-life compositions with food retrieved from trash containers near Columbia University in upper Manhattan (Fig. 3.14). In Eliazarov's photographed organization of refuse, the nascent capitalism of the Renaissance holds hands with today's full-blown one. Like the Dutch painters whose style she consciously and skillfully recreates, the Brooklyn artist acknowledges the beauty of consumables and builds a monument to edible commodities. Sure enough, both in Eliazarov's art (Fig. 3.14), and in contemporary Dumpster-diving practices (Fig. 3.13),

Fig. 3.11: Jeremy Seifert, *Dive!* A Film by Jeremy Seifert.

Fig. 3.12: Jeremy Seifert, *Speedo Photo*, taken by Amanda Hlavaty.

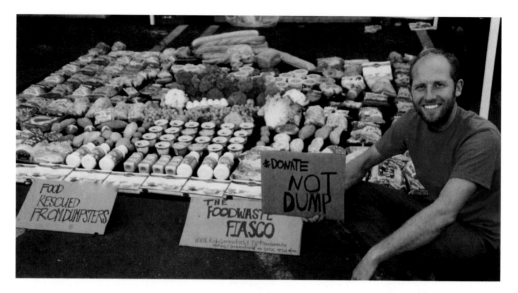

Fig. 3.13: Rob Greenfield, *www.RobGreenfield.tv/foodwaste*.

the careful arrangement of trash replicates the equally painstaking and often highly aestheticized layout of commodities in commercial displays and shop windows.

The world of commodities and the world of discarded artifacts share the same fascination with two paradigmatic opposites, chaos and order. The seduction of objects, at both their useful and subsequently useless (trash) stages, is that they are equally skilled at relentless accumulation (chaos), and similarly pliable to taxonomy (order). Thus, it doesn't come as a surprise that the still-life genre, keen always on creating order and harmony with objects, finds discarded artifacts as inspiring and malleable as their still "functional" counterparts. Nor is it unexpected either that yet another trope or genre, that of the chaotically bursting horn of plenty, which goes back to Greco-Latin antiquity, lends itself to similar artistic subversion, and immersion into the terrain of the discarded. Overflowing Dumpsters, for example, easily suggest overflowing cornucopias—Figs. 3.16 and 3.18 showcase

Filomena Cruz's attempt at imagining trash-laden horns of plenty—though perhaps not vice versa: somehow, it is easier for humans to move from production and consumption to ejection, than to proceed "backward" (Figs. 3.15, 3.16, 3.17, and 3.18).

Still, at the end, and in Western societies at least, chaos and overspilling unavoidably call out for order and containment. In *The Ethics of Waste: How We Relate to Rubbish* (2006), Gay Hawkins refers to trash and to the human manipulation of garbage as "a cultural performance, an organized sequence of material practices that deploys certain technologies, bodily techniques, and assumptions. And in this performance waste matter is both defined and removed; a sense of order is established and a particular subject is made. Waste, then, isn't a fixed category of things; it is an effect of classification and relations" (1–2).

Hawkins then reminds us of Mary Douglas's "most quotable quote" in *Purity and Danger*, "Where there is dirt there is system" (44), and as part of such a system,

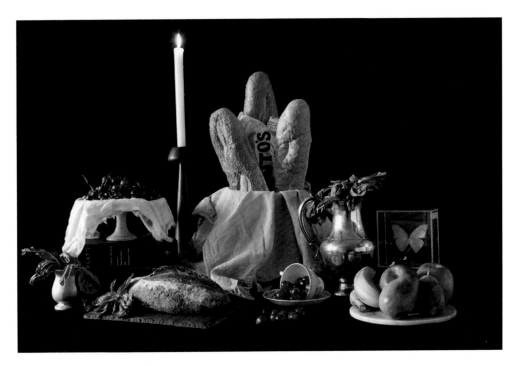

Fig. 3.14: Aliza Eliazarov, *Cobble Hill*, Series *Waste Not*.

the chaotically overflowing Dumpster (that exerts so much fascination on the Dumpster diver) and the carefully arranged goods retrieved from trash containers are two sides ultimately of the same coin. Not unlike capitalism, Dumpster diving too falls prey first to the fascination with excess and then to the impetus toward taxonomy and regulation. Refuse itself becomes the target of taxonomy (what are recycling centers but businesses that make money via a complex and highly efficient classification system?), and of secure containment. In fact, more and more, refuse is kept behind bars or in tightly locked containers, so that only authorized parties who pay for the disposal service have access to them, but also to keep away scroungers (Figs. 3.19, 3.20, 3.21, 3.22, and 3.23).

Dumpster divers frequently complain about the growing number of commercial Dumpsters and trash bins made inaccessible, and how scavenging for discarded food or other usable items often requires jumping over fences. Indeed, locked Dumpsters and barred trash bins have become a common sight of the contemporary American urban landscape, and the locus of the locked Dumpster or the Dumpster behind bars, the site where the law can exert its power. For while scavenging is generally not considered unlawful, what makes it so is precisely the fact that more often than not it involves trespassing and on occasions damage also to private property.

Above I made reference to Ferrell's perceptive observation of Dumpster trash as enjoying a "period of non-ownership." It is true that before garbage is transported to the landfill, Dumpsters can give trash a sense of freedom. Refuse becomes alive, because it is out on the streets, accumulating in urban containers to which many people—

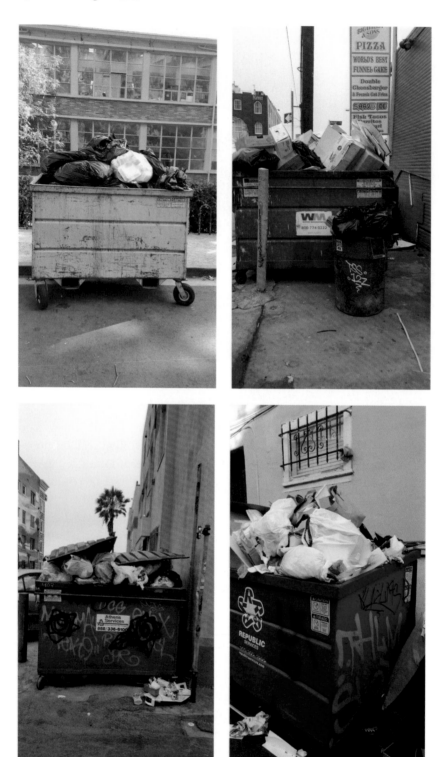

Fig. 3.15: Filomena Cruz, photographs. *Dumpster Series*. Los Angeles, CA.

Fig. 3.16: Filomena Cruz, collage. Series *The Horn of Plenty*. Venice, CA.

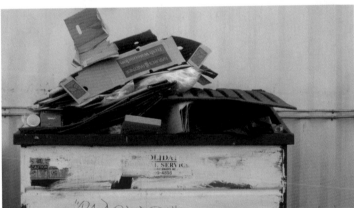

Fig. 3.17: Filomena Cruz, photograph. *Dumpster Series*. Venice, CA.

Fig. 3.18: Filomena Cruz, collage. Series *The Horn of Plenty*. Venice, CA.

Fig. 3.19: Filomena Cruz, collage. Series *Trash Behind Bars*. Venice, CA.

homeless scavengers and can collectors, free-gans and Dumpster divers, artists interested in discarded materials, and others—have unrestricted access. But again, behavior and measures around refuse are changing and becoming less lenient, though in a some-what disorganized and unplanned manner. As a consequence, there are now intriguing urban sceneries in place, such as the one photographed in Fig. 3.21. It shows a park-ing lot where trash has taken center stage, and, even more importantly, where garbage and garbage containers reveal different de-grees of access. In the middle of the parking lot there is a veritable refuse fortress, where three or four massive Dumpsters (it varies) are kept behind tall, densely meshed fences, with menacing spikes pointing toward the sky (Figs. 3.20, 3.21, and 3.23). Farther away at a corner a brightly green Dumpster stands alone and free, though upon closer scrutiny, it becomes evident that a secured bar keeps it tightly locked (Fig. 3.22). Fi-nally, diagonally from the garbage fortress and the standing-alone Dumpster, there are two trash cans with closed but unlocked lids. More and more, Ferrell's hypothesis of street trash enjoying a period of nonownership in American cities is losing its veracity. In fact, the semantics of trash is becoming increas-ingly complex and contradictory. Usually, and as opposed to "private" rollout trash cans, Dumpsters would send out the signal of being "public" (or at least "more public"), and thus accessible to scavenging. But in the example mentioned above, it is rollout trash cans that are accessible, whereas "public" Dumpsters turn into hermetic containers: in stark contrast with the second half of the twentieth century and its open-Dumpster landscape, the Dumpster panorama of the first half of twenty-first century is becoming surprisingly similar to that of the beginning

Fig. 3.20: Filomena Cruz, photograph. Series *Trash Behind Bars*. Los Angeles, CA.

Fig. 3.21: Filomena Cruz, photograph. Series *Trash Behind Bars*. Los Angeles, CA.

Fig. 3.22: Filomena Cruz, photograph. *Dumpster Series*. Los Angeles, CA.

Fig. 3.23: Filomena Cruz, photograph. Series *Trash Behind Bars*. Los Angeles, CA.

of the twentieth century, when the Dempster brothers widely succeeded in populating the streets with their tightly closed and hygiene-minded invention.

Gendered Filth: On the Dangerous Beauty of Dumpsters

There is a certain childish silliness to (white male) Dumpster diving practices, a tendency to "play" (to play shopkeeper, for example, as in Fig. 3.13), and to commit "innocent" acts of juvenile recklessness, such as jumping fences or launching head on into the dirty contents of a Dumpster (Figs. 3.24, 3.25, and 3.26).

Repetition and serialization have the power to intensify the humor behind a particular scene or motif. Male legs protruding from Dumpsters, for example, and as shown above, become even sillier when there is a series of them. However, and as is frequently the case, humor can also be the (rather imperfect) disguise of a more serious and even somber reality. For one, there is a significant semantic kinship between the popular images of men jumping into Dumpsters and burying their heads in trash, and Austrian illustrator and writer Alfred Kubin's drawing of a tiny man with an erect penis propelling himself into a gaping giant vagina (Fig. 3.27). Titled *Der Todessprung* (*Death Jump*, 1902), it is the symbolic representation of Freudian theory on the castration complex. One more version of the modernist tropos of the *vagina dentata*, Kubin's rendition feeds on the cliché of female sexuality as danger and of female genitalia as a site of contamination that simultaneously attracts and repels.

Semihidden and often relegated to back alleys but still visible, Dumpsters open their gaping mouths and both gulp down and excrete filth. Like clichéd prostitutes, they stand on corners, waiting. The Urban Dictionary defines the Dumpster as "a large metal container in which garbage is disposed," but also immediately after as "a slang term for an ugly woman who dresses provocatively to desperately attract men."[2] According to the same dictionary, Dumpster means "slut." "It is the [abbreviated] slang term for the term 'cum dumpster,' describing a loose woman; a woman who frequently pleasures men in the art of sex without thinking of consequences or disease."[3] The image in Fig. 3.28 certainly caters to the pejorative meaning widely embraced by popular culture. The black and red of the female sculpture seamlessly blends in with the black and red of the graffiti-covered Dumpster. The eye flows effortlessly from the sculpture to the trash bin,

Fig. 3.24: Courtesy of *Shutterstock.com*.

Fig. 3.25: Courtesy of Getty Images (US) Inc.

Fig. 3.26: Courtesy of Getty Images (US) Inc.

and back. The image conveys a strong sense of belonging: apparently, there is nothing alien, or ill-fitting, about a woman sitting on top of a Dumpster, scantily clad, wide legged, and high heeled, in the same way in which there is seemingly nothing "wrong" or strange with the increasingly popular "trash the dress" trend (a style of wedding photography that portrays brides posing on beaches and in abandoned buildings, vacant lots, and landfills, and purposely wetting and dirtying, and even tearing and destroying their gowns), or with fashion shows using refuse as their theme and prime material.

"Trashion" (that is, fashion made out of all things discarded) is now a consecrated term, and even well-established designer firms, such as Moschino, have dressed their models in trash and put them on runways (2017), or modeled and photographed their collections in a landfill, as was the case with designer Michael Cinco's eco-friendly couture in 2011, featured in one of the episodes of the popular TV show *America's Next Top Model*. One of the shots, for example, depicts a female model in a long ball gown fitted with a flowing cape (both the dress and the cape are made with black shiny garbage bags) posing in front of a monumental trash heap (PhillyGreenGirl). The image has a strong pictorial resonance. It reminds us of the tradition of landscape painting during the romantic period, where the tropos of a lonely figure (often female, and the result of male artistry) standing against the backdrop of imposing nature became a frequent occurrence. In this case, however, the background is not a "natural" mountain range, but a veritable trash mountain, with a bulldozer on top of it trying to sculpt garbage into shape. The concoction of the natural and the artificial (and of the male and the female) is one of the most salient (and stereotypically

conventional) features of the photograph. Man-made refuse mimics natural topography (a machine, in fact, is busy building and recreating nature), and plastic shapes human anatomy. "Male" technology and its products (the iron of the bulldozer; the plastic of the garbage bag) rein in "female" nature (decomposing matter; female flesh).

Trashion shows and landfill shooting sessions further emphasize the seemingly inextricable bond that ties women to refuse, but they also replicate and thus strengthen the long-standing affair between women and "new" commodities. Much has been written about the role women play as consumers in capitalist societies (Dalley and Rappoport; Grazia and Furlough; Hilton; Lysack; Remus; Sandlin and Maudlin; Silverstein and Sayre). During the nineteenth century, the figure of the female shopper not only took the Parisian boulevards by storm but also heavily populated the European

Fig. 3.27: Alfred Kubin, *Death Jump*, 1902 (public domain).

Fig. 3.28: Diane Kurzyna (aka Ruby Re-Usable), *Dumpster Diva* (repurposed plastic bags, bubble wrap, packaging tape, aluminum pop tops, photographed by Ruby in Olympia Freewall Alley).

realist and naturalist novel, and in the 1950s, the American advertisement industry flooded TV and printed media with brightly colored images of young housewives vigorously pacing the supermarket aisles and overloading shopping carts with goods. The long-standing tradition of tying women to consumerism and of surrounding them with consumer goods further reverberates in the countless images of women supposedly feeling comfortable around trash. For one, the "thingness" of a discarded artifact is not different from the "thingness" of a commodity deemed useful and worth keeping, and it is precisely this palpable materiality of the object (discarded or not) that serves as a mirror to the "thingness" of the female body.

Women and objects thus belong together and find each other in the intimacy of the boudoir, the bustling activity of shopping centers, and the hidden vastness of landfills. And sometimes, discarded artifacts and female anatomy also collude in urban trash containers. To stuff women into garbage bags is not only a fashion statement, but a sinister reminder that when the phrase "body found in a Dumpster" appears in the news, more often than not that body is female. The binary "gender violence and Dumpsters" has evolved into a cultural cliché by now and has made it into Google images, movies, popular fiction, and even video games. But it also remains a grim reality that once again rose to prominence in January 2015, when a young woman, who was brutally raped behind a Dumpster by Stanford freshman and champion swimmer Brock Turner, wrote a powerfully harrowing public letter about the crime committed against her that quickly went viral.

How does one deal with gendered artifacts tainted with blood? What does art do with, and to, an object whose dense semantics loudly and consistently bespeak marginality, crime, and gender violence? Intriguingly enough, artist C. Finley decides to counterbalance urban violence with a "domestic" touch. For more than ten years now, she has been busy wallpapering Dumpsters, and her Dumpster "interventions" have left traces in Rome, New York, and Los Angeles (Figs. 3.29 and 3.30). "It is a simple concept," Finley told the *New York Times* in 2010, "beautifying an ugly object, and the Dumpsters bring together the three things I really care about: art, women, and the environment" (Green). "Wallpapered dumpsters," Finley expands further, "transform environmental activism into unexpected beauty. I like to think of these interventions as polite graffiti. This project is an inquiry into urban waste, free art, and notions of femininity, beauty and domesticity" (Messenger).

By calling her new art form "polite graffiti," Finley acknowledges the harsh reality of bulky metal trash containers turning into effective canvases for urban rebellion. However, she then decides to turn such reality upside down, or, rather, "outward in," for Finley's Dumpsters not only are "polite" but speak the international language of quaint domesticity: Finley's Dumpsters are "so pretty and so domestic, said Catherine McMillan, a passer-by who was visiting from Melbourne, Australia" (Green). Furthermore, Finley not only makes what is urban and public domestic and private but turns art into an arts and crafts project. In the 2015 online piece "Q&A with C. Finley: An Update on Wallpapered Dumpsters," the artist announces that she created a video called *How to Wallpaper a Dumpster* (available on Vimeo and YouTube) that explains the step-by-step process best, but one can also simply follow these instructions:

Fig. 3.29: C. Finley, *Wallpapered Dumpsters*. Port of Los Angeles, 2006. Photo by Lindsay May.

1) Find a dumpster that is not near a grocery or fishmonger (paper/wood etc.); 2) Ask a friend to help you wallpaper a dumpster; 3) You will need two rolls of wallpaper, wallpaper paste, chip brushes, scissors; 4) Precut the wallpaper for the first strip and put the glue on the dumpster then apply the paper. Each additional piece needs to follow the pattern (so you can't precut them all); 5) Work on the fly with scissors to do all of the detail work (this does not need to stay in line with the pattern). If you have the large pieces on the front and back stay with the pattern, the small pieces work out visually without the stress; 6) Photograph your amazing work and send me a pic! (D. J. Johnson)

Finley's intervention swiftly and deliberately turns art into arts and crafts, Dumpsters into domestic objects, and women into home decorators keen on imprinting "feminine beauty" on the urban environment. The question here is, what does the persistent "marthastuartification," and thus ultimate miniaturization and domestication of Dumpsters seek to accomplish? Finley's point of departure for her artistic intervention is quite simple: in agreement with the author of one of the articles on her work, she too believes that "there is nothing unsightlier than a graffiti emblazoned dumpster, filled to the brim with all manner of trash" (Messenger). Turning a blind eye on graffiti as a powerful means of expression, and on Dumpsters (and trash) as the site of highly complex and often contradictory semantics, Finley suggests "feminine politeness" as a solution. Rather than letting the Dumpster speak freely, rather than carefully listening to what urban refuse has to say,

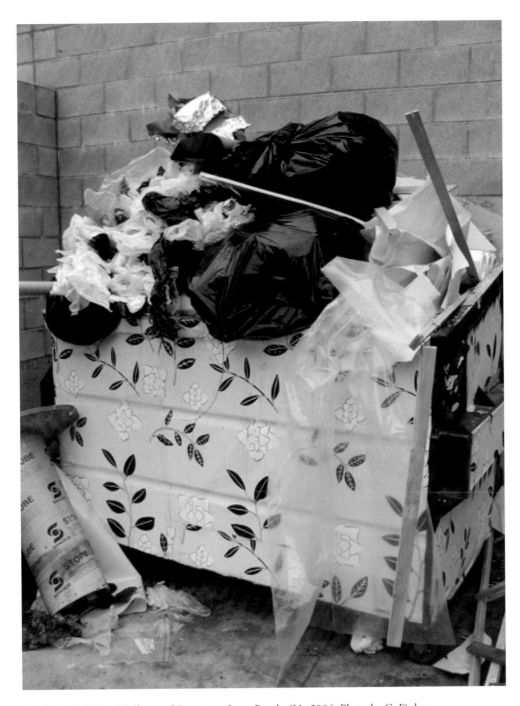

Fig. 3.30: C. Finley, *Wallpapered Dumpsters*. Long Beach, CA, 2006. Photo by C. Finley.

the artist chooses to muffle any strident sound with the help of wallpapered quaintness. Finley's seemingly uncritical embracement of the "values" of femininity and domesticity, and her effort to exert her wallpaper decoration skills on trash containers, effectively, and literally "covers up" the fact that Dumpsters indeed are "dangerous" artifacts, the site often of violence exerted against women, "dirty objects" that patriarchy readily assimilates to female sexuality. Or perhaps not: perhaps wallpapered trash bins are eloquent indeed, and subversive against their will, for they certainly speak to ingrained perception of Dumpsters as gendered. Beautifully clad in decorative paper, Finley's Dumpsters look frail suddenly, and out of place. Exposure to the elements will eventually tear the paper garment, flesh will shine through, yet another filthy Dumpster/cunt hiding in a back alley or soiling a parking lot.

4

Dirty Innocence
Childhood, Gender, and Muck

Among the dirty, children are always the least repulsive, and thus the least menacing, and we need to ask ourselves why. It is not only because children are stubbornly innocent and invariably "cute" (in truth, the concept of cuteness, and of what is cute, and for what reason, demands further study), no matter how caked their skin is with grime, but because the filth on a prepubertal body is easily removable. In other words, children are redeemable. Society can work wonders on them, scrub their endearingly smudgy faces clean until rosy skin shines through, and teach them "proper" behavior. Dirt on a child is a glorious invitation to intervene successfully, in typically Victorian or Prussian fashion.

Children and dirt are close friends, not only because they generally don't shy away from grime and even delight in it, but also because Western culture has made a point of consistently linking filth to infancy, and by extension to women, to the lower social classes, and to whole cultures deemed "childlike" or "primitive" (Cox; Hoy; Vigarello).[1] Freudian emphasis on the anal stage in child development certainly reaffirms the connection between childhood and muck, while at the same time sending the consoling message that coprophilia is a transitory phase and won't ail the mentally sound and (hetero)sexually healthy adult. Hence dirt on an adult, particularly if that adult

is female, is heavy with reproach and blatant (stinking) proof that society's taming apparatus has failed miserably. Patriarchy's frustration with women lies precisely in the fact that they are cyclically and rebelliously "dirty," and therefore beyond redemption. Whereas one can at least partially control the urge to urinate or to defecate, there is no volitional stopping of menstruation or lactation. Fluids will keep emanating from the ripe female body, its "dirtiness" a slap in the face of repressive male power. Children can be potty trained; women, ultimately, cannot.

In the same way in which the (so very difficult to attain and to preserve) "purity" of women often becomes the thermometer of the moral temperature of a nation (R. Johnson; Zubiaurre, *Cultures of the Erotic*; Zubiaurre, *El espacio*), "clean" (or rather "cleanable") children also symbolically stand for a healthy and powerful country or political system. "Cleanliness" is not a natural state, since we all come to this world smeared in blood, thus "to be clean" is to say that some entity has exerted its "cleansing" and "civilizing" powers on us. In contemporary Western culture at large these powers happen on many levels, and discourses fostering hygiene in children and a love for all things squeaky clean densely overlap.[2] But whereas the authoritarian streak that emanates from (often punitive) pedagogies

around personal hygiene has received a fair amount of scholarly attention, critical literature on the cultural representations and discourses around childhood, solid waste, and waste management has remained intriguingly sparse.

And yet these discourses and representations abound, particularly in the context of American popular culture but also beyond, and fan out into different genres and means of expression, from online visual imagery, news articles, documentaries, films, video games, and trading cards, to adventure novels for young adults, (female) children-of-hoarder autobiographies, and stories for young readers. The various genres look at the children-plus-trash composite from different and often complexly nuanced angles, but there is one main divide, namely the one that separates the representation of "third world" filth (and the children in it) from the depiction of childhood and waste in affluent countries. Mainstream American (and generally Western) culture is keen on producing pedagogical literature and imagery that puts children in contact with trash only when it is "controlled" and as an opportunity to teach them a lesson in environmentalism via waste management of the "cleanest" and most effective kind. And all this happens against the "dirty" background of garbage dumps overseas, and of innumerable Google images fixated on feral children living among piles of rotting trash.

The Allure of the Washable: From Trash Dump Children to Garbage Pail Kids

Few subjects and material realities are as chillingly eloquent as trash when it comes to visually representing the abysm that separates affluent childhood from its less privileged counterpart. As Lolita Petrova Nikolova points out,

> For many reasons, the children of the world not only increase the quantity of garbage, because of expanding consumer patterns, but are also exposed to greater amounts of human garbage that in some cases are deadly. In cities like Cairo, Egypt, children comprise up to 50 percent of the labor resources involved in waste cleanup in the streets. There is a gender division: boys pick up the garbage, while girls help the women in sorting the garbage. Children and adults that live or work near hazardous landfills are at greater risk for disease and suffer adverse health effects, including cancer and damage to the fetus in pregnancy. ("Children," 114)

Although Cairo, Egypt, is often used as a well-researched, paradigmatic example—and is the subject of two impactful documentaries, Engi Wassef's *Marína of the Zabbaleen* (2008), and Mai Iskander's *Garbage Dreams* (2009), that merit further discussion later in the chapter—children living among and from trash remains a tragic reality in many developing countries, among them Brazil, Cambodia, China, Ghana, Guatemala, Mexico, Nicaragua, Nigeria, India, Indonesia, Paraguay, Sierra Leone, the Philippines, and Vietnam. According to current statistics, "15 million people in the developing world today survive by salvaging waste, [and] many of them are children" (Watson).

Certainly, the visual representations of the e-waste epidemics that befall China and Africa seem to confirm the hypothesis that children are particularly affected by it. If one types the keyword "e-waste" and chooses to click on "Google Images" the screen fills up

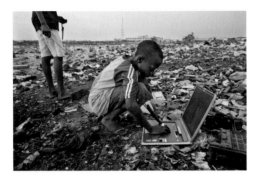

Fig. 4.1: Image by Andrew McConnell/Panos Pictures.

Fig. 4.2: Photo by Natalie Behring.

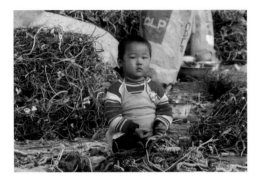

Fig. 4.3: Photo by Natalie Behring.

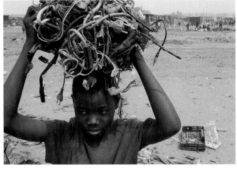

Fig. 4.4: Peter Essick/picDetailCopyrightAddition.

immediately with picture after picture of desolate trashscapes where an avalanche of discarded computers and electronic appliances advances toward the horizon and creates imposing mountains. More often than not the e-topographies are sparsely populated, an eerie prophecy of a polluted planet where tiny forlorn figures—mostly children— sort through electronic trash, play with broken laptops (Fig. 4.1), look at the camera unsmilingly or grin at us through the frame of a shattered TV screen (Fig. 4.2), sit there among a pile of entangled cables (Fig. 4.3), and carry those on their heads (Fig. 4.4).

Guido Viale's observation that the trash world is "complex and symmetrical to the world of merchandise" (quoted in Vergine, 11), turns intriguingly inaccurate when it comes to the social fabric of many of the e-waste dumps in developing countries. In fact, we should think of electronic wastelands as the exact opposite of the high-tech corporate landscape. The aura of hypermasculinity that to this day is a firm landmark of Silicon Valley (and more recently Silicon Beach, now that the digital corporations have taken Venice, California, by storm) vanishes when obsolescence strikes and high technology fills foreign-based garbage dumps to their capacity. Here, women and children replace men, their nimble fingers patiently and dexterously disassembling the electronic wonders that Western affluence is so quick to produce, and even quicker to discard.

But women and children not only work in e-dumps; they also populate "all purpose"

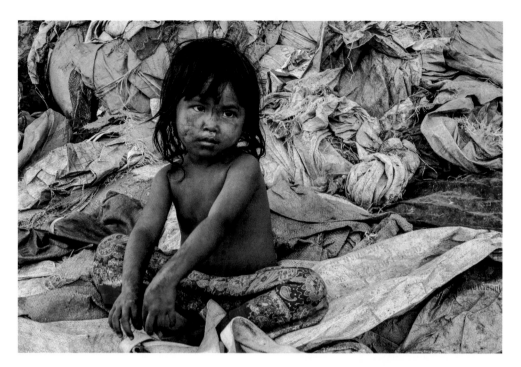

Fig. 4.5: Photo by Omar Havana.

garbage pits, and, as expected, images abound of underaged scavengers sorting through all kinds of refuse. Among these images, the one by Spanish photojournalist Omar Havana reproduced in Fig. 4.5 shows up again and again on the computer screen. In fact, it is even used for teaching purposes; in other words, it is deemed "safe" for (Western) children to see and to derive useful lessons from it. Cristiana Ziraldo's blog on Andy Mulligan's popular young adult novel *Trash*, for example, uses the image (and a second similar one not reproduced here) to elicit commentary from the students: "These children may tell you their stories, if you are interested in listening to them. What questions would you like to pose them? What do you think they are thinking of? They are looking directly into your eyes, what are those eyes telling you?" (Ziraldo).

Ziraldo's "pedagogical" exercise invites a number of stern considerations directly related to Susan Sontag's poignant reflections on the ethical implications of "regarding (and portraying) the pain of others," and, in this case, of further exploiting it for the "educational" benefit of the well-to-do. What we have here are children from affluent countries deliberately instructed to look at undeniably cute (or "cutified") counterparts from less privileged corners of the world, and thus to learn that they have the power and the prerogative to interrogate them and to probe into their lives and the squalor of their surroundings from the vantage point of squeaky-clean homes and schools: What is your story? What are your thoughts? You are looking directly at us (Ziraldo implies), so we have the right to look at you; in fact, we have the right to determine with all certainty that you are pleading for our support and thus acknowledging our superior power as your (potential) savior.

In a country famous for its long-standing and ever-persisting puritanical streak, we painstakingly train our offspring in the pornographic gaze. Western children required to look intently at pictures of landfill children and to pose questions like the ones mentioned above eerily remind us of the institutionalized apparatus and imperialist modus operandi of nineteenth-century ethnography. Moreover there is a disturbing correlation between the fin de siècle erotic postcard that provided our ancestors with a generous and widely distributed supply of seminude prepubescent "ethnographic" beauties from the African colonies and protectorates, and the limitless repository of images of equally prepubertal and scarcely clad "landfill flesh."

If there is "natural" and "redundant" dirt (filth on a female body or a landfill child is often sexualized filth on filth), there is also the "unnatural" or "artificial" kind, which is easily removable, and, more important even, deprived of pejorative nuances. It is the glorified dirt, for example, of soldiers, cowboys, adventurers, football players, and male and hypermasculinized heroes at large, so dear to Hollywood iconography, or the "honest" sweat and dirt of hard-working peasants and factory workers who wash up on Sundays to get ready for church. It is also the big blotches of mud and dirt sullying the body and face of "Rob Slob," or the grotesque amount of quickly solidifying snot coming out of "Nose Drip Skip," two of the characters of the hugely popular trading card series Garbage Pail Kids.[3]

"Rob Slob" and "Nose Drip Skip" stand respectively for rural and urban America during the Reagan years, their overfed bodies a cogent proof of national wealth and prepotency. The trading card that depicts "Rob Slob" shows an overweight boy sitting in a shallow pond, his upper body and face covered with blotches of mud. His piggishly round and rosy anatomy and face, however, are only temporarily soiled, for his surroundings are clean, and green, and water and skies reassuringly blue. Unlike children living in the dump, and thus engulfed in trash and squalor, "Rob Slob" can easily escape filth, if he so wishes, and wash off muck. "Nose Drip Skip," another male character in the Garbage Pail Kids series, has a similar story to tell; in fact, he uses filth, in this case nasal mucus, to his advantage. The card shows a boy wearing a green jacket and a green felt hat climbing up a sturdy pole made of the snot that comes out of his own nose. Bodily excretions and filth do not hold him back; on the contrary, they make it possible for him to climb up, and up, and up, well above the sterilized skyline of a nondescript city, a parodic version of the all-famous "Jack and the Beanstalk."

The contrast between clean-and-sanitized and dirty-and-unsanitary is a recurrent motif throughout all Garbage Pail Kids series. As happens with the gleaming glass-and-steel skyline that serves as backdrop to "Nose Drip Skip's" revolting snot (not bean) stalk, temporary, artificially "staged," and over-the-top display of dirt also happens in the midst of suburban sanitized bliss. Unlike landfill iconography, where filthy skin seamlessly blends with vast, grimy surroundings, excremental excess, Garbage Pail Kids–style, "happens" only against the unpolluted and "washable" background of spotless tiles and gleaming bathroom fixtures. The card that depicts "Boardin' Jordan," for example, shows a boy happily surfing a "fecal tide" forcefully coming out of an otherwise sparkling toilet. And yet another card depicts a girl dubbed "Cornelia Flake," who sits on a gleaming bathroom floor and eats corn flakes from the toilet bowl.

To be able to wash off dirt makes all the (social and gender) difference. It creates a

reassuring ritual of renewal and purification that ultimately speaks of power, the ability to tame nature, and the obstinate will to use it to one's advantage. Sure enough, both "Nose Drip Skip" and "Boardin' Jordan" adroitly climb and surf grime, thus turning scatology into a sport (in the vein of Dumpster divers, as discussed in Chapter 3) and into yet another opportunity to show off their physical condition and superiority. "Cornelia Flake's" story and rapport with filth, however, is a very different one, and one that has everything to do with gender. Unlike her male counterparts, who proudly reign over filth and mold grime to their wishes—in one case, snot becomes a strong stalk to climb; in another, toilet water swells into a mighty wave to surf—the "Cornelia Flakes" of the Garbage Pail Kids world (and beyond) hold no power over muck; to the contrary, filth engulfs them until they become filth themselves. Cornelia looks at us with the big, helpless eyes of a baby while she eagerly gulps down her toilet bowl "cheapios" drowned in fecal water. Stuck in the anal phase, her arrested development will make it impossible for her to distance herself from grime and gluttonous coprophilia. In fact, the dozens of artists and illustrators (the great majority of them male) that over the past thirty years have been contributing to the Garbage Pail Kids trading cards have never really diverted from the "Cornelia model." The motif of the "unredeemable dirty girl" viciously repeats itself throughout the different series of the collection, with a number of characters, such as "Oozy Suzy," "Leaky Lindsay," "Mushy Marsha," "Jenny Jelly," and "Smelly Sally" painfully attesting to it.

Although the Garbage Pail Kids collection was ultimately banned from schools throughout the United States, it was done for fairly innocuous reasons. Teachers insisted that the trading frenzy of the hugely successful Garbage Pail Kids cards was so intense, that, in the fashion of today's cell phones, it distracted students from paying attention in class. Parents and adults in general sided with the teachers and declared the cards disturbing for their emphasis on scatological humor. A more critical and in-depth reading of the card contents, however, was notably scarce, despite the fact that the "humorous" surface of the cards barely disguises its often blatantly misogynist streak.[4] Little girls in particular appear systematically represented as precocious "Lolitas" via filth, their bodies always morbidly soft, moist and protofertile, with a tendency not only to turn mushy and jelly-like ("Mushy Marsha"; "Jenny Jelly"), but also to "ooze" and to "leak" ("Oozy Suzy"; "Leaky Lindsay") and to give away a "fishy" and thus distinctively sexual odor ("Smelly Sally"; "Fishy Phyllis").

Moreover to the systematic misrepresentation of the prepubertal female anatomy and sexuality as dirty and foul smelling, the Garbage Pail Kids trading cards liberally add yet another form of violence, one that literally maims and disfigures little girls, and even kills them. Whereas male deformity is very rarely represented as the consequence of extreme violence, trading cards abound where the female body is compressed into leaky trash cubes ("Trish Squish"); maimed and devoured by carnivorous plants ("Juicy Jessica"); run over by heavy machinery ("Flat Pat"); and even guillotined ("GuilloTina").

Hoarders and Their Daughters

One of the main reasons for the long-lasting and spectacular success of Garbage Pail Kids and its resonance among adults is that it brings up powerful remembrances from a quasi-universal (as well as primal)

experience, namely, that of the inadequacy, awkwardness, and cruelty of childhood, and of school premises as war zone. But childhood does not only occur at school, where kids eagerly trade cards impregnated with scatological humor (or should we call them mirrors, since they so cunningly reflect their fears and anxieties): growing up and filth also happen at home.

Needless to say, domestic spaces vary greatly in their degree of neatness (Arnold, Graesch, Ragazzini, and Ochs), but in the Western world, they all measure up against the standardized ideal of the sparkling interiors of middle-class households routinely showcased in commercials and sitcoms. In stark contrast, the opposite scenario, namely that of the filthy and overcrowded dwellings of compulsive hoarders, has also found its way into TV and computer screens. Shows such as *Hoarders* (2009–2013; 2015–2016), *Hoarding: Buried Alive* (2010–2016), and a lighter, more "uplifting" version, *Clean House* (2003–2013), enjoy high popularity ratings. *Hoarders* in particular, the most successful and influential of the three shows (and also *Hoarding: Buried Alive*, though to a lesser extent) are said to have raised awareness about hoarding as a serious, stigmatizing mental illness that cuts across gender, class, and race divides. Thus "theoretically" they debunk the generalized belief that mindless shopping for worthless objects and obsessive accumulation of junk is the way of life of the underprivileged, and more specifically an unmistakable sign of "white-trashiness." However, the emphasis here is on "theoretically," since these shows very rarely if at all portray hoarders among the well-to-do, and routinely film the interiors of homes inhabited by predominantly white, low-income families. Sure enough, a self-help book on hoarding published as recently

as 2015 still clings to prejudice. Brutally titled *Why Are Hoarders Fat, Sad, and Poor?*, it also has a subtitle encouraging readers to use "the magic of decluttering and minimalism to create wealth, health, and happiness in your life" (Richbucks McGoldberg is the name of the author, clearly a burlesque nom de plume).

The show *Clean House* follows the same principle of applying makeover, decorating, and decluttering strategies toward attaining the American middle-class suburban dream and wealth. Unlike *Hoarders* and *Hoarding: Buried Alive*, however, it only scratches the surface of the "problem," triumphantly proposes and stages an easy fix, and never dwells deeper into the cause of compulsive acquisition and accumulation. *Hoarders*, and later *Hoarding: Buried Alive* certainly go that extra mile, but without relinquishing the decluttering and makeover thrill that is the absolute highlight of *Clean House*. In fact, both *Hoarders* and *Hoarding* are peculiar hybrids, thriving on a mishmash of various reality television genres, such as the self-improvement and makeover show, the interior decoration show, the intervention show, and the tabloid talk show and on-screen therapy session à la Oprah Winfrey and Dr. Phil. *Hoarders*, for example, brings not only professional organizers, experts in extreme cleaning, and whole crews of professional cleaners into cluttered homes, but also psychologists or even psychiatrists specializing in obsessive-compulsive disorders. The show also involves neighbors, family members, friends, and volunteers, who join forces with the rest of the team and are assigned the double task of offering emotional support and of helping throw away the house occupant's possessions. These are deemed useless, even hazardous. By the time the extreme cleaning starts, everybody

involved is fully aware of it and has been also tactfully reassured that the protagonist of the evolving drama is not a quirky collector, but a "hoarder," an individual afflicted by a paralyzing mental illness generally described by medical professionals as "the acquisition of and failure to discard possessions that are useless or of limited value, resulting in clutter that renders living spaces unusable and causes significant distress and impairment" (Frost and Hartl, 341).

Of course one could get cynical about the definition above, and with good reason, for wouldn't many museums, and certainly the filled-to-the brim *Wunderkammern* of the baroque and late Renaissance, or the crowded workshops and studios of many artists and writers perfectly fall within that category? And, back to our contemporary era of savage capitalism, isn't a department store exactly that, an "unusable" and unlivable space really, where "possessions" and commodities "of useless or limited value" accumulate? Certainly, one has to look at hoarding with a level of depth that goes beyond "easy" pathologization. In his book *The Hoarders: Material Deviance in Modern American Culture* (2014), Scott Herring contends that "we cannot comprehend hoarding without appreciating the unlikely confluence of psychiatrists, newspaper reporters, sociologists, social workers, professional organizers, online journalists, and novelists who foster expectations of this supposed mental disease" (3). He then perceptively concludes that hoarding seems "to be less an inherent disease in the head and more a decades-spanning concatenation of medico-legal expertise and popular lore" (3). For Herring, hoarding is "not the trans-historical matter of an irregular mind" (5), but rather "a contestable phenomenon mired in social conditions" (5). Instead of basing his analysis

on "the relation to other anxiety disorders, likelihood of cure, and genetic origins," the author thus traces "different casual chains such as fears over urban disorder, unseemly collecting, poor housekeeping, and old age" (3). Certainly the now "officially" medicalized and pathologized concept of "hoarding" is overwhelmingly conditioned by fears of the kind Herring points out, but also by prejudices related to status, class, and wealth: Poor people hoard; rich people collect.

The effort to tidy up the homes of the poor is also an attempt at further promoting upward mobility through order and the expert management of patrimony. It is not enough to "have." Possessions have to comply with a tight epistemology; they need to be grasped "intellectually," not just accumulate and pile up spontaneously and chaotically. "Minimalism," for example, a style deemed particularly exclusive and lofty, and an aesthetic goal (almost a modus vivendi) that "recovering" hoarders are encouraged to embrace as part of their upward mobility journey (McGoldberg even calls it a "magic" in the subtitle to his book) does not mean one should not "possess." To the contrary, it means one should acquire plenty, but then wisely select and organize his or her belongings. Kura, the traditional Japanese fireproof storehouses, are a cogent example of carefully planned and categorized material wealth. In order to preserve the aesthetics of minimalism, furniture and decorative objects only sparsely populate the homes of the wealthy. Decoration however changes on a rotating basis, with furniture, decorative artifacts, and even kitchen supplies and chinaware moving in and out of the kura according to seasonal demands and customs.

Needless to say, what are called kura dynamics and minutiose storing away and cataloguing of domestic inventory are the

radical opposite of hoarder behavior. In her memoir *Dirty Secret: A Daughter Comes Clean about Her Mother's Compulsive Hoarding* (2011), writer Jessie Sholl diagnoses that her mother "clearly has problems with spatial orientation and memory, that's why all of her possessions have to be kept out in the open, while most of her shelves and drawers remain empty" (22). She also points to what she terms as "the hyper-sentimental attachment [of many hoarders] to their possessions" ("for example not wanting to get rid of a box a gift came in because that would be erasing, or at least tarnishing, the memory of the day that person gave the gift"; 26–27), and to some hoarders' tendency "to anthropomorphize items and take the item's feelings into account—*this empty plastic bag would be hurt if it knew it was so worthless that it was in the trash*" (27). But more importantly, Sholl mentions how creativity becomes a curse to hoarders, for

> it makes categorization—a key part of organizing—a serious challenge. They'll spot something unique about each item and end up with many different categories containing just one object. For example, instead of forty toothbrushes, the hoarder will see one category for the blue toothbrush, one category for the red toothbrush, one category for the sparkly silver toothbrush, and so on. Since each item is one of a kind, it automatically has more value, and it can't be grouped with anything. (25)

To develop a hypersentimental attachment to objects; to look at them not as artifacts of commercial value or pragmatic usefulness, but to endow them with feelings and a soul; to turn off traditional mnemotechnics; to use space in an heterodox fashion; and to refuse to categorize artifacts according to their supposedly "serial" nature are, many would agree, some of the characteristic traits of creativity and the basic modus operandi of the artistic mind . . . if that mind were male, and owned by an affluent member of society. Since it is not, the listed qualities turn into the symptomatic flaws of a disenfranchised and female pathological hoarder.

Although science has shown that, overall, hoarding is evenly distributed gender-wise (in fact, according to some studies, more men are affected by it: Samuels et al.; Otte and Steketee), more often than not popular cultural representations of hoarders and hoarding centers around women. Hoarding researcher Peter Baldwin's response to a viewer's question posted on Quora as to "why are there so many women in the show *Hoarders*," namely, that "there are no gender differences in the presentation of hoarding disorder, however female hoarders may be more likely to talk about their hoarding or admit that their hoarding is a problem,"[5] barely scratches the surface of society's fixation on female hoarders. Normative popular culture remains keen on attributing irrationality and chaos to females and makes them routinely responsible for domestic disarray. To watch a woman living in filth is déjà vu. It reminds us of the long-standing cliché of material dirtiness standing for unbridled sexual behavior, debauchery, and loose morals. It also makes it easy to blame the "patient"— and to blame and to look for a culprit and then to ultimately understand and forgive, is one of the perverse pleasures shows on hoarders warrant—when she is a woman. After all, and to this day, women are made largely responsible for domestic tidiness (or lack thereof). Also, what is intended in the aforementioned "feel-good" TV shows is to

collectively "rescue" the hoarder (in this case, from herself), and the "rescuing" plot, a universal tropos in literature and film, unavoidably centers on "saving" female characters.

There is a deep story hidden underneath, or, rather, *in* the multiple layers of rubbish, and that story is that of the family that once lived with the hoarder and now has fled the scene. The past has a ghostly yet palpable presence in the life stories of hoarders (televised ones included), and women once again are routinely burdened with the role of preserving history and tradition, and of leafing through the yellowed pages of family albums. *Hoarders* and *Hoarding: Buried Alive*, for example, make sure that the past surfaces only a few minutes into the show, in the form of the traumatic event that, according to the mental health professionals, is often the trigger of pathological accumulation. Unavoidably, the trauma narrative, coming mostly from the lips of a female hoarder, and frequently around the loss of a loved one, brings back to life family members now gone and more often than not paints the faded contours of the children who used to live in that house, surrounded by filth, and thus, we fathom as much, grew up isolated and "strange."

"Ghost children" of hoarders, as I like to call them, have now acquired unprecedented visibility and become the protagonists of a newly minted subgenre of the memoir, or, even more specifically, of the mother-daughter memoir, since this particular set of life stories almost always has a daughter and a mother—and only in one case, a father and a daughter (Miller), and very rarely if at all a father and a son—as its main characters. *Dirty Secret: A Daughter Comes Clean about her Mother's Compulsive Hoarding* (Jessie Sholl, 2011); *Dirty Little Secrets* (C. J. Omololu, 2011); *Coming Clean: A*

Memoir (Kimberly Rae Miller, 2014); *Trash: An Innocent Girl; A Shocking Story of Squalor and Neglect* (Britney Fuller, 2014); *Diary of a Hoarder's Daughter* (Izabelle Winter, 2014); *Validate Me! (How My Mom's Hoarding Kind of Messed Me Up)* (Melissa Patton, 2014); *Hoarder: The True Story of My Mother's Downward Spiral* (L. A. Walcop, 2015); and *White Walls: A Memoir about Motherhood, Daughterhood, and the Mess in Between* (Judy Batalion, 2016), are some of the memoirs, listed by date of publication, that since roughly 2010 dare to unveil the traumatic experience of growing up under the "care" of a hoarding mother.

The "daughters of hoarding mothers" genre has not remained static but has evolved considerably since Jessie Sholl's best-selling *Dirty Secret: A Daughter Comes Clean about her Mother's Compulsive Hoarding* was published in 2011. Sholl's memoir is still relatively "contained" when it comes to describing the pain and chaos of growing up with a hoarding mother. Sholl's account is more centered on her adult life, and the psychological and even physical consequences of living among filth that carry over from her childhood, than on her childhood per se. It also devotes many pages on the relationship that develops between her mother and her grownup self, and on her anxious and largely unsuccessful efforts to understand the true nature and origin of her mother's illness. Sholl probes deeper and deeper into her mother's childhood (which she is able to recreate only in feeble colors), and in the process grossly neglects to scrutinize, or represent, her own. The little girl that she once was remains a blurry presence, barely coming to life in the very few episodes where Sholl musters the courage to confront her pre-adolescent past. *Dirty Secret* is fundamentally caught up in the success story mode

and in making it clear to the reader that her future shines bright and that she finally has been able to overcome hardship (hence the subtitle, "*A Daughter Comes Clean about her Mother's Compulsive Hoarding*").

Trash: An Innocent Girl; A Shocking Story of Squalor and Neglect, a memoir by Britney Fuller published three years later, in 2014, follows the opposite approach. Here, grownup Britney remains irrelevant to the point of invisibility, and it is Britney as a little girl (as little as four years old, in fact) who takes center stage. The memoir, published in the UK, yanks the roof off an American suburban house and unveils the horror of a childhood lived in the company of rats, and drenched in her mother's urine and feces. Unlike Sholl's account, Fuller's *is* a "memoir with child." It describes with brutal honesty and heart-wrenching and minutiose detail the life of a little girl doing all she can to cope with her mother's mental illness, in this case an extreme and particularly unsanitary version of pathological accumulation and neglect (of oneself and others) that is often categorized as "squalor (or wet) hoarding." Sholl, whose mother was a "clean" (or dry) hoarder, offers the following definition of the two hoarding modalities in her memoir:

> My mother is what's known as a clean hoarder—I wanted to laugh, then cry, the first time I read the term because her house is anything but clean—as opposed to a squalor hoarder. The house of a clean hoarder doesn't usually contain pools of putrid water from long-ago leaks, piles of feces from animals or humans (yes, sometimes hoarders simply toss dirty diapers, usually adult-sized, on the floor or into bathtubs), rotting food left out in the open, or decomposing corpses or passed-on pets buried beneath layers of garbage. The squalor hoarder is too ashamed to allow a plumber inside when something breaks, so the sink or the toilet or the shower goes unfixed. There's often no running water at all. Sometimes there is no heat. So compared to some other children of hoarders, and the messes they have to clean up, I am lucky. (82)

Fuller, who, unlike Sholl, was (and is) among the unlucky ones, does not attempt to analyze her mother's illness but instead devotes her memoir to describing the "wet" squalor of her home in stark expressionistic colors. At the center is always the all-engulfing mother figure, her behavior disturbingly erratic and unpredictable, and her body—always naked when at home—invariably grotesque, incontinent, and filthy:

> She [the mother] took her shoes off, releasing the pungent odour that had been trapped all day. She usually didn't wear socks, and a black crusty dirt was visible between her toes. In one fell swoop, she slid off her trousers and underwear, and left them where they fell. She walked into the living room, taking off her shirt. She tossed it on a pile of rubbish bags and sat down on the faux leather couch.
>
> Her stomach jiggled with every step. Her butt and thighs were riddled with zits. Some of them wept, others were red, with big heads, and ready to pop; and some were purple from her squeezing them too much. On her hip, just under her belly roll, was a cyst the size of a ten-cent piece. It was always red and inflamed, from getting caught on her trousers or her underwear. Sometimes it would tear, causing her to bleed. (15–16)

Throughout the memoir, mother and daughter are immersed in a dizzying rhythm of rejection and attraction. The former keeps the latter close to the point of incestuous intimacy (mother and daughter share the same urine-soaked bed during two thirds of the book, and to run naked around the house is a "family rule" that is strictly enforced and makes the girl uncomfortable), but scenes of rejection equally abound. The mother often pushes the small girl into the garbage that piles up high around the bed, for example, and then stretches out on the mattress like a "beached whale" or a "giant starfish," or takes over the sofa in the living room, covering it with her sweaty nurse clothing and sitting on it naked and open legged.

Persistent and anguish-ridden parallelisms between the mother's aging and morbidly obese body and the daughter's chubby and still developing anatomy surface again and again throughout the text and become particularly apparent when set against the tidy clothes, slender build, and perfect skin of her cousin Louise:

> Louise was pretty, she was half Asian, and always looked like she had a perfect tan. Her hair was dark brown and straight, ending just above her butt. Even though she was the youngest of four, her clothes were always nice. They weren't stained and didn't have holes in them, like mine. I was only a few months older than Louise, but we looked completely different. I was very pale and never tanned, just burned. My rarely brushed hair had never been past my shoulders. She had lost her baby fat, and was slender and tall. I was short and chubby, and I always seemed to be oozing out of my clothes. (26–27)

The "continuity" and all-engulfing nature of trash—and of bodily fat, since fat is clearly portrayed as equally revolting, overflowing, and invasive—not only erases spatial borders and demarcations (rubbish takes over the different rooms of the house, making them indistinguishable from each other; fat protrudes and "oozes out," and like filth, stubbornly remains put) but also blurs the limits that should separate the body and identity of the mother and her growing female child. Both become one (united by the overaccumulation of artifacts and adipose matter), and one also with the mother-inflicted garbage that threatens to engulf them. More often than not, the memoir highlights the "wet" nature of the latter and brings to the fore the daughter's nightmarish and often unsuccessful attempts at remaining dry and clean in the midst of a urine-drenched trash habitat:

> We used to have sheets and pillowcases and all the sorts of bedding I'd seen at my friends' houses. That had stopped since Mom started wetting the bed. Because she was so big, my mom had a hard time getting up in the middle of the night to go to the bathroom. Most nights she now wet the bed. Sometimes, she did it more than once. I made sure to sleep on the very edge of the bed, so she didn't get me and my blankets wet too. I hated the feeling of waking up in the sticky mess. It was cold by the morning and clung to me like glue. (75–76)

Fuller then describes how she is charged with washing her mother's drenched blankets, and how for a long while she only manages to stand "at the end of the bed, staring at the crater in the middle:" "My mom had peed so much that the springs under her

had rusted and disintegrated, leaving a large dip" (76). When she finally brings herself to move on with her task and to "drag the mass of blankets off the bed" while trying not to touch the wet parts, the blankets then "drop to the floor with a squishy thud, spraying [her] ankles with cold pee" (76). And there is the smell,

> so strong and musty that my throat closed up and my eyes started watering. Taking a step back, I pulled my shirt over my nose and took a few quick breaths. I grabbed the corner of the bottom blanket and dragged the pile of blankets down the hallway to the upstairs door. There was a trail of pee from our room, like a trail of slime behind a slug. . . . I opened the upstairs door, kicking the blankets into the basement. They got caught halfway down the stairs on some books and clothes. My food landed in a puddle as I stepped down. I was confused as to where the water came from, but shrugged it off and continued downstairs. I jumped over the pile of blankets so that I could grab them from below. I stopped in my tracks. There was a stream of pee flowing down the stairs because the blankets were so saturated. Suddenly it dawned on me—I didn't step in a puddle of water, I stepped in a puddle of urine. (76–77)

Ultimately, the little girl of Fuller's autobiographical account is not so different from the "Oozy Susies," "Leaky Lindsays," "Mushy Marshas," "Jelly Jennies," and "Smelly Sallies" who so persistently populate the various—and deeply misogynist—series of Garbage Pail Kids. Not unlike these hugely popular trading cards, memoirs that portray the daughters of female hoarders equally emphasize the dirty, leaky, and smelly nature of the female body from childhood on, and go to great lengths to describe how difficult it is to effectively and permanently wash off filth from skin and dwelling, and how easily "dirty" habits (and even body types) migrate from mothers to daughters.

No matter how graphic and heartwrenching memoirs are that describe these circumstances, the "I am the daughter of a hoarder mom" confessional genre remains an easy enough read, for it falls squarely within what patriarchy and a mainstream and perversely voyeuristic audience ultimately think of, and expect from, the "female condition." Women are chronically and inherently dirty and dangerously contaminating, according to masculinist thought, and thus female hoarders and their female (and often alluringly prepubertal) offspring an exaggerated—and thus "pornographic" version—only of filth as usual.

The concept of the female hoarder genre (in both its narrative and its filmic variant) as yet another form of pornography (and occasionally even Lolita-esque child pornography) is relevant here. In an interview about his just recently published erotic novel *Das Schelling Projekt* (2016), German philosopher Peter Sloterdijk describes pornography as follows when asked (once more: how often have we heard that question?) to differentiate between the erotic and the pornographic:

> Bloss weil Genitalien vorkommen, ist eine Geschichte noch lange nicht pornografisch. Das definierte Merkmal der Pornografie sind die Überbelichtung und die Grossaufnahme: Porno-Genitalien füllen den gesamten Bildraum aus, was die bewussten Organe bei einem alltäglichen Blick auf bewegte Körper so gut wie niemals tun. (Michaelsen, Pfeifer, and Schroeder, 14–15)

(The fact that genitalia appear in a story doesn't make it by any means a pornographic one. The defining trait of pornography is overexposure and close-up: Porn genitals fill out the whole view or screen, something that almost never happens in everyday situations, when one's eye falls on the genital organs of aroused bodies.)

Certainly, the "my mother was a hoarder" genre comes with a powerful magnifying (and thus pornographic) glass, in the sense that it aggrandizes the spectacle of filth glued to female skin, and shines a glaring light on the secrets of domestic disarray and overaccumulation. As in porn films, daughters-of-hoarders narratives constantly shoot close-ups of the hidden and intimate, and they do it by keeping their "cameras" deliberately low. Because of their reduced height in comparison to the average adult, children certainly have a closer view of the ground, and a closer view also of the underbellies and genitals of grownups. Memoirs like the one authored by Britney Fuller certainly take skilled advantage of children's biologically conditioned "way of seeing." *Trash* abounds in close-ups of oversized body parts (like the mother's fleshy and zit-covered behind and wide hips, or her constantly moving and trembling belly, which seems to have a life of its own) and looks at garbage on the floor through an equally obscene, amplifying lens: piles of castoff objects look like mountains or grow into insurmountable barriers; oozing discards or bodily fluids flow like rivers or become subterranean currents that seep through the various garbage strata. Even the sullied body of the little girl living amid the monumentality of all-engulfing filth is closely scrutinized and thus aggrandized: we see her belly protruding

between a tight T-shirt and ill-fitting shorts; her skin erupting in nasty red bumps due to a bedbug infestation; and her mother suddenly discovering pubic hair when impertinently staring at her daughter's naked underbelly.

The "my mother was a hoarder" genre, or even more generally, filmic and written memoir versions that narrate the deeply personal and intimate reality (or realities) of hoarding, are a very recent phenomenon. From the beginning, and roughly since 2010, its success has depended not only on the fact that it offers shameless close-ups of domestic intimacy gone filthy (a form of pornography that feeds on scatology), but also on the circumstance that it endows the hoarding space with a sense of history. The depth of narrative complements, or even compensates for, the "flatness" of the pornographic image. TV crews brutally invade the anxiously shuttered-down home with their cameras but then mitigate the harmful effects of their intrusion by showing that they "care" about the hoarder, and are interested in his (or mostly her) story. Similarly the audience justifies its perverse pleasure in having access suddenly to somebody else's carefully hidden overcrowded squalor by sympathetically following and endorsing the team's efforts to offer psychological support to the "patient"; to help her to revise her past in order to find the cause and then the cure of her ailment; and only then to proceed with a thorough though "sensitive" and relatively slow-paced collective cleaning operation that, truth to be told, ends up being less cathartic and "healing" for the hoarder herself than for the audience.

In any case, to initiate and effect the healing process is precisely what, according to photographer Geoff Johnson, remains at the core of his 2015 *Behind the Door* series,

a collection of dozens of pictures taken after his mother's death that recreate the trash-filled interior of his childhood home in Omaha, Nebraska (*wonderfulmachine.com /blog/geoff-johnson-behind-the-door*). Johnson selected some of these harrowing pictures and superimposed a series of photographic images of his four-year-old son and niece to the different "trash-interiors." One of the pictures shows a little girl (Johnson's niece) sitting on the bathtub rim and peacefully brushing her teeth. A picture-perfect re-creation of white "all-American childhood," the cute girl in her mauve pajamas starkly contrasts with her grimy surroundings: filth covers all the surfaces of the bathroom; what was formerly pearly white (tiles, porcelain of sink, toilet, and bath tub) is now brownish and stained; and the floor remains invisible under piles of dirty clothing and often unrecognizable debris. Yet another of the photographic montages depicts a small boy (the photographer's son) presumably just back from school, wearing a thick jacket, a woolen cap, and a backpack. He is standing in front of an open oven, with his arms outstretched and his hands reaching toward the heat. Needless to say, the oven interior is covered in grime, and, like the bathroom, the kitchen too is filled with trash covering every surface (tables, chairs, counters) and piling up knee-high on the floor.

Both the photographer (father to the little boy) and his sister (mother to the little girl) adamantly attest to the therapeutic quality of the photographic montages. To see one's own children inhabiting the traumatic landscapes (in this case, trashscapes) of their now distant but no less painful childhoods (both Geoff Johnson and his sister are in their mid-thirties) apparently helps. But why, and how, or, to give these questions a broader meaning, what effect do these widely publicized

montages and the history behind them have on the general audience?

Historically, montages are self-reflective or metapictorial; in other words, they lay bare their "cut and paste" technique and nature. Not here. Photographs—images in general—are supposed to be self-evident and speak by themselves, but this is one of those cases where, owing to flawless blend-in "montage" via Photoshop, a textual explanation changes the meaning dramatically. Thus Johnson is quick to explain to us that his son and his niece do *not* live in such squalor, rather, "only" stand for what he and his sister had to go through. Immediately the "flat" image acquires unexpected depth. Similarly to what happens to the "shallow" stills of filthy interiors in hoarder shows, the added narrative makes the audience sigh in relief: Chronology gives hope. There is a reason, a (clinical) history behind hoarding, and thus strong potential for a cure, and there is the reassurance that, from now on, children among filth will be possible only as pasted-on figments of the imagination—or at least children from affluent countries, for the somber irony is that images and photographs of landfill children have never been collages, and certainly have never been conceived, perceived, or interpreted as such (Figs. 4.1, 4.2, 4.3, 4.4, 4.5, 4.6, and 4.7).

Nothing in images 4.6 and 4.7, for example, indicates that these are not photomontages, particularly since one can do wonders now with the digital programs at hand. However, we (Westerners) uncritically accept that these are "genuine" photographs with "real" children working in "real" though remote landfills. They fit right in, we think (or feel, rather), and are part of the "natural" landscape. Hence our impulse is not to remedy their situation

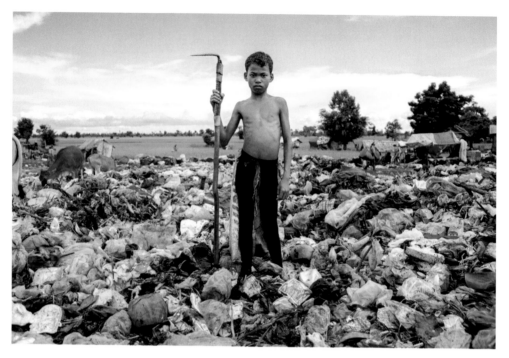

Fig. 4.6: Photo by David Rangel, *Kon Mai*. Siem Reap-Cambodia.

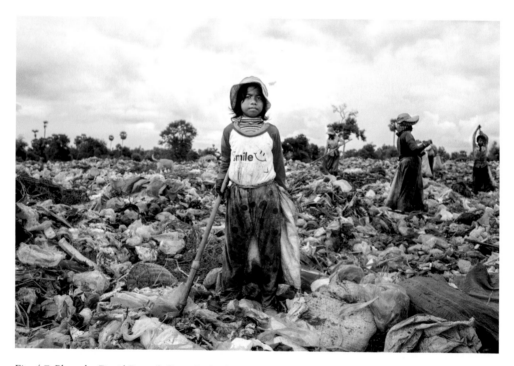

Fig. 4.7: Photo by David Rangel, *Sigen Rathy*. Siem Reap-Cambodia.

(hoarder-show-style), but to pose questions instead to these children who look straight at us—for the sake of "our" children, really, and not for the sake of the ones languishing in foreign dumps—exoticizing questions very similar to the ones that Cristiana Ziraldo posts in her "pedagogical" blog on Andy Mulligan's novel *Trash*.

"What are your thoughts?" and "What is your story?," however, is certainly not what we feel compelled to ask Johnson's "hoarder children." In fact, we don't feel like asking anything. Even if we wouldn't know that the little silhouettes of a girl and a boy are "artificially" pasted on, we somehow think (or rather distinctively feel) they are, for it is clear to us that they absolutely don't belong there. Accordingly our impulse is not to waste time with pointless inquiries, but to act quickly, to run into that filthy bathroom, or into that kitchen drowning in trash, and yank them out of their unspeakable misery. Or perhaps, our urgency is not such, after all? If we carefully look at the pictures, and particularly at the picture of the little girl sitting on the rim of a grimy bathtub and peacefully brushing her teeth, what we see is gratifying "cuteness," further enhanced by surrounding squalor, so perhaps we would like to linger a bit more, and enjoy? The boy and the little girl are Oliver Twist and Tom Sawyer and Huckleberry Finn and Little Match Girl cute. There is a long literary and pictorial tradition that painstakingly portrays the irresistible allure of (Western) child poverty, and Johnson's "hoarder children" are one more link in a seemingly endless chain. A chain, needless to say, that is not uniform, but molds its pieces according to gender.

The photographer "chooses" to put the little girl in mauve pajamas, for example, and the little boy in a rain jacket, a wool hat, and a backpack. This automatically enhances and makes possible the "cuteness effect," since "cute" is only that which is perfectly harmless and does not threaten patriarchy and the social apparatus. Certainly, a little girl/woman confined to one of the most intimate spaces of the domestic and going about her daily cleansing and beautifying routine is irresistibly alluring in all its predictability, as is an equally patriarchy-conforming boy/precocious little man who "mans up" in the face of adversity and knows how to combat the cold and fend for himself.[6] For one, the picture of the ravaged kitchen and living area with the standing boy in street clothes makes it perfectly clear that the latter is free to leave the house and to come and go as he pleases, whereas such sense of freedom is noticeably lacking from the photographic montage of a little girl in pajamas sitting on a filthy bathtub rim.

Johnson's photomontages are highly effective at exploiting a palpable sense of (cutified) vulnerability and loneliness, particularly in the pictures that showcase his "paste-on" niece. In fact, the photographer himself and his sister must have been deeply scarred by similar feelings of abandonment, and a sense of inadequacy and isolation. Certainly both were forced to live among filth from early childhood on, which begs the question if a similar experience is now imposed on yet another little four-year-old boy and a little girl of the same age. Granted, this is not happening directly to them, but only to their photographic reproductions. However, the easiness with which one can seamlessly paste on the image of an unknowing child to a nightmarish background of squalor and neglect is not so far away from grim reality. Not unlike digital technology (or even

Daniel Canogar's and Gregg Segal's artistic interventions and photographic series—Chapter 1), reality too has a talent for placing children (and women) amid garbage and for making sure they "harmoniously" match their surroundings.

On Landfill Heroes and Epic Narratives: "Huck Finns in a Sea of Trash"

Female characters in particular seem to be notably skilled at becoming one with rubbish, as the various Garbage Pail Kids trading card series and the growing number of hoarder memoirs show. This trend continues in other genres as well, for example in the aforementioned BBC period drama TV series *Call the Midwife* (2012), created by Heidi Thomas and based on Jennifer Worth's memoirs, or in the documentary *Estamira* (2004), by Brazilian film director Marcos Prado. Both *Call the Midwife* and *Estamira* make a point of showcasing disenfranchised aging females who live among filth and look at the world with childlike eyes. Particularly in the case of the Brazilian documentary, innocence and even a certain degree of feeblemindedness is accompanied by deep philosophical wisdom, yet another version of the persistent trope of the old female as ailed/blessed with the savant syndrome and endowed with the powers of clairvoyance.

However, wisdom learned from and among trash is not the sole prerogative of the gray-haired female outcast. Literature and film also like to portray adolescents who feel at home among rubbish and derive life lessons from it. Pippi Longstocking's playfully disheveled appearance and her capriciously chaotic and crowded "Villa Villekulla" and garden are only a decaffeinated and "family-friendly" version of childhood hoarding.

Unlike Swedish author Astrid Lindgren's longtime bestseller (1945) and subsequent filmic adaptations (1969; 1988), a new literary sensation, however, German writer Wolfgang Herrndorf's novel *Tschick* (2010) and the filmic adaptation by Turkish German director Fatih Akin (*Tschick*, 2016) offers a much harsher portrait of a chronically neglected adolescent girl (called Isa in both the novel and the film) who hides in a garbage dump.

Praised as the German equivalent of American masterpiece *Catcher in the Rye* and widely reviewed in hyperbolic terms, *Tschick* is a "Jugendroman" or coming of age novel about two fourteen-year-old boys who steal a car and embark on a road trip through (former) rural East Germany. The point of departure is Berlin—we know that much—but the landscapes that ensue are difficult to locate with any precision on a map. Still, some attempts have been made in that direction (Kramper), particularly toward creating a taxonomy and description of the real enough—though consistently surreal-looking and deeply symbolic—topographies that become the existentialist backdrop to the journey (Kramper; Möbius; Wölke). Werner Kramper, for example, points out that the lives of the two teenagers are constrained to Berlin and its urban outskirts, and that therefore "das Verlassen der Stadt schafft für die Jungen neue Horizonte-nicht nur wegen der aufregenden Ereignisse und unerwarteten Begegnungen, sondern auch weil die beiden neue, wechselnde ländliche Umgebungen erleben" (Herrndorf, *Tschick*, 86) (leaving the city creates new horizons for the boys, not only because of the exciting adventures and unexpected encounters, but also because it provides them with new and changing natural environments).

Kramper emphasizes the soothing effect that nature has on Maik and Tschick (86) but also notes that the boys have a fear-infused respect toward the power and violence of nature ("eine Ehrfurcht vor der Naturgewalt"), and that throughout the novel the landscape acquires increasingly menacing and even apocalyptic features. A coalmine, for example, which some critics have identified as located in the Lausitz region in East Germany, looks as if there the world would end abruptly ("zehn Meter dahinter war die Welt zu Ende"; 179) (ten meters beyond, the world ended; 172):[7]

Und das musste man gesehen haben: Die Landschaft hörte einfach auf. Wir stiegen aus und stellten uns auf die letzten Grasbueschel. Vor unseren Füssen war die Erde senkrecht weggefräst, mindestens dreissig, vierzig Meter tief, and unten lag eine Mondlandschaft. Weissgraue Erde, Krater, so gross, dass man Einfamilienhäuser dadrin hätten bauen können. Ein ganzes Stück links von uns begann eine Brücke über den Abgrund. Wobei, Brücke ist wahrscheinlich das falsche Wort. Es war eher so ein Gestell aus Holz und Eisen, wie ein riesiges Baustellengerüst, schnurgerade bis zum anderen Ufer. Vielleicht zwei Kilometer, vielleicht mehr. Die Entfernung war schwer zu schätzen. Was drüben lag, war auch nicht zu erkennen, vielleicht Sträucher und Bäume. Hinter uns der grosse Sumpf, vor uns das grosse Nichts, und wenn man genau hinhörte, hörte man auch genau überhaupt nichts. Kein Grillenzirpen, kein Gräserascheln, kein Wind, keine Fliege, nichts. (179–80)

(You had to have seen it: The landscape just stopped. We got out and stood by the last clump of grass. At our feet the ground

had been steeply cut away, dropping at least thirty or forty meters down. And below was a moonscape. The ground was whitish gray and pockmarked with craters so big entire buildings could fit in them. Off to our left was a bridge that led out over the abyss. Although bridge is probably not the right word. It is more like a trestle made out of wood and steel—like a giant scaffold running dead straight across the pit to the other side, which was maybe two kilometers away. Maybe more. It was impossible to gauge the distance. You couldn't tell what was on the other side either. Maybe trees and shrubs, but who knew. Behind us the massive swamp, in front of us the [great] void. And even if you listened closely, you heard absolutely nothing. No crickets, not a single blade of grass rustling, no wind, no flies, nothing.) (172–73)

Undoubtedly, the fascination of the two boys with the "lunar landscape" is also the fascination with the "backward exoticism" that once communist rural East Germany still exerts on West Germans. It is important to note that to this day, Germany in many ways remains split in two, and "slumming" (that is, reveling in the picturesque "rundownness" of a capitalism-resistant East) still appeals to the richer half. Although this has not been emphasized by the critics (in fact, it has not been mentioned at all), I am convinced that one of the reasons *Tschick* remains furiously popular is that it allows for "guilt-free" voyeurism. Through the "innocent" eyes of two boys, the West gazes at the East but, more importantly, eagerly basks in the poetic light that the narrator shines on the threatening and the desolate. Herrndorf's novel is indebted to romanticism, the tradition of the *Bildungsroman*, and, to a lesser extent, to the romanticism-infused

German garden variety of realism known as "poetischer Realismus." Certainly "das grosse Nichts," "the great nothingness or void" that extends at the boys' feet in the passage quoted above strongly evokes the sweeping, imperialism-infused panoramas of German romantic painter Kaspar David Friedrich, and very specifically the one portrayed in his famous painting, *Wanderer above the Sea of Fog* (1818).

The panoramic view as a masculinist gesture of colonization and a preamble often to "real" conquest is a deeply ingrained chronotopos in Western tradition that manifests itself with equal efficacy and eloquence in literature, film, and the painterly arts (Huhtamo; Oettermann; Zubiaurre, *El espacio*). Not surprisingly, *Tschick*'s filmic adaptation also resorts to the panorama in an effort to symbolically (and rather stereotypically) represent the attempt of two young males at visually conquering and making sense of the world. In both the literary original and its filmic version, *Tschick* closely follows the conventional rhythm of the coming-of-age novel, which is both spatially and emotionally represented as a continuous flow of ups and downs. Thus rather predictably, sweeping panoramic views or the endless horizons that open up dramatically in front of the boys while driving their stolen car on the highway give way to cramped interiors, to tangled patches of overgrown nature, and, most notably, to yet another apocalyptic landscape, that of a populated garbage dump with huge trash mountains surrounded by forest and highways: "Und tatsächlich brauchten wir noch zwei Stunden, bis die Müllberge in Sicht kamen. Riesige Berge, ganz von Wald und Autobahn umgeben, und wir waren nicht die Einzigen, die da rumkraxelten" (149) ("It did in fact take two hours before we caught site of the dump. Giant mountains

of garbage, hemmed in by the autobahn on one side and woods on the rest. We weren't the only ones poking around there"; 142).

A garbage dump is always a "messy" place, not only in the most immediate sense of being dirty and chaotic par excellence, but also in the sense that in places where the discarded festers and accumulates, meanings invariably multiply and densely overlap. For one, and as *Tschick* masterfully brings to the fore, overflowing trash sites always exist in implicit or, as in the case of Herrndorf's novel, explicit contrast to eerily empty and desolate spaces, such as the coalmine. In both instances, civilization leaves an indelible imprint on nature, by either excavating (the coalmine) or accumulating (the landfill). And in both instances, based on the opposed tactics of subtraction and addition, the destruction of the environment generates new contrasting landscapes that perfectly mimic nature, with a vengeance: the coalmine—"das grosse Nichts" (the great void; 173)—becomes a vast desert; and the landfill—"das grosse Alles" (the great all)—builds up into a colossal mountain range.

Moreover, human behavior quickly readjusts to these new/old landscapes and obediently follows gender-conditioned conventions. Thus faithful to the long-standing tradition and misogynist representation of all-male panorama viewers and mountain climbers (Zubiaurre, *El espacio*; Zubiaurre, "Panoramic Views"), Maik and Tschick also solemnly take in spectacular landscapes from high above (or far away) and conquer mountains when they see them. Sure enough, both the novel and its filmic version—a double mise en abyme of the aforementioned masculinist chronotopos—portray the boys purposefully climbing huge trash piles: "Ich hatte einen Berg mit Haushaltsmüll zu fassen" (149) ("I started working through a

mound of household trash"; 143); "Tschick war auf einen anderen Berg gestiegen" (150) ("Tschick had climbed on another mound"; 143); "Am Ende traf ich mich mit Tschick auf dem grössten Berg" (150) ("After a while I went up and met Tschick on top of the biggest mound"; 144). This is in stark contrast to the scattered ground-level and background activities of other scavengers, an old man, two children, and a girl their age and covered in filth: "Irgendwo ganz hinten lief ein alter Mann gebückt herum und sammelte Elektrokabel ein. Und ein Mädchen in unserem Alter war auch da, ganz verdreckt. Und zwei Kinder. Aber die schienen nicht zusammenzugehören" (149) ("We could see an old man bent over collecting electrical wire. And there was a girl our age there too, covered in filth. And two children. But they didn't seem to be together"; 142–43).

It is important to note that in his film, Fatih Akin further accentuates the masculinist gender divide between the male climber/conqueror and the female who more often than not remains at ground level or even retreats behind walls. For example, whereas in the novel, Isa shouts at the boys while sitting on a mountain slope ("Nur das dreckige Mädchen sass uns noch auf einem anderen Berg gegenüber. Ihre Beine hingen aus der offenen Tür einer alten Wohnzimmerschrankwand. Sie rief irgendwas in unsere Richtung"; 151) ("The only person left was the girl, who sat on top of another mound looking across at us. Her legs hung from the open door of an old wardrobe. She yelled something in our direction"; 144), in the film she is portrayed as throwing insults at the boys through a barred window.

The film director's choice to substitute the discarded built-in living room closet ("Wohnzimmerschrankwand") for the window, and to have the female character

standing behind bars instead of sitting at a mountain slope, her legs freely hanging from the open closet door, is by no means innocent, and it certainly has relevant consequences on how gender is represented in the film and thus read by the audience. By emphasizing the domestic in close conjunction with squalor and disarray (the window is broken; Isa's hair is unkempt and her clothes dirty; she carries a battered box with her at all times, bag lady–like) the film is firmly placing the character within the genealogy of female hoarders, and thus widening the gap that separates the daring male adventurer from the risk-averse and secluded female.

But there are more indications, in both the novel and its cinematic versions, that neither the novelist nor the filmmaker had the intention or the ability to create a less conventional female character. Isa certainly is not more than yet another version of the seemingly endless chain of "little savages" or tomboyish creatures that inhabit literature (one illustrious example being Shakespeare's *The Taming of the Shrew*) and the popular imagination:

Auch das verdreckte Mädchen kletterte einmal wie ein kleines, schnelles Tier an mir vorbei, ohne mich anzusehen. Sie lief barfuss, ihre Beine waren schwartz bis zum Knie. Darüber trug sie eine hochgekrempelte Army-Hose und ein versifftes T-Shirt. Sie hatte schmale Augen, wulstige Lippen und eine platte Nase. Und ihre Haare sahen aus, as wäre beim Schneiden die Maschine kaputtgegangen. . . . Unterm Arm hielt sie eine Holzkiste, und ich war mir nicht sicher, ob sie die hier gefunden hatte oder ob sie darin etwas aufbewahrte oder was sie überhaupt hier suchte. (150)

(The girl shot past me like a quick little animal at one point too, but she didn't even look at me. She was barefoot and her legs were blackened with dirt all the way up to her knees. She had on rolled-up army pants and a filthy T-shirt. She had small eyes, bulging lips, and a flat nose. And her hair—it looked like the clippers had gotten fouled up while she was having a haircut. . . . She had a wooden box under her arm, but I wasn't sure if she'd found it there or had brought it to carry things, and it wasn't clear what she was looking for anyway.) (143–44)

For the male protagonists, entering the garbage dump and finding Isa means to come face to face with their own sexuality. Against the backdrop of festering filth, Isa's "dirty" female anatomy elicits different reactions in each of the two boys. That Maik is attracted to Isa becomes quickly evident to the reader, and so does the fact that Tschick is clearly not. Still, both boys "use" the girl as a means of giving expression to a more profound tension between them, the one that comes from Tschick at that point still unconfessed homosexuality. As in *Y tu mamá también* (*And Your Mother Too*, 2001) the film of Mexican director Alfonso Cuarón where two closeted gay men famously make love to each other by sharing a female, and as it turns out, gravely ill partner "contaminated" by cancer, here too two boys push the boundaries of their sexuality by entangling themselves with "filthy" Isa.

Again, Tschick will confess his homosexuality to his friend only much later in the novel, and only after Maik's heterosexuality has been firmly established. Ultimately, Herrndorf's "Bildungsroman" is an anxious effort at making sure that Maik's heterosexuality remains uncontested, and

his timid flirting, here and there, with homosexuality, only a transient phase that will lead to a "healthy," nonsexual friendship with Tschick. It is also an attempt at reaffirming the "(hetero)masculine principle" at all levels, mostly by imposing stereotypical roles on female characters (the shallow high school belle; the sexy nurse; the quirky yet devoted mother of many children who also happens to be a marvelous cook; and the savage/mysterious female holding on to her Pandora's box), and ultimately by "cleansing" and "taming" the ones that are dirty and unruly. Sure enough, there is an episode in the book, and later in the film, in which the boys push Isa into a lake and even throw a bottle of liquid soap after her. And there is yet another episode where Maik cuts the hair of bare breasted Isa—it is certainly difficult not to think of it as yet another version of the (male/masculinist) West diligently devoted to grooming (female/feminized) "savages"—and that has become a favorite scene of the various theatrical representations of Herrndorf's novel.

In fact, the determined attempt at restoring clear-cut masculinity and heteronormativity eloquently materializes in the frantic search for a hose. Predictably, the stolen car runs out of gas, and the boys come up with the idea of extracting fuel from parked cars. For that they need a hose, and the search for the latter takes them back to the landfill that they had passed two hours before. Hoses there twist and coil like giant snakes, and sure enough it is Isa—Eve reigning over a garden of filth—who directs the boys to the imposing pile. However, the evident biblical reference that ties a female to a serpent is only one of the metaphorical layers that the novel imprints on one specific artifact. The hose stands, rather cliché-like, for the male sexual organ, something that becomes

apparent in a later scene, when Maik's efforts at sucking out fuel from car tanks remain stubbornly unsuccessful. It is Isa, once more, who masters the "technique" and after only one attempt is able to extract fluids from the hose.

The landfill becomes the paradigmatic locus in the novel where, somewhat ironically, muddled adolescent sexuality undergoes a thorough "cleansing" and "straightening" process. The dirty girl that calls a garbage dump her home and welcomes the boys with vociferous insults ends up following them and willingly submits to grooming and "blow-jobbing" (the hose-sucking scene is quite explicit in its symbolic implications). By the same token, Maik's sexuality also "shapes up" rather quickly. Faithful to heteronormative principles, he fails deplorably on the homosexual front (as his clumsy dealings with the hose cogently metaphorize), while at the same time gaining confidence and becoming more skillful when it comes to heterosexual conquest and romance. Fully embracing the engrained tropos of female redemption ("whore repents and embraces virtue"), Herrndorf's novel charges Maik with the conventional task of cleansing and taming Isa, not only by throwing her, and a soap bar, into the lake (thus literally forcing her to take a bath) and by agreeing on cutting her hair, but also by idealizing her "inner beauty" and keeping her "pure" in the most stereotypical terms. Maik favors the light touch on his knee of Isa's hand to having sex, and feels deeply moved by her melodious voice:

"Jetzt singt sie auch noch kacke," sagte Tschick, und ich sagte nichts, denn im Ernst sang sie nicht kacke. Sie sang "Survivor," von Beyoncé. Ihre Ausschprache war absurd. Sie konnte überhaupt kein Englisch, hatte ich den Eindruck, sie machte nur die Worte nach. Aber sie sang wahnsinnig schön. Ich hielt eine Ranke mit Daumen und Zeigefinger vorsichtig von mir weg und schaute zwischen den Blättern durch auf das Mädchen, das da singend and summernd und Brombeeren kauend im Gebüsch stand. Dazu dann noch der Brombeerengeschmack in meinem eigenen Mund und die orangerote Dämmerung über den Baumkronen and im Hintergrund immer das Rauschen der Autobahn—mir wurde ganz seltsam zumute. (157–58)

("Now she is singing some crap too," said Tschick. I said nothing, because for one thing she wasn't singing crap. She was singing "Survivor" by Destiny's Child. Her pronunciation was ridiculous. She must not have spoken English—it sounded as if she was just imitating the sounds. But she sang unbelievably well. I gingerly gripped a thorny branch with my thumb and pointer finger and pulled it aside to have a look through the leaves at the girl singing and humming and munching berries there in the bushes. Add to that the taste of blackberries in my own mouth, the orange-red sunset, and the background sound of the autobahn, and I found myself in an extremely weird mood.) (150–52)

Tschick's spectacular success among critics and the general public is closely related to the fact that it ultimately endorses and restores the heteronormative principle. "Marginal" spaces do not divert from the norm but eagerly conform to it (the landfill becomes yet another, rather conventional, garden of Eden), and the daring quest for freedom and (sexual) experimentation (two

boys escaping in a stolen car) leads to heterosexual platonic love. In a scene that reads as the novel's paradigmatic mise en abyme, Tschick unearths a hose with a built-in bent: "'Eingebaute Krümmung,' rief [Tschick] und strahlte. Das Mädchen würdigte er keines Blickes. 'Krümmung ist Mist,' sagte [Maik]. . . . 'Krümmung ist immer gut,' sagte Tschick, und hielt das gekrümmte Ende in den Kanister" (153) ("Built-in angle!" [Tschick] called [and his face beamed]. He wouldn't look at the girl. "No, an angle is no good," [Maik] said. . . . "An angle is always good," said Tschick, running the angled end into his canister"; 146). At the end, however, the story will prove Maik right, and Tschick wrong, for it is the "straight" hose and not the "queer" one that ultimately provides the necessary fuel for the car (and for the novel).

The "landfill adventure" narratives by Luis Alberto Urrea (*By the Lake of Sleeping Children*, 1996) and Andy Mulligan (*Trash*, 2010) follow a very different pattern. Whereas *Tschick* is a coming-of-age novel built around the sexual and social anxieties of the main characters as they play out against the symbolic (and half utopian, half dystopian) background of a recycling facility, Urrea's poetic account, for example, is "only" about the perils of squalor and the abject poverty of children that grow up among dangerous trash. A hybrid genre between memoir and poetic essay, *By the Lake of Sleeping Children*, has two main sections ("A Lake of Sleeping Children" and "Dompe Days") that offer a desolate portrait of landfill upbringing and childhood. In both sections, the beginning and the end of human existence are inextricably tied together, and life, in fact, is routinely depicted as tragically short. The first essay, "A Lake of Sleeping Children," starts with a harshly

sarcastic portrait of the Tijuana open pit dump:

> Since I am lately seen as some kind of expert on Tijuana's poverty, I often found myself leading mini-safaris to the southland's favorite representation of hell. You know the drill by now: we go to some shacks, maybe stop at an orphanage or two, gobble fish tacos and go to Tacos El Paisano, then gird ourselves for the Tijuana dump. Everybody loves the dump—cameras fly off purses, and wanderers walk into the trash, furtively glancing at me over their shoulders so they can be sure they are no *really* in danger. If there aren't a million gulls, some living-dead pit-bull mongrel bitches, or overwhelming stenches rising in eye-watering clouds, the tourists feel cheated and blue. But the sight of an open and festering wound, say, on a garbage-picker's hand . . . well! That sends them right over the moon. Pus polaroids for the apocalypse scrapbook. It seems to me that the gringos at the King Kong group, those sultans of NAFTA trash operating the dump and syphoning easy millions off the efforts of these hungry *basureros*, could open an amusement park right here. Hieronymus Bosch Land: The Garden of Earthly Delights Ride in 3-D Stinkovision! (37–38)

But very soon, and with the abruptness that characterizes Urrea's relentless style, "3-D Stinkovision" will give way to a new apocalyptic landscape that looks anything but "Disneylandish." Instead, it reminds us of biblical floods and the devastation brought on humankind by natural disasters. For one, Urrea describes the dump in "geological," rather than "technological" terms, as feature films like *Wall-E* (2008), and documentaries

like National Geographic's episode "Garbage Mountain" (2006), as part of its *Megastructures* series routinely favor:

> The dump was quiet. Once a gaping
> Grand Canyon, it gradually filled with
> the endless glacier of trash until it rose,
> rose, swelling like a filling belly. The canyon filled and formed a flat plain, and the
> plain began to grow in bulldozed ramps,
> layers, sections, battlements. New American garbology affected the basic nature
> of the place. From a disorderly sprawl
> of *basura* to a kind of Tower of Babel of
> refuse. (40)

The cliché of American science and technology (in this case, in the form of "Garbology") taking over and spoiling Mexico's pristine nature is accompanied by yet another stereotype, namely, that of Mexican fixation with death, and its penchant for surrealist images deeply influenced by catholic iconography. Sure enough a flood of "biblical" proportions inundates the dump, and the bodies of children from a nearby cemetery eerily rise to the surface:

> The slopes of this [cemetery] vale, small
> as it was, were crowded with the sad
> wooden crosses of the dead children's
> graves. The whole area was full of nameless, abandoned, forgotten, sleeping little
> corpses. Plastic flowers faded from blue
> to pink by the sun. A toy or two. Cribs.
> From somewhere the flood had come.
> And the vale filled with water. And the
> water ate away at the slope, the clay and
> sand coming loose and the little crosses
> toppling and falling into the water to float
> around like model sailboats. And other
> crosses, those at the bottom of the vale,
> stood in the water at angles, reflecting

on the still surface. It looked like a Pink Floyd album cover, actually. . . . And the water revealed small brown and green and reddish objects. A kind of layer beneath the surface, like seaweed. Like the clouds of stuff in miso soup. Like algae, but not algae. And we looked: looked at the shore, where the ground was swelling with its noxious water and crumbling. And we looked in deep, where the bed of the lake was mud, and the mud was drifting up, and the rotten soil was broken, and the coffins, the cardboard boxes, the pillowcases, the wooden crates, the winding sheets, were coming up. They were coming up. The children themselves were rising, expanding into the water, and the gulls were eating them. The gulls had become too fat to fly on the flesh of these sleeping children. (44, 45)

Urrea calls the "sky above" the cemetery and the dump "yet another perfect southern California blue" and compares it with "the blue of a stained glass window" and with "clouds as bright as electric signs over our heads." He also makes a point of indicating that "the same sky, spreading farther than any of us can know, shading different colors in different spaces, covered the garbage dump in Mexico City, the garbage dump in Manila, the garbage dumps in El Salvador, Guatemala, Zaire, Rwanda, Honduras, Mexicali, Matamoros, Juárez, Belize, Ho Chi Minh City, Patpong, Calcutta, Sarajevo, Tripoli, New Jersey, and Three Mile Island, Pennsylvania" (49).

If the same sky spreads out its blue and its clouds over seemingly countless open pit dumps, certain motives also expand themselves throughout the different "landfill narratives." The trope of children as the main victims of poverty (even after death, as *By*

the Lake of Sleeping Children cogently evokes) is certainly one of the most prevalent ones, and Urrea does not shy away from using it liberally in yet another of his essays, "Dompe Days." Here, the straightforward narrative recounts the tragic fate of a *basurero* boy called Eduardo, who grows up as an orphan, and dies under the wheels of a garbage truck:

> The one game [the boys] loved the most was the most dangerous. Everyone . . . warned them about it. Everyone told them to stop. But they loved it to the point of madness. The boys loved to jump on the backs of moving garbage trucks.
>
> Eduardo thought he had a firm grip on the back of the big truck.
>
> Retired from San Diego, the truck was rusty and dented. It was heavy with trash, and greasy fluids drained out of its sides like sweat. Its hunched back was dark with dirt, and its smoke-stack belched solid black clouds. . . . Eduardo had run behind the truck, had flung himself at it and caught the upper edge of the open maw in back. He swung back and forth, doing an impromptu trapeze act, and the other boys called insults: "Faggot!" and "Coward!" He turned once to laugh at them, hanging by one hand and starting to flash them a hand sign. The truck slammed on its brakes. Eduardo flew inside, hit the steel wall, and was flung back out, hitting the ground on his back, hard enough to knock the breath out of him. . . . The truck ground its gears and lurched into reverse. The boys yelled for Eduardo to get out of the way, but it must have sounded like more taunting. He raised one hand. The truck backed over him and the hand was twisted down to the ground, and the double wheels in the back made Eduardo disappear. (56, 57)

"Dump boy narratives" seem to be very popular, if one were to judge from the best-selling success garnered by aforementioned *Tschick*, but also by Andy Mulligan's young adult novel *Trash*, and its filmic adaptation (*Trash*, 2014), or even more so by *Wall-E* (2008), since the "cute" robot is certainly a "boy," or at least paradigmatically "boyish" in its behavior. "Cuteness," in fact, is one of the prevalent traits of these landfill narratives that borrow so many features from the genre of the melodrama. Urrea, for example, is keen on idealizing even the most dreadful of boyhoods. For him, "boys living on the edges of the dump have a vast playground of sorts" (55). Eduardo and his three brothers "played and romped in the mounds, found the occasional toy, found clothes and tins of food, found waterlogged magazines with pictures of nude women. . . . The boys had rats to kill, fires to set, food to steal, huts to spy on. . . . And there were always the fights to watch: drunks and gang members and warring young turks from alien barrios and young women throwing punches like the meanest macho" (55, 56).

The narrator calls the boys from the "dompe" "small Huck Finns on a sea of trash" (56), and indeed, the reader cannot but feel the compelling charm of romping youth. We see "boys will be boys" all over Urrea's narrative, and, as with Twain's masterful piece, we smile and become all mushy, and teary-eyed, and forgiving. The Dickensian need to identify "cuteness" with (often semi-delinquent) deprived boyhood is as persistent in visual iconography as it is in narratives and essayistic writing. This chapter already showcased a number of photographs of "landfill children" that once again perfectly fit the cuteness imperative (Figs. 4.1, 4.2, 4.3, 4.4, 4.5, 4.6, and 4.7), and even children inhabiting the dwelling of hoarders, as portrayed in

Johnson's photographic series (or on the cover of *Trash*, Britney Fuller's memoir, for that matter), amply satisfy the requisite.

Here, I want to call attention to a different though somewhat related trope, that of "rubble children" (Figs. 4.8 and 4.9). If one types in "children playing amidst the rubble," for example, a similarly high number of photographic depictions takes over the computer screen.

In fact, contemporary photographs of both "dump children" and "rubble children" eerily remind us of the vast repository of black-and-white photographs (and even of so-called Trümmerfilme, or rubble films, from World War II) that show German and Austrian children playing amid the urban debris of their bombed neighborhoods (Fig. 4.10).

Trümmerfilme, in particular, stress the uncanny ability of the German population to forget the Allied bombing (an ability that deeply angers W. G. Sebald in his essay *On the Natural History of Destruction*, 2004) and to continue their quotidian lives amid rubble, with women chatting among the debris of their homes, and children happily climbing rubble mountains. This attitude of "life must go on, no matter what" is also one of the hallmarks of the Egyptian documentary *Marína of the Zabbaleen* (Engi Wassef, 2008), only this time "cuteness" comes back with a vengeance (Fig. 4.11). The film documents the dire working and living conditions of the "Zabbaleen," the ragpicker cast of Cairo. But it also highlights the efficiency of the recycling process in the Egyptian capital: whereas the United States only manages to recycle 35 percent of its refuse, Egypt reuses 85 percent of its trash. Multinationals are now taking over Cairo's rubbish and destroying the fragile but highly efficient trash ecology of the Zabbaleen, as *Marína of the Zabbaleen*, and yet another documentary,

Garbage Dreams (Mai Iskander, 2009), are eager to show.

Garbage Dreams is a fast-paced film that narrates the struggle of the Zabbaleen against the multinationals with epic (and often Hollywood-like) intensity. Instead *Marína of the Zabbaleen* chooses a slow tempo and, even more notably, turns the pretty face of a little girl into the passive leitmotiv of the film (Fig. 4.11).

One needs to ask what role exactly Marína is supposed to play, particularly since she does not do much in the film besides showing off her beauty and silently looking at the viewer with big, velvety eyes. Marína's portrait also appears on the movie cover and reminds us of TV images of children from developing countries hoping that somebody from an affluent country will "adopt" them and send some money along: the same cute little faces, the same huge, dark eyes. Thus, and to respond to our previous question, the sole role Marína plays in the film is to ignite the viewer's compassion via beauty and innocence. Gender once again is an important factor. Unlike "trash narratives" driven by male characters, where rubbish is an obstacle that demands action, often of the adventurous kind, *Marína of the Zabbaleen* invites only empathy, triggered by the irresistible combination of poverty plus (female) passive beauty plus innocence.

Trash, Andy Mulligan's best-selling novel for young adults, once again resorts to the cliché—a veritable subgenre at this point—of what Urrea poignantly describes as "Huck Finns in a Sea of Trash" (56). In Mulligan's novel it is boys once again who engage in a dynamic relationship with rubbish. Refuse here is not "just" an accumulation of discarded objects, but a trashscape, a whole closed-off continent really, a big island that invites conquest, and is all about adventure,

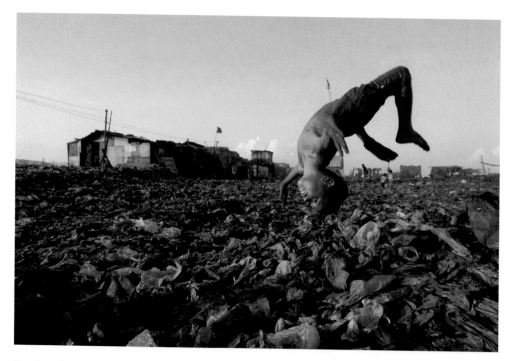

Fig. 4.8: Photo by Darren Whiteside, Tondo, Manila, courtesy of Reuters Pictures.

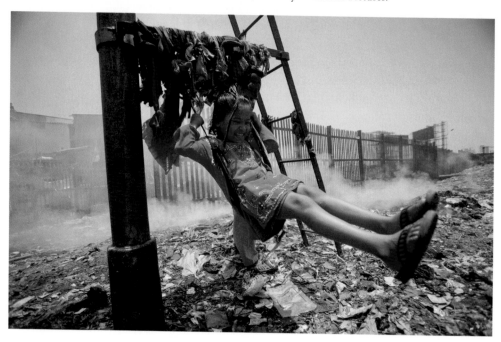

Fig. 4.9: Photo by Vivek Prakash, Mumbai, India, courtesy of Reuters Pictures.

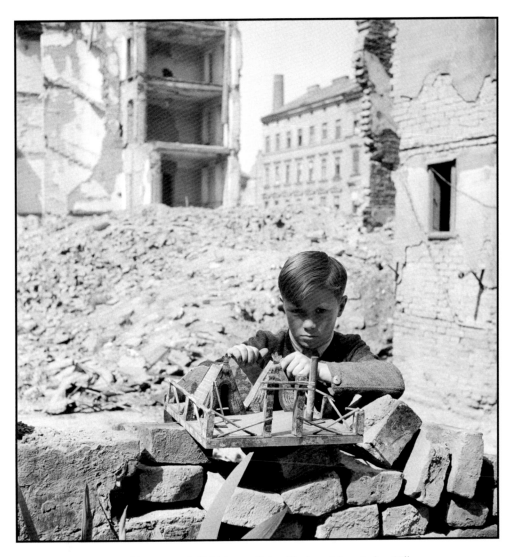

Fig. 4.10: Photo by David Seymour, *A Child Among Ruins, Playing with an Indian Village, a Toy he Made Himself.* Austria, 1948. Courtesy of Magnum Photos.

and sometimes (as in Urrea's "Dompe Days") about tragedy and death.

Trash recounts the story of fourteen-year-old Raphael Fernández, who calls himself "a dumpsite boy," and makes a living scavenging through trash in the open pit landfill of an unnamed developing country. Raphael and his friends Gardo and Jun unearth a wallet sought by the police but decide not to return it. From that moment on the plot thickens, and after a number of complicated adventures, Raphael and his friends find themselves in possession of a sizable amount of money, which they decide to throw into the air in handfuls, for the scavengers to pick up (Fig. 4.12).

What matters here is that in narratives where the main characters are male, a landfill invariably becomes the site of adventure and self-discovery. Sure enough, and in stark opposition to the flat streets and surfaces of the recycling neighborhood in Cairo in

Fig. 4.11: Photo by Tom Toro. Engi Wassef, *Marina of the Zabbaleen*.

Marina of the Zabbaleen, refuse in "Dompe Days," *Tschick*, and *Trash* piles up and forms veritable mountain ranges. As Raphael describes it, Behala, the "rubbish town" where he lives and works, was first located on "Smoky Mountain"; "but Smoky Mountain got so bad they closed it down and shifted us along the road. The piles stack up—and I mean Himalayas: you could climb forever, and many people do . . . up and down, into the valleys. The mountains go right from the docks to the marshes, one whole long world of steaming trash. I am one of the rubbish boys, picking through the stuff the city throws away" (4). Thus "the stuff the city throws away" is not only "stuff," but an intricate and radical topography, where high mountains fall abruptly into deep valleys. Not surprisingly, the cover of *Trash* shows the three friends standing on top of a high trash mountain (Fig. 4.12), a trope—that of male characters enjoying

a panoramic view—that is equally prevalent and semantically relevant in *Tschick*, in "Dompe Days," and in the graphic novel series *Great Pacific Trashed!* Here too the landfill—in this case the Great Pacific Garbage Patch—showcases a rugged topography, with rubbish once more accumulating into mountains. And, as expected, the illustration makes a point of repeatedly portraying the hero—the twenty-one-year-old heir of a Texas oil magnate—proudly standing on the top, sometimes even wearing a flag in the form of a cape, and reigning over the Great Pacific Garbage Patch, now called "New Texas" (Fig. 4.13).

Sanitation Narratives: Crisp Topographies and the Dream of the Urban Clean

So far, we have seen the powerful emergence of two very different and even opposing

Fig. 4.12: Concept and Illustration by Richard Collingridge.

subcategories within the increasingly popular genre of trash narratives, namely, the "daughter of a hoarder" memoir (Sholl's *Dirty Secret: A Daughter Comes Clean about Her Mother's Compulsive Hoarding*; Fuller's *Trash: An Innocent Girl; A Shocking Story of Squalor and Neglect*) that routinely showcases a victimized and traumatized main female character; and the "trash hero" adventure novel or film (Herrndorf's *Tschick*; Urrea's "Dompe Days"; Mulligan's *Trash*; Harris and Morazzo's *Great Pacific Trashed!*), where trash becomes an excuse for climbing mountains and overseeing a landscape as a metaphor for (male) conquest and appropriation. Certainly, both genres are radically conditioned by gender and location. Whereas the overwhelming majority of the hoarder memoirs have female protagonists and take place in the domestic interiors of suburban America, "trash hero" adventures are led by male teenagers and take place outdoors and at the periphery of the developed world, such as Mexico ("Dompe Days"); the Philippines (*Trash*); the deindustrialized landscape of former East Germany (*Tschick*); the Pacific Garbage Patch (*Great Pacific Trashed!*); and the bombed cities of postwar Germany.

But there is yet another subgenre geared toward a very young (predominantly male) audience that demands careful attention, and which I like to call "sanitation narratives." Here, the landscape is neither the sea of trash that engulfs suburban interiors, nor the trash mountains of the developing countries. It is the squeaky-clean streets of our American cities, and the reassuring traffic on these streets of garbage trucks and sanitation vehicles. Books for young readers such as *Trashy Town* (Zimmerman and Yaccarino, 1999); *I Stink!* (Kate and Jim McMullan, 2002); *Smash! Mash! Crash! There Goes the Trash!* (Odanaka and Hillenbrand, 2006); and *I Am a Garbage Truck* (Miglian and Landers, 2008) all include "trash" as part of their title, in stark contrast with the squeaky-clean streets and trash-free sidewalks of the book contents. And all center predominantly on white sanitation workers and neighborhoods.

In his book *Clean and White: A History of Environmental Racism in the United States* (2016), Carl E. Zimring makes a point of highlighting that trash collection and race are inextricably intertwined. According to the author, the creation of the Memphis

Fig. 4.13: Illustration by Joe Harris and Martín Morazzo. *Great Pacific Trashed!* Image Comics, 2013.

Sanitation Department under Colonel George E. Waring Jr. made it feasible "to build modern sewers, pick up garbage, keep the streets clean and reduce the presence of infectious diseases in the community as much as possible, [a new development that] truly saved Memphis in the 1880s" (193). However, and as Zimring points out further, "Memphis was the central city of a vast rural *hinterland* where impoverished African Americans lived and worked. Many of the sanitation workers had worked fields in Mississippi in abject poverty with few rights and had come to the city for better wages. Collecting garbage and yard waste was in many ways a step up, but the work was dangerous, brutal, and ill paid" (193). "The tensions over waste and race," as Zimring puts it, continued well beyond the 1880s and in fact remain a reality in the contemporary world. Trash collection and sanitation jobs are not professional occupations that only white people seek, but something that overwhelmingly falls on other races, particularly on African Americans and Hispanics.[8] And yet, Mr. Gilly, the amiable (and somewhat sinisterly smiling trash collector of *Trashy Town*, as I point out in Chapter 1, Fig. 1.3) is perfectly white (Figs. 4.14 and 4.15), and even in books where the sanitation workers are anthropomorphized animals, the latter automatically imply "whiteness." In *Smash! Mash! Crash! There Goes the Trash!* (2006), for example, the characters are pigs, but their rosy complexion, and the fact that they are committed trash collectors automatically "whitens" and "cleanses" their skin (Fig. 4.16). In fact, out of seventeen illustrations, only one depicts a trashman with slightly darker complexion (Fig. 4.17).

Sanitation narratives, videos, and video games geared toward young audiences are all but "innocent" or ideologically neutral.

Fig. 4.14: Dan Yaccarino, *Trashy Town*. Harper Collins, 1999.

They systematically conflate cleanliness with whiteness and describe a neighborhood as "safe" by indicating that only white workers are allowed to enter it and take care of its trash. Moreover, they make sure that the heavily technologized and factory-like efficiency of the white middle-class home also becomes a landmark of the suburban landscape. When discussing so-called excessive accumulation in his book on hoarding, Herring points out that standards of American cleanliness respond to the scientific imperative, adopted at the beginning

Fig. 4.15: Dan Yaccarino, *Trashy Town*. Harper Collins, 1999.

of the twentieth century, of making houses as ordered and efficient as factories, but also the repository of (white) Christian values. According to the author, "merging cleanliness with godliness with modern science" constitutes "an ironic blend of spirituality and rationalization that took hold under the sign of proper house maintenance" (90), and it is important to add, of proper suburb maintenance also, since suburban utopia is the "natural" continuation of the domestic interior, and further perpetuates a white, middle-class, Christian ideal of punctilious cleanliness.

Not surprisingly, the many video games on street sanitation that one can purchase or even find for free online further re-create pristine streets and flawless front yards and

Fig. 4.16: From SMASH! MASH! CRASH! THERE GOES THE TRASH! by Barbara Odanaka with illustrations by Will Hillenbrand, copyright © 2006 by Will Hillenbrand. Reprinted with the permission of Margaret K. McElderry Books, an imprint of Simon & Schuster Children's Publishing Division. All rights reserved.

Fig. 4.17: From SMASH! MASH! CRASH! THERE GOES THE TRASH! by Barbara Odanaka with illustrations by Will Hillenbrand, copyright © 2006 by Will Hillenbrand. Reprinted with the permission of Margaret K. McElderry Books, an imprint of Simon & Schuster Children's Publishing Division. All rights reserved.

lawns. Moreover, impeccable curb appeal, in this case, and as is the matter also with gleamingly clean kitchens, is directly related to technology. The modern, hygienic kitchen could not have existed without increasingly sophisticated appliances. In the same way, videos and video games such as *Garbage Truck Simulator*; *Street Cleaning Simulator*; *City Real Hero Garbage Truck Driver*; *Frank the Garbage Truck*; *Garbage Truck (Videos for Kids)*; *Garbage Trucks: On Route, in Action!*; *Garbage Truck Song for Kids*; and *Kids Truck Video-Garbage Truck* are deeply interested in highlighting garbage trucks as technological wonders, in the same way in which the advertisement industry praises the skills of ultramodern household appliances.[9] One of the beauties of the latter is that they have a robotic quality to them, and thus don't need humans to be involved: the dishwasher hums away in an empty kitchen, with the

refrigerator chiming in at routine intervals; and washers and dryers produce their own kind of distinctive noises in an equally deserted basement.

Accordingly, and since suburban streets, as noted above, are nothing else but an obsessive prolongation of the domestic interior, video games make sure that garbage trucks also work independently from humans. Similarly to dishwashers, refrigerators, washing machines, and dryers, street sanitation "appliances" too are autonomous robots, going on about their business and emitting machinic sounds while they traverse eerily empty neighborhoods. What we see is a technological utopia/dystopia that is as mesmerizing as it is terrifying, and that happens simultaneously indoors and outdoors. This dystopian utopia machinery effectively helps humans—the contribution of household appliances to feminism and woman's

rights and labor cannot be overlooked—but it also spreads the fallacious message of a "hygienic" world where trash has literally "disappeared" and become invisible. *Trashed*, the 2012 award-winning documentary by British filmmaker Candida Brady, evolves around the fact that the only thing we know about rubbish is that, once we take it outside and leave it at the curbside, it vanishes from view and from our conscience simultaneously. Sure enough one of the many garbage truck videos geared toward young (and predominantly male) viewers, this time accompanied by a song, makes the same point by enthusiastically proclaiming,

> I'm Frank the Garbage Truck
> I can load up tons and tons of waste
> Although I love my work
> It tends to have a funny aftertaste
> I'm Frank the Garbage Truck
> I pick up the garbage through the day
> *Can you guess where it all goes*
> *Without a trace*
> *Haha! That's a mystery I will leave you to*
> *solve!*" (Kids Channel, *Road Rangers*;
> emphasis mine).

It is important to stress that these strangely oxymoronic videos and video games that are about something—trash (that remains blatantly absent from the screen and that nobody knows—or cares—where it will go)—have high popularity rates. The aforementioned video and song *Frank the Garbage Truck*, for example, showcased an audience of roughly two million as of December 2016, and yet another video, *Garbage Trucks: On Route, in Action!* (Thrash 'N' Trash Productions) registered the mind-boggling number of more than fourteen million viewers as of December 2016. What is it that makes these videos and video games so immensely popular?

What is it that makes them profoundly detrimental to our environment, and gives them an authoritarian, exclusionary streak? What is it exactly that we are teaching our children? These are all fundamental questions that need to be answered.

Let's take the hugely popular *Garbage Trucks: On Route, in Action!*, for example. This roughly twenty-minute-long YouTube video (a descendant of sorts of the silent film from the 1940s that promoted the Dempster Dumpster—Chapter 3) shows the arrival of garbage truck upon garbage truck to various suburban neighborhoods and the mechanical process of unloading the garbage cans and Dumpsters. The auditory background is simply the noise produced by the truck engine and by the mechanical contraptions that pick up the trash containers and empty them into the garbage truck. The whole effect is strangely soothing: we enjoy the beauty of affluent suburbs, with their well-kept front yards and clean streets, and even the mechanical noises and movements from the garbage trucks are reassuring, for, by way of repetition, they create a marked sense of rhythm and musicality. Rhythm and routine, in fact, are further reinforced by the changing of the seasons. The video is quite skillful at adding seasonal variety to the neighborhoods and makes a point of stressing the alternating beauty of wintery bare trees, the golden hue of the summer sun, the budding green of the spring season, and the glorious colors of the autumn months.

So far so good, if it weren't for the fact that there is a sinister side to suburban bliss and its frantic efforts at sanitation. For one, the streets appear eerily empty. Throughout the video, the only people we see are the garbage collectors, who, in turn, are all male and 99 percent white. Their faces remain expressionless, and they move about their

business with mechanical, robot-like movements. If one thinks about it, these garbage men are the perfect male counterparts to the "Stepford wives," but, unlike the latter, they are consistently merchandised as perfectly "normal." "Normalcy" here means to make sure that neighborhoods (at least, neighborhoods that "matter") remain clean. Cleaning is a law-abiding exercise that further trains children (we need to remember that sanitation narratives are specifically geared toward a young audience) to fully acknowledge and respect authority. As I stressed already in Chapter 1, the garbageman is a close relative to the police officer, in the same way in which videos on police cars and on fire trucks are closely related to videos and video games on garbage trucks. All of them— police cars, fire trucks, garbage trucks— are part of the overarching and deeply authoritarian sanitation narrative, for the act (and narration) of sanitation certainly goes beyond the cleaning of "physical" dirt once more, and seamlessly moves to cleaning "moral" and "social" filth.

In fact, and quite ironically, "real" muck is as absent from garbage truck videos and video games as it is from children's literature about street sanitation, and this applies not only to *Garbage Trucks: On Route, in Action!*, but to the other videos mentioned above as well. This then raises the question, are these videos and books "really" about trash? No, they are not, or only obliquely so. For what is at stake here is not the protection of the environment, or the denunciation of refuse-generating consumerism, but the emphasis on authority strategically coupled with technology.

Children (boys in particular) are supposed to fall under the mesmerizing spell of technological prodigy, and there is certainly much to admire in the impeccable efficiency of a seemingly endless variety of trash

gulping and digesting monsters on wheels. Sure enough, yet another video on trash trucks ignores trash altogether and emphasizes instead the way these trucks are built (Kids Channel, *Garbage Truck*). While the truck—first, only one piece of it—moves along a street, metal components literally fly down from the sky and quickly assemble. At the end of the trip, the truck has become "whole," and we watch in wonder of its technological complexity and perfection. However, the video ends before we can truly enjoy the truck in action. Only one very short concluding scene shows how the truck quickly gulps down trash. Once more, trash remains sparse and incomprehensibly absent from a video theoretically construed around garbage collection. And, as is customary, the urban streets that the garbage trucks supposedly clean from trash remain equally empty of people, and of debris. Moreover, in this case the garbage truck does it all without human help, from being built, to driving, to collecting the small amount of trash in the final scene. Perfection, literally, falls from the sky, yet another "divine intervention" benefitting the suburban affluent.

This chapter has deliberately moved from the crowded scenes of open pit garbage dumps in developing countries; to the accumulation and chaos of the domestic dwellings of hoarders and their (female) offspring, as represented both in real life (the autobiographical genre of the memoir) and in trading cards (the Garbage Pail Kids series); and finally, to the mega-cleansing operation of sanitation narratives (children's books and videos). It has also moved from agency, in the form of male "trash heroes" who learn from trash and use it to their advantage, to lack of agency and dispossession. Isa Schmidt, *Tschick*'s main female character; the daughters of hoarding mothers; and Marína, in

Marína of the Zabbaleen, are all victims of trash, unable to escape filth (Marína), their garbage-infested past (the daughters of hoarders), or the misogynist stereotypes of bad Eve in dystopian paradise (Isa). And so are suburban children: not unlike Marína, Isa, and the victims of hoarding mothers, children from affluent American neighborhoods are equally unable to overcome or to master trash. In fact, they are not even allowed to see it or to smell it, let alone to play with it, or to find hidden treasures. Big machines (as a metaphor for technology almighty) and white male operators (as a metaphor for capitalist classism) take care of business. The streets are clean. We don't know where trash goes. Consumerism remains intact, and the link between production and excretion invisible. Everybody is happy.

Two paradigmatic documentaries, *Garbage Dreams* (Mai Iskander, 2009) and *Waste Land* (Lucy Walker, 2010), follow a path very similar to the one followed by this chapter. Here too both films start with a landfill located in a developing country (Egypt in the case of *Garbage Dreams*; Brazil in the case of *Waste Land*) but then travel to the affluent West. Or, to be more accurate, they take two "aborigines" out of their environment and bring them for a short while to Europe (Wales in the case of *Garbage Dreams*; London in the case of *Waste Land*), very much in the style of the "savages" that were brought as ethnographic curiosities to Bismarck Germany and imperial Europe at large, and then exhibited in museums and fairs (Corbey). Some of these "trash natives" imported into the West are two of the three teenage boys that are the main characters of *Garbage Dreams* and that work in the world's largest recycling slum, on the outskirts of Cairo. Transplanted into

a state-of-the art recycling facility in Wales, and standing in front of a conveyer belt, one of the boys dares to challenge the status quo. While the trash literally rushes by and leaves him behind, he quickly picks up a tiny piece of metal and exclaims: "Why is this thrown away? It should be recycled, no matter how big or small. There is technology here, but no precision."

One of the last scenes of *Waste Land* takes place in London. Vik Muniz, the renowned Brazilian Brooklyn-based artist whose creation in the Rio de Janeiro landfill is featured in the film, pays for the trip of one of the ragpickers that collaborated in the installation. The trip's main goal is to attend the auction of the monumental photographs that capture the artistic intervention, but Muniz seizes the opportunity to guide his friend and collaborator through the museum. Among other pieces, he shows him Gavin Turk's garbage bag made out of painted bronze and invites him to guess what it contains. The garbage picker humors Muniz and, figuring out the contents from the shape of the garbage bag, mentions yogurt cups, hearts of palms, a box from a new cell phone. His response is much more compliant and playful than the one from the Zabbaleen boy, but the probably unintended implications of the two scenes are very similar. In both cases, "trash natives" are transplanted to Europe to receive instruction for the amusement of the affluent, and in both cases, the documentaries move far away from trash and into the domain of technology and power. Once again, and as is the case with sanitation narratives for children, the requisite for a "happy ending" is a well-mixed blend of puritanical hygienization via pedagogy, (colonial) male-dominated authoritarianism, and white technophilia.

Conclusion

Accumulation

The introduction to *Talking Trash: Cultural Uses of Waste* was resolutely straightforward: it indicated that it is a book essentially on "small" trash and urban litter, though always against the background of the monumentality of garbage. The obvious backdrops are imposing sanitary landfills and (nonsanitary) megadumps, but, if we think of it, there are other, more recent, monumentalities (or teratologies), such as the growing space trash that orbits the earth; the Great Pacific Garbage Patch, or Pacific Trash Vortex, a quickly expanding floating island of junk that is now colonizing our ocean; or, very recently, the London underground rubbish monster known as the "Whitechapel fatberg."

The London "fatberg" is pertinent to what until this page this book does not dare to say directly and only insinuates, namely that the fascination with all things small (and in this case, of trash that is tiny, comparatively speaking) lies in the fact that it will eventually grow. The certainty that it will expand, accompanied by the thrill that eventually it could become gigantic, is what fuels our imagination. And our fear. And then, of course, reality imitates fiction, and our dread is suddenly confirmed: Underneath the streets of London, debris (small, domestic things) have accumulated and conglomerated into a rock-hard colossus. On November 3, 2017, in an article titled "'Victory Declared' over 130 Tonne Whitechapel Fatberg," the BBC News reported, "A 250-metre long fatberg weighing 130 tonnes which was blocking an east London sewer has been cleared after a nine-week battle. The solid mass of congealed fat, wet wipes, nappies, oil and condoms was found in the Victorian-era tunnel in Whitechapel, London" (BBC News).

It is certainly mesmerizing, to imagine that the small-sized and pliable commodities that aid our very private scatology (we pee into diapers; we menstruate into sanitary napkins; we ejaculate into condoms) mix with perfectly ordinary cooking products (oil; fat) and harden into a giant tumor underneath our homes. And it is no less mindboggling to face the reality of our "inconsequential" disposable plastic utensils and gadgets (a fork; a candy wrap; a shopping bag) contaminating whole oceans and forming immense floating islands. Quickly, we find ourselves propelled from the miniaturesque to the gigantic (Stewart), and from (individual) innocence to (collective) guilt. And suddenly, what was "simply" lying on the pavement, mostly ignored, and a minor nuisance at best (a disposable fork; a candy wrap; a torn shopping bag) is now menacingly looming over us, and threatening our planet and our lives on it. The artistic installation by Margaret and Christine Wertheim (*The Midden*, "four years' worth of [the

Fig. C.1: *The Midden*, four years worth of Margaret and Christine Wertheim's domestic plastic trash, suspended in a fishing net to form a ceiling of rubbish at the Mary Porter Sesnon Art Gallery, UC Santa Cruz, 2017. Image courtesy of the Institute of the Arts and Sciences, University of California, Santa Cruz. © the Institute For Figuring.

artists'] domestic plastic trash, suspended in a fishing net to form a ceiling of rubbish at the Mary Porter Sesnon Art Gallery, UC Santa Cruz, 2017"—Fig. C.1) cogently shows how what is small and on the floor will soon grow and rise above us, and how the exercise of "looking down," on which much of this book's reflections are based, ultimately will lead to "looking up." The couple on the image is doing both, namely, carefully scrutinizing small litter (as if they were looking down at the pavement) while at the same time feeling the oppressive immensity of it.

"To look," and more specifically and intentionally, "to look down," are, metaphorically speaking, the verbs most often conjugated in this book. The question remains though if the scopophilic nature of my writing is justified, or pertinent, and if its subject (trash) can really be apprehended with the sole assistance of the eyes. For . . . isn't trash intrinsically dirty, and malodorous, and wouldn't it make much more sense thus, in order to capture the true nature of garbage, to smell it, and to touch it? I must confess that (though left-handed) I wrote my book with my right hand solely, the hand that Hindu philosophy considerers "pure" and sacred, whereas the left hand is reserved for profane and scatological needs. My hand thus remained suspiciously clean throughout the writing process; I always used the "right" one (Fig. C.2). I did not touch or smell trash (or never confessed to my audience that I did, for that matter): I just looked

Fig. C.2: Photo by Filomena Cruz, *My Right Hand*.

at it (or said I did), and therefore invited the reader to do the same. I limited the experience of my audience, but, to be fair, so do most of the artists who work on—and even directly with—trash.

Mexican forensic artist Teresa Margolles learned her métier at the morgue in Mexico City, and more often than not her art installations are literally drenched in the blood of the victims that fall prey to drug and state violence. During one of her earlier performances, and in protest against José Efraín ríos Montt's dictatorship, Guatemalan performance artist Regina José Galindo walked from the Congress building to the National Palace in Guatemala City with her feet soaked in human blood. But . . . how many Margolleses and José Galindos can one find among the trash artists? Not many, for the primordial impulse, when artists encounter garbage, is not to "get dirty" or to fully embrace the abject (Kristeva), but rather, to establish order where there is intrinsic chaos. The panoramic view and

grand-scale perspectives cherished by Gursky, Canogar, Jordan, Muniz, and Schult; the "naive" sameness of Kiefer's serial "collages"; Wilson's quaint miniatures on chewing gum canvases; even de Pájaro's anthropomorphized trash bags, are all efforts to (re)create harmony and make garbage speak an understandable language. Take Rozin's *Trash Mirror* discussed in the Introduction, for example. As Rozin explains, his piece is a "calming" mirror (very different from the mirror that enrages the queen in *Snow White*), one that uses digital technology not only to make it possible for us to find reflection in (carefully arranged) trash, but also to provide pleasant acoustics. The mechanical mirror has "video cameras, motors and computers on board and produce[s] a soothing sound as the viewer interacts with them. . . . The piece celebrates the ability of computation to inflict order on even the messiest of substances—trash."

Let's face it, "to inflict order" and a sense of calm to the "messiest substance of all,

trash," is not only Rozin's prerogative, but the intention and modus operandi of the great majority of artists inspired by garbage. In some ways, trash is even less incomprehensible than bodily finality and demise, and therefore more threatening. For one, there is no ritual that helps us come to terms with the reality of obsolescence: we don't know how to find closure confronted with the spectacle of commodities that we declare "dead," but that remain very much alive. In fact (and plastic is to blame for it), discarded objects keep growing endlessly, and coming back, via accumulation: trash (particularly the contemporary kind) is goods turned into zombies.

Finally, there is the added and very important factor that museums, art galleries, and art institutions in general are stubbornly "hygienic" entities, where all the properties dear to trash (messiness; smelliness; overabundance; incommensurability) noisily clash with what, to this day, makes a museum a museum, namely: order (for order means beauty, still); minimalism (more often than not); rigorous classification (sometimes obvious; other times more nuanced, but always there); and lack of (bad) smell.

Museums aren't landfills (though sometimes they are morgues), and books (or mirrors, for that matter) aren't either. Garbage does not thrive, nor does its true nature come to the fore when encased in the rigid and sanitized quadrature of museum structures and books. Somehow we have to come to terms with it. Ultimately, and after having written a book on trash, I have to concede that I have not written a book on trash . . . and that it is time for me now to get my hands dirty.

Notes

Introduction

1. To follow the trajectory, history, and purpose of the archives, collections, and exhibits of border artifacts found in the Arizona desert is in itself a complex, and fascinating, task. This note offers some basic background as a point of departure for further research. It is worthwhile to note, for example, that the collections housed in the Center for Religious Life at USC and at the Museum of World Culture in Goteburg, Sweden, are both donations from self-taught border artist and collector Valarie Lee James. Anthropologist Jason De León, on the other hand, donated objects from his collection to the Smithsonian Museum of American History. Finally, the border artifacts that are part of Mexican film director Alejandro González Iñárritu's virtual reality intervention *Carne y Arena* (2017–2018)—showing simultaneously at Fondazione Prada, Milan, LACMA, Los Angeles, and the Centro Cultural Universitario Tlatelolco, Mexico City—come partly from Valarie Lee James's collection donated to the Center for Religious Life at USC, and from the comprehensive archive owned by Thomas Kiefer, yet another self-taught artist, photographer, and collector based in Arizona.

Chapter 1

1. The image of contemporary trash as restless long-distance traveler resonates powerfully in what Kathy Wilson Peacock fittingly terms "the strange saga of the Khian Sea:"

 > In 1986, the city of Philadelphia, Pennsylvania, hired a company to get rid of the ash from their incinerator plant. Some of this ash contained hazardous chemicals.

 13,000 tons (11,700 metric tons) of ash were loaded on a ship named the *Khian Sea*. It spent twenty-seven months at sea stopping in Panama, Haiti, Honduras, Bermuda, Africa, and the Bahamas, trying to unload its cargo, which was labeled as fertilizer ash. The ship eventually returned to Philadelphia where it was turned away. With the ship showing signs of rusting, it left Philadelphia with a new name, the *Felicia*. It sailed to the Philippines where it was again turned away. After another name change, this time to *Pelicano*, the ship docked at Singapore. The cargo of hazardous waste had disappeared. No one would say what had happened to it (quoted in AIMS Multimedia, 21).

 As Peacock mentions in a different online article,

 > three years later—in 2000—the [Haiti] ash was loaded onto a barge and shipped to Florida. Haiti, however, was still on the hook for the lion's share of the shipping costs to remove the ash they didn't want in the first place. The barge remained docked in the St. Lucie Canal for a couple of years until the Environmental Protection Agency declared the ash nonhazardous and thus suitable for the landfill. The ash's long journey ended at the Mountain View Reclamation Landfill in Antrim, Pennsylvania, not far from where it had been generated sixteen years earlier. (Peacock, "The Strange Case")

 It is important to note that, as Wilson Peacock concludes, "the saga of the *Khian Sea* was an impetus for the Basel Convention on the Control of Transboundary Movements of Hazardous Wastes and Their Disposal. This UN treaty was signed in 1989, shortly after the Philly ash had been illegally dumped in

the ocean, and entered into force in 1992, amidst the worst of the legal wrangling" (Peacock, "The Strange Case").

2. Even if the sanitary landfill has been touted as the less harmful method for long-term garbage disposal, landfills aren't the panacea. In Thomson's words, "although [the modern sanitary landfill] must meet much more stringent health and environmental standards than the town dumps they replaced, they are still sources of air and water contaminants. In the United States, landfills are the largest resource of human-generated methane—a powerful greenhouse gas—and carcinogens like benzene and vinyl chloride are among the exotic cocktail of trace gases that emanate from them. Landfill leachate often contains toxic compounds, and despite elaborate precautionary measures which include soil covers, synthetic liners, and leachate collection systems, landfills can contaminate groundwater or nearby surface waters. In fact, the United States Environmental Protection Agency has concluded that all landfills will eventually leak liquids into the surrounding environment" (2–3).

3. In children's literature, the subgenre on waste management, recycling, and the figure of the garbage man perfectly overlaps in content, intention, and iconography with the popular and propaganda-infused subgenre on the police and particularly on the figure of the police officer (*Keeping You Safe: A Book about Police Officers*; *A Day in the Life of a Police Officer*; *Let's Meet a Police Officer*; *Meet My Neighbor, the Police Officer*; and *Police Officers to the Rescue* are some of the titles among many). The police officer and the trash collector are perfectly interchangeable characters, soft spoken, friendly heroes with a pristine and identical agenda: to keep us safe (from trash and from bad people). The authoritarian undertones are barely noticeable, although both the garbage man and the police officer will quickly embrace a "tough guy" demeanor and mentality when they resurface in literature, films, and documentaries geared towards young (male) adults and to adults in general.

4. Of all tossed-out and abandoned objects, none seems as compellingly moving as shoes. The symbolic density of that particular artifact—as made evident in Frederic

Jameson's comparison of Van Gogh's *A Pair of Shoes* and Andy Warhol's *Diamond Dust Shoes* in *Postmodernism; or, The Cultural Logic of Capitalism* (1991)—has attracted the attention recently not only of scholars (such as urban critic Christoph Lindner) but also of a number of photographers, artivists, and anthropologists, discussed in Chapter 2, such as Alejandro Durán, Guillermo Galindo, Susan Harbage Page, and Richard Misrach.

Chapter 2

1. Brian Thill points out that trash fossilization is so prevalent and extended that "geologists have now begun to study 'technofossils,' and the sedimented debris-layers of our vast compressed cities, so immense and consequential that they now constitute part of the geological and planetary record" (4).

2. For a more detailed analysis of TRES's *Chicle y Pega* intervention and some additional reflections on Ben Wilson's chewing gum paintings, see my article "Litter: On Chewing Gum and Street Art."

3. In her article "The Archive as Dumpster," Mél Hogan perceptively discusses the hands-on activity "of picking through trash" as a way of "subverting traditional archival methodologies" (7). Refuse and the archive certainly speak to each other in various ways. For one, the archive as concept and practice (and in its different variations, such as "real" and virtual collections, taxonomies, museums, and libraries; Manoff) is particularly appealing to "trash artists." The latter often center their art on collecting and exhibiting refuse and thus directly engage in explicit and implicit conversation with what it means to create an archive of the discarded. A number of critics have written extensively about the archive (among them Michel Foucault, Jacques Derrida, Gayatri Spivak, and Giorgio Agamben, often in the context of postcolonial and Holocaust studies), but when trash is at stake, reflections on the act of collecting and classifying tend to focus on a more specific (and somewhat elusive) subcategory of the archive, namely that of the "anti-archive" or "counterarchive." Critics have tackled the concept from various angles (Elisabeth Friedman, for example, discusses anti-archives in the context of the Holocaust and the sheer

impossibility of documenting and archiving it in any orthodox fashion; Anderson Araujo reads the narrativized photographs in Virginia Woolf's *Three Guineas* as an anti-archive of the Spanish Civil War), but the most straightforward explanation probably comes from artist and border trash collector Susan Harbage Page. In an e-mail to me, and referring explicitly to her *Anti-Archive from the US-Mexico Border Project* that I discuss later in this chapter, the artist had the following to say: "When I named my project this in 2007, I was thinking that most of our state-sanctioned archives save things (documents and objects) from people who are rich and famous . . . [such as George Washington's false teeth preserved at Mount Vernon]. I wanted to show the history (largely invisible at the time) of the contemporary 'great northern migration" by the Latin community through the collection of objects left in the border area near the Rio Grande by people who . . . were throwing their identity cards out to stay in the U.S. This collecting allowed a new history to be remembered. My archive is the antithesis of most archives which save the histories of the rich and famous—therefore the 'Anti-Archive.' . . . The 'Anti-Archive' [now kept in North Carolina] is a way of making the imaginary space of the border concrete. . . . I felt that . . . [what I often call] the 'Anti-Archive of Trauma on the U.S./ Mexico Border' . . . is the antithesis of major state sanctioned archives to immigration like Ellis Island."

4. Trash and its usefulness is not only perceived differently according to gender, but women have a more limited access to garbage as well. As Christine Furedy notes, "Although local systems usually have distinctive characteristics, the main status lines in waste recovery are uniform in developing countries: women and children predominate in the lowest levels of waste gathering, that is, those that depend on the least valuable wastes whose retrieval demands the greatest amount of simple labour for the lowest cash returns. Thus on dump sites that receive largely organic and inert rubbish in Asia one finds mainly women and children, except at times when men know that trucks will arrive from special areas such as the airport or certain commercial and residential neighbourhoods" (26).

5. The close interaction with refuse as part of the job in the case of janitors, maintenance workers, and housekeepers has ignited the interest of a number of writers, artists, journalists, and scholars. Laderman Ukeles's interventions are one example, but there are others, and not all favor the compassionate angle. Articles on cleaning ladies "stupid" or "ignorant" enough for mistaking art for trash and consequently throwing it away appear routinely in the press, and popular cultural representations of janitors as "dirty old men" and sexual predators also abound. *Waste* (2008), a novel by Eugene Marten, is a particularly harrowing and nuanced recreation of the cliché. Efforts at elevating trash to the category of art via collecting on the part of maintenance workers, like in the two cases discussed in this chapter, Nelson Molina's *Treasures in the Trash Museum*, and Thomas Kiefer's *El Sueño Americano Project* are effective attempts at counteracting pejorative depictions of maintenance jobs and at creating a sense of legitimacy and self-worth.

Chapter 3

1. Ferrell recounts the story of a man, by the name of Robert Cercelleta, who is arrested in Rome for "fishing tourist-tossed coins out of the famous Trevi Fountain," and of an unnamed woman, who, "inspired by media coverage of Cercelleta's arrest, is arrested as she wades in after her own free coins in the fountain" (14). He also brings to our attention the case of John Collinson, apprehended by the police "as he walks across Leicester's Whetstone Golf Course, wearing a rubber diving suit and carrying some 1,100 golf balls, all of which he and a friend have just scrounged from Lily Pond, a notorious water hazard on the course's fifth hole" (14). The public figures related to the golf world that eagerly jump to his defense argue alongside the "perpetrator" that "the balls don't belong to anyone," and that they are "finders keepers" and "abandoned property." Finally, "some months later, two Court of Appeal judges overturn the [initial] six-month sentence, imposing instead a two-year conditional discharge and warning Collinson away from subsequent 'clandestine' dives" (14).

2. Urban Dictionary, s.v. "Dumpster," by Nabeel, February 8, 2004. *www.urbandictionary.com /define.php?term=Dumpster*

3. Urban Dictionary, s.v. "Dumpster," by Joe Graf, November 25, 2006. *www.urban dictionary.com/define.php?term=Dumpster.*

Chapter 4

1. The engrained social belief that "white" means "clean" (and, by extension, nonwhite, dirty) is not new but is based on deep-seated historical roots. As Rosie Cox points out, "marginalized ethnic groups are often depicted to be inherently dirtier than those who are more privileged. . . . Immigrants and members of minority groups are often abusively characterized as 'smelly' or 'dirty,' hence not as clean as their [white] neighbors. For at least two centuries white skin has implied cleanliness" (57–58).

2. To this day, cultural artifacts strategically built around the transition from "dirty" to "clean" exert unfailing fascination on the audience. Not only cleaning products advertisements (the most obvious example), but also hugely popular TV shows on home renovation such as *Extreme Makeover, Clean House, Fixer Upper, Property Brothers, Rehab Addict,* and even the much bleaker but equally famous *Hoarders* and *Hoarding: Buried Alive* feed the powerful dream of the pristinely clean, clutter-free, and "healthy" domestic interior, while similar and no less successful shows, such as *What Not to Wear* and *How Do I Look,* lure us into believing that ugly ducklings can effectively morph into a beauty, groomed and sleek. In the realm of child hygiene, the great success of the British TV series *Call the Midwife* is similarly based on the dirty/clean opposition, which this time manifests itself in the messy business of birth giving invariably followed by frantic cleaning efforts. Notable for its deeply authoritarian and misogynistic streak despite (or even because of) its many edifying episodes, quaint scenes, amiable domesticity, and even faint attempts at subversion, *Call the Midwife* bombards the viewer with highbrow institutionalized hygiene: doctors and midwives clad in pristine white and nuns showing off primly starched habits tirelessly attend to the poor, that is, to women drenched

in bodily fluids, and to their equally slimy offspring.

3. "The Garbage Pail Kids parody stickers were released by the Topps Chewing Gum company starting in 1985 and were created by Art Spiegelman and Mark Newgarden, both art directors, editors, writers, and concept artists for the GPK franchise and its entire original series run" (Booton). By 1988, Topps "had published more than six hundred stickers" (Pound), and as another well-documented website recounts, "the response the stickers received in the public was epic. Stores could not keep them on the shelves. Schools were banning them from classrooms. Movies and morning cartoons were developed. In addition to nine different series being released in the first 24 months, the market also saw an influx of Garbage Pail Kids merchandise. From trash cans to Halloween costumes to key chains to sunglasses. . . . Garbage Pail Kids were everywhere" ("History of the Garbage Pail Kids"). The GPK craze died out in 1988, after the publication of its fifteenth series, but came back to life in 2003. That year "the Topps Company, Inc. took advantage of the increasingly nostalgic craze for 80's games and toys and released seven All-New Series GPK sets over a period of several years through 2007 and then three Flashback sets that contained original GPK artwork as well as Lost material and All-New content in 2010 and 2011. Three rejuvenated Brand-New Series GPK sets were released in 2012 and 2013 with a nostalgic GPK feel and two Chrome technology sets in 2013 and 2014. The latest Yearly GPK sets have been released from 2014 through 2016 with the most current having themes" (Booton).

4. When I approached the legal department of the Topps Company asking for reproduction rights for the Garbage Pail Kids trading cards that I discuss in this chapter, I received a contract that prohibited me from saying anything "negative" or "derogatory" about them. Fortunately (or unfortunately, rather) reproductions of the cards and of the characters I mention in this chapter are widely available online. The website *geepeekay.com,* for example, is one of, if not *the* most comprehensive online source devoted exclusively to the various Garbage Pail Kids series. Its gallery offers a staggeringly

rich visual repository of the different series, organized chronologically. There is also detailed and well-documented information on the artists that illustrated the trading cards, on the history and origin of Garbage Pail Kids, and on its many foreign releases. Another essential source is the book *Garbage Pail Kids* (2012) cited in the bibliography. An illustrated catalogue really of the different trading card series, it also includes a very useful introduction by Art Spiegelman, and an afterword by John Pound.

5. Peter Baldwin, "There are no gender differences," September 8, 2014. Response to anonymous question, "Why are there so many women on the show Hoarders?" *www.quora.com/Why-are-there-so-many-women-on-the-show-Hoarders*.

6. The pictorial motif of the little girl portrayed as cute housewife doubly tending to her home and to her beauty is a long-standing trope. In fact, it created a whole postcard subgenre that became highly popular during the first half of the twentieth century (Zubiaurre, *Cultures of the Erotic*).

7. The page numbers for the German refer to Herrndorf, *Tschick*; the page numbers for the English versions are from Herrndorf, *Why We Took the Car*.

8. Denzel Washington's recent filmic masterpiece *Fences* (2016), based on the Pulitzer Prize–winning play (1987) of the same name by August Wilson, brings to the fore the tensions in the sanitation department during the 1950s. The main character, an African American trash picker, has to appeal to the union in order to be promoted to driver, thus highlighting the fact that it was predominantly white employees who drove the garbage trucks. In midcentury America, the actual task of collecting the trash fell on black workers.

9. Many of these are available on YouTube. See, for example, *City Real Hero Garbage Truck Driver*, by Pago Kids (www.youtube.com/watch?v=RfHBK4kRSRo); *Frank the Garbage Truck* (www.youtube.com/watch?v=3Su3PrUyWaU) and *Garbage Truck*, by Kids Channel (www.youtube.com/watch?v=rbd8v-E__QQ); *Garbage Trucks: On Route, in Action!*, by Thrash 'N' Trash Productions (www.youtube.com/watch?v=LTUjiLxzDQs); *Garbage Truck Song for Kids*, by New Sky Kids (www.youtube.com/watch?v=d9mUGr7yoIM); and *Kids Truck Video-Garbage Truck*, by twentytrucks (www.youtube.com/watch?v=HWLuXiA-Lsw).

Bibliography

Acaroglu, Leyla. "Where Do Old Cellphones Go to Die?" *New York Times Sunday Review*, May 4, 2013. *www.nytimes.com/2013/05/05 /opinion/sunday/where-do-old-cellphones-go-to -die.html?_r=1.*

Agamben, Giorgio. *Remnants of Auschwitz: The Witness and the Archive.* Trans. Daniel Heller-Roazen. Boston: MIT Press, 2000.

AIMS Multimedia. *Trash and the Environment.* Chatsworth, CA: AIMS Multimedia, 1999. *www.nhptv.org/kn/itv/guides/realworldsci_trash .pdf.*

Albanese, Daniel. "Entrevista con 'El arte es basura.'" TheDustyRebel (website). June 27, 2014. *www.thedustyrebel.com/post/89968008247 /entrevista-con-el-arte-es-basura.*

Araujo, Anderson. "Pictures and Voices: Virginia Woolf's *Three Guineas* as Anti-archive." In *Rewriting Texts Remaking Images: Interdisciplinary Perspectives*, ed. Leslie Boldt, Corrado Federici, and Ernesto Virgulti, 3–13. New York: Peter Lang, 2010.

Arnold, Jeanne E., and Anthony P. Graesch, Enzo Ragazzini, and Elinor Ochs. *Life at Home in the Twenty-First Century: 32 Families Open Their Doors.* Los Angeles: Cotsen Institute of Archeology at UCLA, 2012.

Bakhtin, Mikhail. "Forms of Time and of the Chronotope in the Novel: Notes Towards a Historical Poetic." In *The Dialogic Imagination: Four Essays*, ed. Michael Holquist. Austin: University of Texas Press, 1981.

Bataille, George. *Visions of Excess (Selected Writings, 1927–1939).* Minneapolis: University of Minnesota Press, 1985.

Batalion, Judy. *White Walls: A Memoir about Motherhood, Daughterhood, and the Mess in Between.* New York: New Amerian Library, 2016.

Baudelaire, Charles. *Artificial Paradises.* Trans. Stacy Diamond. New York: Citadel, 1996.

———. *The Painter of Modern Life and Other Essays.* London: Phaidon, 1995.

Baudrillard, Jean. "The System of Collecting." In *The Cultures of Collecting*, edited by John Elsner and Roger Cardinal, 7–24. Cambridge, MA: Harvard University Press, 1994.

BBC News. "'Monster' Fatberg Found Blocking East London Sewer." BBC News (website). September 12, 2017. *www.bbc.com/news/uk -england-london-41238272.*

———. "'Victory Declared' over 130 Tonne Whitechapel Fatberg." BBC News (website). November 3, 2017. *www.bbc.com/news/uk -england-london-41860764.*

Benjamin, Walter. *The Arcades Project.* Trans. Howard Eiland and Kevin McLaughlin. Cambridge, MA: Belknap Press of Harvard University Press, 2000.

———. *Charles Baudelaire: Lyric Poet in the Era of High Capitalism.* Trans. Harry Zohn. London: NLB, 1969.

Bennett, Jane. *Vibrant Matter: A Political Ecology of Things.* Durham, NC: Duke University Press, 2010.

Berger, John. "A Professional Secret." In *Selected Essays: John Berger*, ed. Geoff Dyer, 536–40. New York: Vintage International, 2001.

———. *Ways of Seeing.* London: Penguin, 1977.

Boltvinik, Ilana, and Rodrigo Viñas. *Ubiquitous Trash.* Hong Kong: WYNG Foundation and Festina Publicaciones, 2016.

Booton, Aaron. Home page. "Barren Aaron's Garbage Pail Kids World" (website). n.d. (accessed November 2, 2018). *members.tripod .com/garbage_pail_kids.*

"*Border Signs*: Turning a Lens on the Tragedy and Mystery of the U.S.–Mexico Frontier." *California Sunday Magazine*, November 2,

2104. *story.californiasunday.com/richard -misrach-border-signs*.

Bornay, Erica. *La cabellera femenina*. Madrid: Cátedra, 2010.

Butler, Judith. *Precarious Lives: The Power of Mourning and Violence*. London: Verso, 2006.

Call, Laura. "Waste Treatment: Resource Recovery in *Les Glaneurs et la Glaneuse* and *La Clôture*." In *Ecocritical Approaches to Literature in French*, ed. Douglas L. Boudreau and Marnie M. Sullivan, 145–68. Lanham, MD: Lexington Books, 2015.

Campkin, Ben, and Rosie Cox. *Dirt: New Geographies of Cleanliness and Contamination*. London: I. B. Tauris, 2013.

Carter, Hodding W. *Flushed: How the Plumber Saved Civilization*. New York: Atria Books, 2006.

"The Chewing Gum Portraits by Jason Kronenwald." November 22, 2010. *www .odditycentral.com/pics/the-chewing-gum -portraits-of-jason-kronenwald.html*.

Círculo A. "Chicle y Pega - Tres Art Collective - Casa Vecina." Círculo A (website). August 11, 2012. *www.circuloa.com/casavecina -tresartcollective*.

Colwell Miller, Connie. *Garbage, Waste, Dumps, and You: The Disgusting Story behind What We Leave Behind*. Minneapolis: Capstone, 2008.

Corbett, Kevin. "*Gleaners* and *Waste*: The Post-issue/Advocacy Documentary." *Journal of Popular Film and Television* 41, no. 3 (2013): 128–35.

Corbey, Raymond. "Ethnographic Showcases, 1870–1930." *Cultural Anthropology* 8, no. 3 (1993): 338–69.

Cordal, Isaac. *Cement Eclipses: Small Interventions in the Big City*. London: Carpet Bombing Culture, 2011.

Cortez, Marisol. "Time Out of Mind: The Animation of Obsolescence in *The Brave Little Toaster*." In *Histories of the Dustheap: Waste, Material Culture, Social Justice*, ed. Stephanie Foote and Elizabeth Mazzolini, 227–52. Cambridge, MA: MIT Press, 2012.

Cox, Rosie. "Dishing the Dirt: Dirt in the Home." In *The Filthy Reality of Everyday Life*, ed. Kate Forde, 37–73. London: Profile Books, 2012.

Dalley, Lana L., and Jill Rappoport, eds. *Economic Women: Essays on Desire and Dispossession in Nineteenth-Century British Culture*. Columbus: Ohio State University Press, 2013.

Debord, Guy. *Society of the Spectacle*. Detroit: Black and Red, 2000.

Debord, Guy, Ivan Chtcheglov, Asger Jorn, Raoul Vaneigem, and Mustapha Khayati. *Situationism: A Compendium*. Bread and Circuses, 2014.

De León, Jason. *The Land of Open Graves: Living and Dying on the Migrant Trail*. Oakland: University of California Press, 2015.

———. "Undocumented Migration, Use Wear, and the Materiality of Habitual Suffering in the Sonoran Desert." *Journal of Material Culture* 18, no. 14 (2013): 321–45.

Derrida, Jacques. *Archive Fever: A Freudian Impression*. Trans. Eric Prenowitz. Chicago: University of Chicago Press, 1995.

Douglas, Mary. *Purity and Danger: An Analysis of Concept of Pollution and Tabu*. London: Routledge, 2002.

Durán, Alejandro. "What Is the *Washed Up* Project?" *Washed Up: Transforming a Trashed Landscape*, Alejandro Durán (website). n.d. *www.alejandroduran.com*.

Elmore, Julia. "Art on Chewing Gum: Ben Wilson." *RawVision*. Summer 2006. *rawvision .com/articles/art-chewing-gum-ben-wilson*.

Elrod, Leslie. "Marketing, Consumer Behavior, and Garbage." In *Encyclopedia of Consumption and Waste: The Social Science of Garbage*, ed. Carl A. Zimring and William L. Rathje, 503–8. Los Angeles: Sage, 2012.

Engler, Mira. *Designing America's Waste Landscapes*. Baltimore: Johns Hopkins University Press, 2004.

Faircloth, Kelly. "Garbage Cans Become WiFi Hotspots in Perfect Metaphor for the Internet." July 14, 2015. *jezebel.com/garbage -cans-become-wifi-hotspots-in-perfect-metaphor -f-1717717471*.

Fallon, Clair, "Where Did 'Dumpster Fire' Come from, Where Is It Rolling? *Huffington Post*, January 15, 2017. *www.huffingtonpost.com /entry/dumpster-fire-slang-history_us*.

Farina, Blaise. "History of Consumption and Waste, U.S., 1950–Present." In *Encyclopedia of Consumption and Waste: The Social Science of Garbage*, ed. Carl A. Zimring and William L. Rathje, 364–70. Los Angeles: Sage, 2012.

Feinberg, Paul. "Splendor in the Trash." *UCLA Magazine*, October 1, 2015. *magazine.ucla .edu/features/splendor-in-the-trash*.

Ferrell, Jeff. *Empire of Scrounge: Inside the Urban Underground of Dumpster Diving, Trash*

Picking, and Street Scavenging. New York: New York University Press, 2006.

Fidler, Matt. "Seven Days of Garbage—in Pictures." *Guardian*, July 16, 2014. *www .theguardian.com/environment/gallery/2014 /jul/16/seven-days-of-garbage-in-pictures.*

Finley, Christine. *How to Wallpaper a Dumpster.* Vimeo. Uploaded January 18, 2010. *vimeo .com/8831211.*

Fischer, Lucy. "Generic Gleaning: Agnes Varda, Documentary, and the Art of Salvage." In *Gender Meets Genre in Postwar Cinemas,* ed. Christine Gledhill, 111–22. Urbana: University of Illinois Press, 2011.

Folino White, Ann. "History of Consumption and Waste, U.S., 1900–1950." In *Encyclopedia of Consumption and Waste: The Social Science of Garbage,* ed. Carl A. Zimring and William L. Rathje, 361–64. Los Angeles: Sage, 2012.

Foucault, Michel. *The Archaeology of Knowledge and the Discourse on Language.* Trans. A. M. Sheridan Smith. New York: Pantheon Books, 1972.

Foxy Production. "OVERAWE: Sarah Dobai, Ruth Maclennan, Ester Partegàs, 15 October 2005 to 19 November 2005." Foxy Production (website). 2005. *www.foxyproduction.com /exhibitions/173/pr.*

Freud, Sigmund. *Civilization and Its Discontents.* Trans. and ed. James Strachey. New York: Norton, 1961.

Friedman, Elisabeth. "The Anti-archive? Claude Lanzmann's *Shoah* and the Dilemmas of Holocaust Representation." *English Language Notes* 45, no. 1 (Spring-Summer 2007): 111–21.

Frost, Randy O., and Tamara L. Hartl. "A Cognitive Behavioral Model of Compulsive Hoarding." *Behavior Research and Therapy* 34, no. 4 (April 1996): 341–50.

Fuller, Britney. *Trash: An Innocent Girl; A Shocking Story of Squalor and Neglect.* London: Virgin Books, 2014.

Furedy, Christine. "Women and Solid Wastes in Poor Communities." 16th WEDC Conference. Infrastructure for Low-Income Communities. Hyderabad, India, 1990.

Gabrys, Jennifer. *Digital Rubbish: A Natural History of Electronics.* Ann Arbor: University of Michigan Press, 2011.

Garbage Pail Kids. Introduction by Art Spiegelman, afterword by John Pound. New York: Abrams Comicarts, 2012.

Genuske, Amber. "Trashcam Project Uses Dumpsters as Cameras (Photos)." *Huffington Post*, April 21, 2012. *www.huffingtonpost.com /2012/04/21/trashcam-project_n_1441416 .html.*

George, Rose. *The Big Necessity: The Unmentionable World of Human Waste and Why It Matters.* New York: Holt, 2008.

Goldberg, Carey. "Scenic Mountains Scarred by Illegal Border Crossings." *New York Times*, Archives, 1996. *www.nytimes.com/1996/11/17 /us/scenic-mountains-scarred-by-illegal-border -crossings.html.*

Gómez de la Serna, Ramón. *Ensayo sobre lo cursi.* Madrid: Moreno-Avila Editores, 1988.

Grazia, Victoria de, and Ellen Furlough, eds. *The Sex of Things: Gender and Consumption in Historical Perspective.* Berkeley: University of California Press, 1996.

Green, Penelope. "The Dumpster Beautified." *New York Times*, January 13, 2010. *www .nytimes.com/2010/01/14/garden/14events.html.*

Grossman, Elizabeth. *High Tech Trash: Digital Devices, Hidden Toxins, and Human Health.* Washington, DC: Island, 2006.

Grundhauser, Eric. "The Treasures in the Trash Collection." Atlas Obscura (website). n.d. (accessed July 8, 2017). *www.atlasobscura.com /places/the-treasures-in-the-trash-museum.*

Guzzardi, Joe. "Mounting Border Trash Proves Alien Invasion Alive and Well." Californians for Population Stabilization (website). February 11, 2012. *www.capsweb.org/blog /mounting-border-trash-proves-alien-invasion -alive-and-well.*

Haraway, Donna J. "A Cyborg Manifesto: Science, Technology, and Socialist-Feminism in the Late Twentieth Century." In *Simians, Cyborgs, and Women: The Reinvention of Nature,* by Donna Haraway, 149–81. New York: Routledge, 1991.

Harbage Page, Susan. "U.S.-Mexico Border Project." Susan Harbage Page (website). n.d. (accessed November 1, 2018). *susanharbage page.blogspot.com/p/us-mexico-border.html.*

Harris, Joe, and Martín Morazzo. *Great Pacific Trashed!* Image Comics, 2013.

Hawkins, Gay. *The Ethics of Waste: How We Relate to Rubbish.* Lanham, MD: Rowman and Littlefield, 2006.

———. "Sad Chairs." In *Trash*, ed. John Knechtel, 51–60. Boston: MIT Press, 2007.

Hawkins, Paula. *The Girl on the Train*. New York: Riverhead Books, 2015.

Heidegger, Martin. "On the Origin of the Work of Art." In *Basic Writings*, ed. David Farrell Krell, 143–12. New York: Harper Collins, 2008.

———. *Parmenides*. In Gesamtausgabe, Band 54, Abt. 2, *Vorlesungen*, 1919–44. Frankfurt am Main: Vittorio Klostermann, 1982.

Herring, Scott. *The Hoarders: Material Deviance in Modern American Culture*. Chicago: University Chicago Press, 2014.

Herrndorf, Wolfgang. *Tschick*. Berlin: Rowohlt Taschenbuch Verlag, 2010.

———. *Why We Took the Car*. Trans. Tim Mohr. New York: Arthur A. Levine Books, 2014.

Hesler, Jakob. "Playing with Death: The Aesthetics of Gleaning in Agnès Varda's *Les Glaneurs et La Glaneuse*." In *Telling Stories: Countering Narrative in Art, Theory and Film*, ed. Jane Tormey and Gillian Whiteley, 193–205. Newcastle upon Tyne, England: Cambridge Scholars, 2009.

Hilton, Mathew. "The Female Consumer and the Politics of Consumption in Twentieth-Century Britain." *Historical Journal* 45, no. 1 (March 2002): 103–28.

"History of Garbage Pail Kids." GeePeeKay (website). n.d. (accessed November 2, 2018). *geepeekay.com/history.html*.

Hogan, Mél. "The Archive as Dumpster." *Pivot: A Journal of Interdisciplinary Studies and Thought* 4, no. 1 (2015): 7–38.

Holdsworth, Stuart. "The Chewing Gum Man Paints a Trail of 400 Mini-Artworks on the Millenium Bridge." Inspiring City (blog). April 18, 2014. *inspiringcity.com/2014/04/18/the-chewing-gum-man-paints-a-trail-of-400-mini-artworks-on-the-millenium-bridge*.

Hollingsworth, Jonathan. *Left Behind: Life and Death along the U.S. Border*. Manchester: Dewi Lewis, 2012.

Horne, R. H. "Dust; or, Ugliness Redeemed." In *The Filthy Reality of Everyday Life*, ed. Kate Forde, 178–85. London: Profile Books, 2012.

Hoy, Suellen. *Chasing Dirt: The American Pursuit of Cleanliness*. Oxford: Oxford University Press, 1996.

Huhtamo, Erkki. *Illusions in Motion: Media Archeology of the Moving Panorama and Related Spectacles*. Cambridge, MA: MIT Press, 2013.

Humes, Edward. *Garbology: Our Dirty Love with Trash*. New York: Avery, 2012.

Hunt, Jeremy (jeh). 2012. "Vik Muniz: Pictures of Junk, Jardim Gramacho, Rio de Janeiro." *AAJ Press* (blog). February 24, 2012. aajpress.wordpress.com/2012/02/24/vik-muniz-pictures-of-junk-jardim-gramacho-rio-de-janeiro.

Ibarz, Vanesa. "Entrevista Daniel Canogar: Proyecto *Otras Geologías*." *Disturbis: Publicación periódica del Máster de Estética y Teoría del Arte Comtemporáneo* 5 (Spring 2009). www.disturbis.esteticauab.org/Disturbis567/VIbarz.html.

IMDb. s.v. *Megastructures*: "Garbage Mountain." n.d. (accessed November 1, 2018). *www.imdb.com/title/tt0947424*.

Institute for Figuring. "Art Center College of Design, Pasadena, CA: Hyperbolic: Reefs, Rubbish, and Reason." Crochet Coral Reef (website). 2011. *crochetcoralreef.org/exhibitions/art_center.php*.

Jameson, Frederic. *Postmodernism; or, The Cultural Logic of Late Capitalism*. Durham, NC: Duke University Press, 1991.

Johnson, D. J. "Q&A with C. Finley: An Update on Wallpapered Dumpsters." The Fill (blog). July 29, 2015. *www.budgetdumpster.com/blog/qa-with-c-finley-an-update-on-wallpapered-dumpsters*.

Johnson, Roberta. *Gender and Nation in the Spanish Modernist Novel*. Nashville, TN: Vanderbilt University Press, 2003.

Jordan, Chris. "Intolerable Beauty: Portaits of American Mass Consumption." Chris Jordan Photographic Arts (website). 2005. *chrisjordan.com/gallery/intolerable/#about*.

Jorgensen, Dolly. "History of Consumption and Waste, Medieval World." In *Encyclopedia of Consumption and Waste: The Social Science of Garbage*, ed. Carl A. Zimring and William L. Rathje, 348–50. Los Angeles: Sage, 2012.

Kantaris, Geoffrey. "Waste Not, Want Not: Garbage and the Philosopher of the Dump (*Waste Land* and *Estamira*)." In *Global Garbage: Urban Imaginaries of Waste, Excess, and Abandonment*, ed. Christoph Lindner and Miriam Meissner, 52–67. Abingdon: Routledge, 2016.

Katz Cooper, Sharon. *Garbage Cans and Landfills*. Chicago: Raintree, 2010.

Kendall, Tina. "Cinematic Affects and the Ethics of Waste." *New Cinemas: Journal of Contemporary Film* 10, no. 1 (2012): 45–61.

———. "Utopia Gleaners." In *Trash*, ed. John Knechtel, 224–29. Cambridge, MA: MIT Press, 2007.

Kids Channel. *Garbage Truck | Videos for Kids | Street Vehicle Toys | Compilation*. YouTube. December 11, 2016. *www.youtube.com /watch?v=rbd8v-E__QQ*.

———. *Road Rangers | Frank The Garbage Truck | Garbage Truck Song | Ep #14*. YouTube. November 12, 2016. *youtu.be/3Su3PrUyWaU*.

Kiefer, Tom. "El Sueno: An Americano Project." LensCulture (website). 2015. *www.lensculture .com/articles/tom-kiefer-el-sueno-an -americano-project*.

Kim, Annette Miae. *Sidewalk City: Remapping Public Space in Ho Chi Minh City*. Chicago: University of Chicago Press, 2015.

Kramper, Werner. *Wolfgang Herrndorf: Tschick*. Munich, Germany: Stark Verlag, 2016

Kristeva, Julia. *Powers of Horror: An Essay on Abjection*. New York: Columbia University Press, 1982.

Krotzer Laborde, Katheryn. *Do Not Open: The Discarded Refrigerators of Post-Katrina New Orleans*. Jefferson, NC: McFarland, 2010.

Laporte, Dominique. *History of Shit*. Cambridge, MA: MIT Press, 2000.

Latour, Bruno. *The Pasteurization of France*. Cambridge, MA: Harvard University Press, 1993.

Liborion, Max. "History of Consumption and Waste, U.S., 1800–1850." In *Encyclopedia of Consumption and Waste: The Social Science of Garbage*, ed. Carl A. Zimring and William L. Rathje, 356–58. Los Angeles: Sage, 2012.

———. "Litterati: A Digital Landfill of Good-Looking Trash." *Discard Studies: Social Studies of Waste, Pollution and Externalities* (blog). July 29, 2013. *discardstudies.com/2013/07/29 /litterati-a-digital-landfill-of-good-looking-trash*.

Lindner, Christoph, "The Oblique Art of Shoes: Popular Culture, Aesthetic Pleasure, and the Humanities." *Journal for Cultural Research* 19, no. 3 (2015): 233–47.

"Lost—Then Found—along the Border, Objects Become Art." *All Things Considered*. November 22, 2014. *www.npr.org/2014/11/22 /365937723/lost-then-found-along-the-border -objects-become-art*.

Loukaitou-Sideris, Anastasia, and Renia Ehrenfeucht. *Sidewalks: Conflict and Negotiation over Public Space*. Cambridge, MA: MIT Press, 2012.

Lysack, Krista. *Come Buy, Come Buy: Shopping and the Culture of Consumption in Victorian Women's Writing*. Athens: Ohio University Press, 2008.

Manoff, Marlene. "Theories of the Archive from across the Disciplines." *Libraries and the Academy* 4, no. 1 (January 2004): 9–25.

Marten, Eugene. *Waste*. New York: Ellipsis, 2008.

May, Caroline. "Illegals Immigrants Leave Tons of Trash in Arizona Desert, Devastating Environment." *Daily Caller*, July 29, 2010. *dailycaller.com/2010/07/29/illegal-immigrants -leave-tons-of-trash-in-arizona-desert- devastating-environment*.

McGoldberg, Richbucks. *Why Are Hoarders Fat, Sad, and Poor?: Using the Magic of Decluttering and Minimalism to Create Wealth, Health and Happiness in Your Life*. Self-published. 2015.

McMullan, Kate, and Jim McMullan. *I Stink!* New York: Harper Collins, 2002.

Megastructures: Garbage Mountain. Written by Victoria Kirk and Shirley Tatum. Season 3, episode 6, aired June 18, 2006, on National Geographic Channel.

Melosi, Martin V. *Garbage in the Cities: Refuse, Reform, and the Environment*. Pittsburgh: University of Pittsburgh Press, 2005.

Messenger, Stephen. "Wallpapered Dumpsters: A Site for Sore Eyes?" *Treehugger*, January 12, 2010. *www.treehugger.com/sustainable-product -design/wallpapered-dumpsters-a-sight-for-sore -eyes.html*.

Michaelsen, Sven, David Pfeifer, and Vera Schroeder. "Guter Sex braucht Freiheit" (Interview with Peter Sloterdijk). *Süddeutsche Zeitung* 216, no. 17/18 (September 2016): 13–15.

Miglian, P., and Ace Landers. *I Am a Garbage Truck*. New York: Happy Books, 2008.

Miller, Kimberly Rae. *Coming Clean: A Memoir*. New York: New Harvest, 2013.

Mitchell, W. J. T. *Cloning Terror: The War of Images, 9/11 to the Present*. Chicago: University of Chicago Press, 2011.

———. *What Do Pictures Want? The Lives and Loves of Images*. Chicago: University of Chicago Press, 2005.

Möbius, Thomas. *Textanalyse und Interpretation zu Wolfgang Herrndorf (Tschick)*. Hollfeld: Bange Verlag, 2015.

Muller, Maria, and Anne Schienberg. "Gender and Urban Waste Management." Global

Development Resarch Center: Documents and Info Sheets (website). 1997. *www.gdrc.org/uem/waste/swm-gender.html.*

Mulligan, Andy. *Trash.* New York: Ember, 2010.

Nagle, Robin. "The History and Future of Fresh Kills." In *Dirt: The Filthy Reality of Everyday Life,* ed. Kate Forde, 187–205. London: Profile Books, 2012.

———. *Picking Up: On the Streets and behind the Trucks with the Sanitation Workers of New York City.* New York: Farrar, Straus, and Giroux, 2014.

Nash, Elizabeth. "The Art of Abu Ghraib." *Independent,* April 13, 2005. *www.zonaeuropa.com/20050413_2.htm.*

Oakes, Rosa P. "Desert Trash: Illegal Immigrants' Impact on the Environment." Evergreen-Energy (website). December 15, 2007. *www.nyu.edu/classes/keefer/EvergreenEnergy/oakesr.html.*

O'Brien, Martin. *A Crisis of Waste? Understanding the Rubbish Society.* London: Routledge, 2008.

Odanaka, Barbara, and Will Hillenbrand. *Smash! Mash! Crash! There Goes the Trash!* New York: Simon and Schuster, 2006.

Oettermann, Stephan. *The Panorama: History of a Mass Medium.* Cambridge, MA: Zone Books, 1997.

Olalquiaga, Celeste. *The Artificial Kingdom: On the Kitsch Experience.* Minneapolis: University of Minnesota Press, 1998.

Omololu, C. J. *Dirty Little Secrets.* New York: Walker, 2011.

"One Man's Trash Is Another's Museum Piece." *The Leonard Lopate Show.* March 19, 2015. *www.wnyc.org/story/treasures-trash-museum.*

Otte, Susan, and Gail Steketee. "Psychiatric Issues in Hoarding." *Psychiatric Times* 28, no. 8 (August 20, 2011). *www.psychiatrictimes.com/articles/psychiatric-issues-hoarding.*

Páramo, Arturo. "Chicles, reflejo de la sociedad de la cuidad de México." *Excélsior,* July 25, 2013. *www.excelsior.com.mx/comunidad/2013/07/25/910664.*

Patton, Melissa K. M. *Validate Me! (How My Mom's Hoarding Kind of Messed Me Up).* 2014.

Paulos, Eric, and Tom Jenkins. "Urban Probes: Encountering Our Emerging Urban Atmospheres." In *CHI 2005: Proceedings of the SIGCHI Conference on Human Factors in Computing Systems,* 341–50. New York: ACM, 2005. *www.paulos.net/papers/2005/Urban%20Probes%20(CHI%202005).pdf.*

Pavlich, Katie. "Illegal Immigrants Trashing the Environment along Southern Border." *Townhall,* January 7, 2011. *townhall.com/tipsheet/katiepavlich/2011/01/07/illegal-immigrants-trashing-the-environment-along-southern-border-n704845.*

Peacock, Kathy Wilson. "The Strange Saga of the Khian Sea." *Getting to GREENR* (blog), Cengage Learning-Gale. October 6, 2015. *resources.gale.com/gettingtogreenr/uncategorized/the-strange-saga-of-the-khian-sea.*

Periscope Film. "Dempster Dumpster World's First Dumpster Waste Management Promo Film 42174." YouTube. Uploaded May 22, 2016. *www.youtube.com/watch?v=UDLO7ObmK_k&t=625s.*

Petrova Nikolova, Lolita. "Children. In *Encyclopedia of Consumption and Waste: The Social Science of Garbage,* ed. Carl A. Zimring and William L. Rathje, 112–16. Los Angeles: Sage, 2012.

———. "History of Consumption and Waste, U.S., 1850–1900." In *Encyclopedia of Consumption and Waste: The Social Science of Garbage,* ed. Carl A. Zimring and William L. Rathje, 358–61. Los Angeles: Sage, 2012.

PhillyGreenGirl. "Green Fiend!" PhillyGreenGirl (blog). April 19, 2011. *phillygreengirl.wordpress.com/2011/04/19/green-fiend.*

Pisani, Elizabeth. "Leviticus Be Damned: Dirt in the Community." *The Filthy Reality of Everyday Life,* ed. Kate Forde, 91–129. London: Profile Books, 2012.

Pound, John. "Garbage Pail Kids." John Pound Art (website). n.d. (accessed November 2, 2018). *www.poundart.com/gpk.*

Rathje, William, and Cullen Murphy. *Rubbish! The Archeology of Garbage.* Tucson: University of Arizona Press, 2001.

Remus, Emily. *Consumers' Metropolis: How Monied Women Purchased Pleasure and Power in the New Downtown.* Cambridge, MA: Harvard University Press, forthcoming.

———. "Disruptive Shopping: Women, Space, and Capitalism." *American Historian,* May 2017. *tah.oah.org/may-2017/disruptive-shopping-women-space-and-capitalism.*

Rodríguez, Ana Mónica. "La goma de mascar como 'fósil' y objeto de estudio en la muestra *Chicle y pega.*" *La Jornada,* August 13, 2012.

www.jornada.unam.mx/2012/08/13/cultura
/a17n2cul.

Roy, Abhijit. "History of Consumption and
Waste, U.S. Colonial Period." In *Encyclopedia
of Consumption and Waste: The Social Science of
Garbage*, ed. Carl A. Zimring and William L.
Rathje, 354–56. Los Angeles: Sage, 2012.

Royte, Elizabeth. *Garbage Land: On the Secret
Trail of Trash*. New York: Back Bay Books/
Little Brown, 2005.

Rozin, Daniel. "Trash Mirror-2001." Daniel Rozin
Interactive Art. n.d. (accessed November 1,
2018). *www.smoothware.com/danny
/newtrashmirror.html*.

Sadler, Stephanie. "London Art Spot: Ben Wilson
(Part I)." Little London Observationist (blog).
July 31, 2013. *littlelondonobservationist.word
press.com/2013/07/31/london-art-spot-ben
-wilson-part-1*.

———. "London Art Spot: Ben Wilson (Part II)."
Little London Observationist (blog). August 1,
2013. *littlelondonobservationist.wordpress.com
/2013/08/01/london-art-spot-ben-wilson-part-2*.

Samuels, J. F., O. J. Bienvenu, M. A. Grados,
B. Cullen, M. A. Riddle, K. Y. Liang, W. W.
Eaton, and G. Nestadt. "Prevalence and
Correlates of Hoarding Behavior in a
Community-Based Sample." *Behavioral
Research Therapy* 49, no. 7 (July 2008):
836–44.

Sánchez, Sandra, and Rosa Castillo. "'Chicle y
pega': Basura en restauración." *Voy & Vengo*
23 (June 2012). *www.voyvengo.com.mx/revista
/item/chicle-y-pega-basura-en-restauracion*.

Sandlin, Jennifer A., and Julie G. Maudlin.
"Consuming Pedagogies: Controlling Images
of Women as Consumers in Popular Culture."
Journal of Consumer Culture 12, no. 2 (2012):
175–94.

Scanlan, John. *On Garbage*. London: Reaktion
Books, 2005.

Schult, HA. "Action: Trash People." HA Schult
(website). 1999. *www.haschult.de/action
/trashpeople#content*.

Sebald, W. G. *On the Natural History of
Destruction*. New York: Modern Library,
2004.

Segal, Gregg. "Gregg Segal: 7 Days of Garbage."
The FENCE (website). 2014. *fence-archive
.photoville.com/2014/gregg-segal*.

Sholl, Jessie. *Dirty Secret: A Daughter Comes Clean
about Her Mother's Compulsive Hoarding*. New
York: Gallery Books, 2011.

Silverstein, Michael J., and Kate Sayre. "The
Female Economy." *Harvard Business Review*,
September 2009. *hbr.org/2009/09/the
-female-economy*.

Slinkachu. *Little People in the City: The Street Art
of Slinkachu*. Foreword by Will Self. London:
Boxtree, 2008.

Sloterdijk, Peter. *Das Schelling Projekt*. Frankfurt:
Suhrkamp, 2016.

Smith, Monica. "History of Consumption and
Waste, Ancient World." In *Encyclopedia of
Consumption and Waste: The Social Science of
Garbage*, ed. Carl A. Zimring and William L.
Rathje, 346–48. Los Angeles: Sage, 2012.

Smith, Virginia. "Evacuation, Repair, and
Beautification: Dirt and the Body." *The Filthy
Reality of Everyday Life*, ed. Kate Forde, 7–35.
London: Profile Books, 2012.

Sontag, Susan. *Regarding the Pain of Others*. New
York: Picador, 2003.

Spivak, Gayatri Chakravorty. "The Rani of
Sirmur: An Essay in Reading the Archives."
History and Theory 24, no. 3 (October 1985):
263.

Spooky. "The Chewing Gum Portraits of Jason
Kronenwald." Oddity Central (website).
November 22, 2010. *www.odditycentra
.com/pics/the-chewing-gum-portraits-of-jason
-kronenwald.html*.

Squire, Vicky. "Desert 'Trash': Posthumanism,
Border Struggles, and Humanitarian Politics."
Political Geography 39 (2014): 11–21.

Stewart, Susan. *On Longing: Narratives of the
Miniature, the Gigantic, the Souvenir, the
Collection*. Durham, NC: Duke University
Press, 1993.

Stone, Nick. "Richard Misrach | Guillermo
Galindo | *Border Cantos*." Guillermo Galindo
(website). 2014. *www.galindog.com/wp
/richard-misrach-guillermo-galindo-border
-cantos*.

Strasser, Susan. *Waste and Want: A Social
History of Trash*. New York: Holt Paperbacks,
1999.

Thill, Brian. *Waste*. New York: Bloomsbury,
2015.

Thomson, Vivian E. *Garbage In Garbage Out:
Solving the Problems with Long-Distance Trash
Transport*. Charlottesville: University of
Virginia Press, 2009.

Thrash 'N' Trash Productions. *Garbage Trucks:
On Route, in Action!* YouTube. Uploaded
March 27, 2015.

Urrea, Luis Alberto. *By the Lake of Sleeping Children: The Secret Life of the Mexican Border.* New York: Anchor Books, 1996.

Valis, Noel. *The Culture of Cursilería: Bad Taste, Kitsch, and Class in Modern Spain.* Durham, NC: Duke University Press, 2002.

Vergine, Lea. *When Trash Becomes Art: Trash Rubbish Mongo.* Torino: Skira Editore, 2007.

Vigarello, Georges. *Concepts of Cleanliness: Changing Attitudes in France since the Middle Ages.* Cambridge: Cambridge University Press, 1988.

Voytko, Eric. "Beginnings: The Dempster Dumpster." *History of Dempster Refuse Equipment.* Classic Refuse Trucks (website). January 7, 2006. *www.classicrefusetrucks.com /albums/DE/DE01.html*

Walcop, L. A. *Hoarder: The True Story of My Mother's Downward Spiral.* Self-published. 2017.

Watson, Renata. "Meet the Kids Scavenging on Rubbish Dumps to Survive." ActionAid (website). January 30, 2015. *www.actionaid .org.uk/blog/news/2015/01/30/meet-the-kids -scavenging-on-rubbish-dumps-to-sur.*

Whiteley, Gillian. *Art and the Politics of Trash.* London: I. B. Tauris, 2011.

Winter, Izabelle. *Diary of a Hoarder's Daughter.* CreateSpace Independent Publishing Platform, 2014.

Wölke, Alexandra. *Wolfgang Herrndorf: Tschick.* Paderborn: Shöning Verlag, 2014.

Wood, Betty. "Pablo Delgado's Paste-Up Prostitutes." *Don't Panic: Magazine/Arts/ London,* July 17, 2011. dontpaniconline.com /magazine/arts/pablo-delgados-paste-up -prostitutes.

Zimmerman, Andrea, and Dan Yaccarino. *Trashy Town.* New York: Harper Collins, 1999.

Zimring, Carl A. *Clean and White: A History of Environmental Racism in the United States.* New York: New York University Press, 2016.

Ziraldo, Cristiana. "Trash by Andy Mulligan." Blog di Cristiana Ziraldo. October 18, 2017. *cristianaziraldo.altervista.org/trash -by-andy-mulligan.*

Zubiaurre, Maite. *Cultures of the Erotic in Spain, 1898–1939.* Nashville, TN: Vanderbilt University Press, 2011.

———. *El espacio en la novela realista: Paisajes, miniaturas, perspectivas.* Mexico City: Fondo de Cultura Económica, 2000.

———. "Litter: On Chewing Gum and Street Art." In *The Routledge Companion to Urban Imaginaries,* ed. Christoph Lindner and Miriam Meissner. Routledge: forthcoming.

———. "Panoramic Views in Th. Fontane, B. Pérez Galdós, and L. Alas, 'Clarín': An Essay on Female Blindness." In *Theodor Fontane and the European Context: Literature, Culture and Society in Prussia and Europe,* ed. Patricia Howe and Helen Chambers, 253–63. Amsterdam: Rodopi, 2001.

———. "Trash Moves: On Landfills, Urban Litter, and Art." *ReVista: Harvard Review of Latin America* 14, no. 2 (Winter 2015): 38–39.

———. "Trashtopia: Global garbage/art in Francisco de Pájaro and Daniel Canogar." In *Global Garbage: Urban Imaginaries of Waste, Excess, and Abandonment,* ed. Christoph Lindner and Miriam Meissner, 17–34. Abingdon: Routledge, 2016.

Illustration Credits

Fig. 2.5.5 *Chicle #142*, proceso de clasificación de chicles, intervención en sitio específico, calle Regina, Centro Histórico, CDMX. TRES (Ilana Boltvinik, Rodrigo Viñas, Mariana Mañón + Javier Cuervo), 2012.

Fig. 2.5.6 *Morfología del chicle*, lápiz y tinta sobre papel 20 × 14 cms. TRES (Ilana Boltvinik, Rodrigo Viñas, Mariana Mañón + Javier Cuervo), 2012.

Fig. 2.6 Ben Wilson (aka Chewing Gum Man), 2008.

Fig. 2.7 Ben Wilson (aka Chewing Gum Man), 2008.

Fig. 2.8 Ben Wilson (aka Chewing Gum Man), 2008.

Fig. 2.9 Jason Kronenwald, *Gum Blonde XI*, 2004, Chewed bubblegum on plywood sealed in epoxy, 24 × 32 inches. Photo by artist.

Fig. 2.10 Jason Kronenwald, *Gum Blonde LVIII*, 2008, Chewed bubblegum and gum wrappers on plywood sealed in epoxy, 16 × 22 inches. Photo by artist.

Fig. 2.11 Filomena Cruz, photographs. *Roadkill Series*. Los Angeles, CA.

Fig. 2.12 Filomena Cruz, photographs. *Roadkill Series*. Los Angeles, CA.

Fig. 2.13 Filomena Cruz, photographs. *Dangerous Beauty Series*. Venice, CA.

Fig. 2.14 Ester Partegàs, *Life Is Tremendous*, 2005. Courtesy of the artist and Foxy Production, New York.

Fig. 2.15 Filomena Cruz, photographs. *Roadkill Series*. Los Angeles, CA.

Fig. 2.16 Allison C. Meier, photograph taken at Trash Museum.

Fig. 2.17 Filomena Cruz, photograph. Santa Monica, CA.

Fig. 2.18 Filomena Cruz, photographs. Venice, CA.

Fig. 2.19 Filomena Cruz, photographs. Los Angeles, CA.

Fig. 2.20 Filomena Cruz, photograph. Los Angeles, CA.

Fig. 2.21 Filomena Cruz, photograph. Los Angeles, CA.

Fig. 2.22 Filomena Cruz, photograph. Los Angeles, CA.

Fig. 2.23 Filomena Cruz, photograph of an anonymous thrift store painting. Los Angeles, CA.

Fig. 2.24 Gregg Segal.

Fig. 2.25 Sonoran Roam, Courtesy of Bureau of Land Management. Arizona State Office (Public Domain).

Fig. 2.26 Sonoran Roam, Courtesy of Bureau of Land Management. Arizona State Office (Public Domain).

Fig. 2.27 Alejandro Durán, *Vena*, 2011.

Fig. 2.28 Alejandro Durán, *Sueño de Niña*, 2010.

Fig. 2.29 Michael Wells, Undocumented Migration Project.

Fig. 2.30.1 Jonathan Hollingsworth, *Left Behind*, Lockers, Pima County Forensic Science Center, Tucson, Arizona.

Fig. 2.30.2 Jonathan Hollingsworth, *Left Behind*, Lockers, Pima County Forensic Science Center, Tucson, Arizona, Personal Effects, ML# 11-00709, Doe, Jane.

Fig. 2.30.3 Jonathan Hollingsworth, *Left Behind*, Lockers, Pima County Forensic Science Center, Tucson, Arizona. (unidentified sleeve).

Fig. 2.31 Jonathan Hollingsworth, Series *Left Behind*.

Fig. 2.31.5 Jonathan Hollingsworth, Series *Left Behind* (detail).

Fig. 2.31.7 Jonathan Hollingsworth, Series *Left Behind* (detail).

Fig. 2.31.8 Jonathan Hollingsworth, Series *Left Behind* (detail).

Fig. 2.32 Jonathan Hollingsworth, *Left Behind*, Lockers, Pima County Forensic Science Center, Tucson, Arizona, Personal Effects, ML# 11-01569, Doe, John.

Fig. 2.33 Thomas Kiefer, *Billfolds and Wallets*, 2014.

Fig. 2.34 Thomas Kiefer, *Water Bottles*, 2013.

Fig. 2.35 Thomas Kiefer, *Gloves*, 2013.

Fig. 2.36 Thomas Kiefer, *Earphones*, 2015.

Fig. 2.37 Richard Misrach, *Stranded Soccer Ball*. Tijuana Estuary, San Diego, 2013. © Richard Misrach, courtesy Fraenkel Gallery, San Francisco, Pace/MacGill Gallery, New York and Marc Selwyn Fine Art, Los Angeles.

Fig. 2.38.1 Susan Harbage Page, *Girls Love Shoes*.

Fig. 2.38.2 Susan Harbage Page, untitled.

Index